CLIVE BELL'S EYE

CLIVE BELL'S EYE

William G. Bywater, Jr.
ALLEGHENY COLLEGE

WAYNE STATE UNIVERSITY PRESS DETROIT, 1975

Library of Congress Cataloging in Publication Data

Bywater, William G 1940–
 Clive Bell's eye.

 "A checklist of the published writings of Clive
Bell, by Donald A. Laing": p.
 Includes index.
 1. Bell, Clive, 1881–1964. 2. Form (Aesthetics)
3. Art—Philosophy. I. Title.
N7445.2.B44B9 1974 701'.17 74–23853
ISBN 0–8143–1534–8

For Patrick

CONTENTS

PART III.
A Checklist of the Published Writings of Clive Bell, by Donald A. Laing

PLATES

ACKNOWLEDGMENTS

First, I must record my debt to Anne Philbin, my wife, whose unfailing belief that Clive Bell has something important to say kept me at work on the manuscript which became this book. President Lawrence Pelletier of Allegheny College was kind enough to provide a grant which enabled Ms. Philbin and me to travel to England and Italy during the summer of 1970. We read the Charleston Papers at King's College, and viewed at first hand much of the art which Bell so admired. *Clive Bell's Eye* is a direct consequence of our trip. We must thank Mr. Quentin Bell for taking time away from his work on Virginia Woolf's biography to speak with us about his father and about Bloomsbury. Mr. Munby of the King's College Library, too, helped in making our trip a success.

Secondly, I owe to Mr. Donald Laing a large debt for permitting me to produce for the first time his checklist of the published writings of Clive Bell. So far as he and I know, this is the most complete list of Bell's work now in print.

The *New Statesman,* London, has kindly given me permission to reprint the following articles by Bell: "Criticism," "The Artistic Problem," "Order and Authority, I," "Duncan Grant," "The Two Corots," "Black and White," and "Art Teaching." The *New Republic,* New York, has kindly given permission for: "De Gustibus," "The Critic as Guide," "The 'Difference' of Literature," and "The Bran-pie and Eclecticism." The date and location of each article are listed in the body of the book. I have annotated the articles for the present-day reader and have Americanized spelling for consistency.

10

Acknowledgments

The following have granted permission to reproduce copyrighted photographs of paintings and mosaics:

The Tate Gallery, London, and Mr. Ivon Hitchens: *Coronation* and *Forest Edge No. 2.*

Fratelli Alinari, Florence: S. Apollinare in Classe and S. Apollinare Nuovo mosaics; Giotto, *Madonna di Ognissanti,* and Cimabue, *Madonna in trono.*

The Tate Gallery, London: Duncan Grant, *The Queen of Sheba, Bathers,* and *Lemon Gatherers.*

The Baltimore Museum of Art: Cézanne, *Mont Sainte Victoire, Seen from Bibemus Quarry.*

The Barnes Foundation, Merion, Pa.: Renoir, *Mont Sainte Victoire.*

My thanks go to Sarah M. Jacobs of the Tate Gallery, and to Barbara Ehrlich White for helping me to arrange for these reproductions.

Many other people were indispensable in the production of this work: for typing manuscript I am indebted to Pauline Mooney, Dorothy Hawkins, and Elizabeth Hughes; for working on footnotes special recognition goes to Elizabeth Grimbergen, Bronson Stadler, and William Kammen; Pol Corvez and Sam Edwards aided with translations. Professor S. P. Rosenbaum of the University of Toronto, Harold Osborn, editor of the *British Journal of Aesthetics,* and Professor Berel Lang of the University of Colorado offered helpful suggestions. Herbert Schueller, director, Barbara Woodward, chief editor, and the staff of Wayne State University Press were continually helpful and kind.

11

PART I
Clive Bell's Eye

Introduction

 In the essay which follows I try to touch upon the main themes in Bell's work on aesthetics. Of course I have drawn heavily from his major work, *Art,* but I have also included many references to his shorter essays, which appeared in various magazines and journals. These essays help considerably in understanding Bell's position. The themes upon which I focus, in the order of their appearance, are Bell's view of criticism, the nature of significant form, the import of Bell's metaphysical hypothesis, and Bell's movement toward what I have come to call a humanistic formalism. I believe that the order in which these topics are presented is important. Familiarity with Bell's position on criticism helps in our grasp of the notion of significant form, which is, after all, the focus of criticism. Once the scope of the concept of significant form becomes clearer, we can more easily see the shape of the terrain covered by the metaphysical hypothesis. Finally, what I take to be the eventual breakdown of the metaphysical hypothesis reveals Bell's tendency toward a humanistic formalism.

 What follows in this essay is not simply a report upon Clive Bell's position. Such a thing would be an impossibility, for although *Art* was an influential book, there are many themes in it which strain at one another and tend to pull the book apart. For this reason it requires interpretation. What I offer in the following pages is an argumentative construct which, I believe, does justice to the themes in Bell's work listed above, and to the problems which Bell believed fundamental to aesthetic theory.

The Nature of Criticism

Arnold Isenberg's work on the nature of criticism can help us come to an understanding of Bell's position. In "Critical Communication"[1] Isenberg distinguishes two modes of criticism. The first is normative criticism, in which a critic's reasons and his judgments are related *via* a norm. A reason supports a judgment because it points out a quality of the work which, if the work truly possesses it, will make the work valuable. By appealing to a norm—"Any work which has X is good"—the critic, seeing X as a quality of the work, concludes that the work is good. Isenberg's second mode of criticism is non-normative. Reasons and judgments are not logically related *via* a norm. In fact, the point of this mode of criticism is not to pass judgment—although a critic may do so by the way. The point of this mode of criticism is to achieve communication at the level of the senses. Through his language, the critic gives his audience directions for perceiving what he sees in the work. If a sameness of vision and experienced content is created, then communication at the level of the senses has taken place. No norms are employed, for the critic's language is not used to designate qualities the perception of which leads to a judgment about the work. When a critic is attempting to bring about a shared experience at the level of the senses, he uses his words to convey to the audience a feeling for a quality "no idea of which is transmitted to us by his language."[2]

Reading *Art*,[3] one might infer that Bell holds a normative position in criticism. "Art is significant form" could be taken as the norm which he employs. On this understanding, critical argument about paintings would look like this: All paintings

with significant form are art; painting X possesses significant form; therefore, painting X is art. The conclusion to this argument is not a tautology, for Bell distinguishes between something being a painting, and being a work of art. In his critical essays Bell maintains this distinction by referring to picture-makers as painters, but refusing to call them artists. Only the good painters—those who create forms of aesthetic significance (art)—are artists. In a parallel fashion Bell maintains a dichotomy between works which are paintings and those which are art.[4] So, the conclusion tells us something.

However, we can raise a question as to the status of the major premiss in our critical argument. We can ask if the statement "All paintings with significant form are art" is a tautology, or if it tells us anything. For normative criticism to work, in Isenberg's view, it must be possible to establish that a work possesses the good-making quality in question without raising questions about the work's value. Thus, the statement attributing this quality to the work would have to be a purely descriptive statement, as Isenberg calls it. If our major premiss is a tautology, then "significant form" does not designate a quality which could be included in a purely descriptive statement, for "possessing significant form" and "being a work of art" would both have, at least, the same evaluative force.

Bell does say some things which indicate that "possessing significant form" cannot be taken as simply descriptive. We have already seen that Bell equates creating forms of aesthetic significance with creating works of art. In addition, there are passages in *Art* which indicate that "X has significant form" is not on the same level as such descriptive statements as "X is polychromatic," "X has red in it," or "X has a frame." It is not the case that every normal person, without any training, can spot significant form. Nor is it the case that significant form is just another quality of works of art similar to which colors they contain, or what subject matter they depict. Bell claims that there are any number of people with normal eyesight, intelligence, etc., who do not, and perhaps never will, recognize significant form. Such people lack the requisite sensitivity, says Bell.[5]

At this point those who desire to maintain that Bell's criticism must be of the normative type could admit that "signifi-

cant form" does not designate any condition like that of contain-
ing the color red, or of having a frame, but does designate in a
descriptive way a different kind of quality. Our knowledge of this
quality does not come to us through any of the six senses, but it is
grasped, or intuited, through some other means. There is no evi-
dence in Bell's writing that he believed there to be a special
aesthetic faculty, although he did believe that there is discernible
aesthetic emotion. Yet, the suggestion that "significant form" de-
signates in an unusual way may be helpful. Perhaps it is Bell's
term for that quality no idea of which is transmitted to us by the
critic's language, but which the critic tries to prod us into seeing.
This understanding of significant form is supported by what Bell
says about criticism, as we shall see.

Bell's approach to criticism is audience-oriented rather
than artist-oriented—"A critic no more exists for artists than a
palaeontologist does for the Dinosaurs."[6] The critic is not inter-
ested in establishing canons for propriety in the creation of works
of art, rather he is a guide, or signpost—a fallible one—who
helps his audience see things they might otherwise overlook:

> A critic should be a guide and an animator. His it is first to bring
> his reader into the presence of what he believes to be art, then to
> cajole or bully him into a receptive frame of mind. He must,
> therefore, besides conviction, possess a power of persuasion and
> stimulation: and if anyone imagines that these are common or
> contemptible gifts, he mistakes. It would, of course, be much nicer
> to think that the essential part of a critic's work was the discovery
> and glorification of Absolute Beauty; only unluckily it is far from
> certain that absolute beauty exists, and most unlikely, if it does,
> that any human being can distinguish it from what is relative.
> The wiser course, therefore, is to ask of critics no more than sin-
> cerity, and to leave divine certitude to superior beings. . . .[7]

The realities of the critical situation indicate to Bell
that belief in "Absolute Beauty" will not serve, nor accurately
reflect, the activity of the practicing critic: "I do not disbelieve in
absolute beauty any more than I disbelieve in absolute truth.
. . . Only can we recognize it?"[8] We cannot be certain that we
have recognized absolute beauty in a work of art, for not only
might the critic be mistaken in a particular case, but it is also
impossible to expect that any critic could recognize beauty in all

of its forms, Bell argues. There will always be works which move one critic and fail to move another, and Bell refuses to establish a vantage point from which critical disagreements may be finally resolved. Thus, a critic must possess both a sense of humor, and some modesty, for he might always have to revise his judgments on the basis of new things which he comes to see and feel:

> To be continually pointing out those parts, the sum, or rather the combination, of which unite to produce significant form, is the function of criticism. But it is useless for a critic to tell me that something is a work of art; he must make me feel it for myself. This he can do only by making me see; he must get at my emotions through my eyes.[9]

For Bell, critics do not make absolute judgments about artistic quality. Their language is not designed to render verdicts on the basis of norms and reasons. Everything which Bell says points in the direction of Isenberg's non-normative mode of criticism. Bell's critic is a guide—he leads the audience to art—and an animator. He must excite and interest his audience so that they, too, have the opportunity to see and feel what he has seen and felt. The critic bullies and cajoles in an effort to achieve a unity, an agreement, at the level of vision and feeling. The critic's task is to point out the parts of a work which combine to produce significant form, and to somehow convey to his audience, through their eyes, the significant combination of the parts. The critic does not employ the norm "art is significant form," for he does not point to the presence of significant form in the work. Nor is there any other norm involving parts of works to which he can appeal, for we are not dealing with a simple sum of parts. The critic cannot tell us anything; he must show us significant form. His positive evaluation of a work—the assertion that it possesses significant form—is irrelevant unless, and until, the members of the audience experience the presence of significant form for themselves. (The critic's efforts become irrelevant at the same time at which they become successful). The critic may be of the opinion that a work is of value because it possesses significant form, but he cannot use this as a reason in criticism, for to grasp the significance of form is to see at the same time that a work is valuable.

According to Isenberg:

The truth of R [reason] *never adds the slightest weight to V* [judgment], because R does not designate any quality the perception of which might induce us to assent to V. But if it is not R, or what it designates, that makes V acceptable, then R cannot possibly require the support of N [norm]. The critic is not committed to the general claim that a quality named Q is valuable because he never makes the particular claim that a work is good in virtue of the presence of Q.[10]

What Bell says about criticism indicates that there is no R available to the critic upon which to base a judgment. The possession of significant form by a work cannot be an R, for the perception of the presence of significant form is already judgmental. There are no other R's which can be used, for any substitution which might be made here would overlook the need to move beyond the reason to a vision and feeling shared by critic and audience.

Let us look for a moment at a piece of criticism by Bell himself.

The second and third paragraphs of his review "Black and White" (see below, part II) are significant. If the comments which we find there are to be understood as exhibiting Isenberg's non-normative mode of criticism, then they must attempt to convey a quality no idea of which is transmitted to us by the language, and they must give directions for perceiving this quality by guiding us in the discrimination of details, organizations, patterns, and the like. Throughout the review Bell gives directions, and attempts to bring his audience to see something. We are looking at drawings of nudes. The forms which we see are languid, broken, weak, flower-like. Yet, Bell tells us to look again, for these forms reveal themselves as very powerful, very expressive. Look at those two lines! They somehow convey all the substance of a human limb. A doubled-up, elongated petal somehow presents the essence of an arm. These limbs which emerge are crumpled but taut, cracked yet substantive. From calligraphic lines, to languid, broken stems, to the essence of human limbs, Bell leads us deeper into the work. As we follow, the expressiveness of the drawings emerges. There is something there which

Bell cannot directly describe, but to which he desires to lead us. The plasticity and expressiveness seem to be a function of the crumpled and the taut, the languid and the live. We can appreciate this condition only through direct perception of the drawings; as we look we will come to see and feel the expressiveness which Bell's guidance helps to reveal. Bell is striving to communicate a certain perception, and a certain understanding of the Matisse drawings. He moves beyond a discussion of the decorative aspects in an attempt to confront us with their expressiveness. His procedure here conforms essentially to Isenberg's description of non-normative criticism.

One more facet of Isenberg's notion of critical communication must be considered:

> It is a function of criticism to bring about communication at the level of the senses; that is to induce a sameness of vision, of experienced content. If this is accomplished, it may or may not be followed by agreement, or what is called 'communion'—a community of feeling which expresses itself in identical value judgments.[11]

Sameness of vision does not guarantee a community of feeling as its result, but it is at least possible to begin non-normative criticism without a community of feeling, and with the hope that one will arise. Normative criticism, on the other hand, requires a community, at least at the level of norms, before the critical work can begin. For two normative critics to discuss, or argue about, a work of art—as opposed to arguing about norms—they must first agree on what norms are to be applied. This is also true in a situation in which a normative critic addresses an audience for the purpose of establishing agreement upon the value of some work. The critic must assume that the audience shares his norms. No assumptions about norms, or about common perceptions, are made by the non-normative critic. His efforts may fail because his audience is insensitive or hostile, or because he is reading too much into a work. But no matter how diverse the critic's audience, communication at the level of the senses followed by a community of feeling cannot be regarded as impossible *a priori*.

The non-normative mode of criticism is thus potential-

21

ly effective when there is widespread confusion or disagreement about norms. Its use could allow a critic to cut through disagreement at the level of norms to concentrate upon the unencumbered perception of works of art. This mode of criticism could be of great value to the critic who desires to bring about a fresh look at art, and, at the same time, suggest that prevailing norms should be abandoned. Reflecting upon Bell's situation at the beginning of this century—*Art* was published in 1914—we can see how a form of criticism which challenges, and at the same time bypasses, norms would be most attractive to him. Writing in the preface to the new edition of *Art* in 1948, Bell describes the conditions as he had found them thirty-seven years earlier:

> [Y]ou must remember that "the battle of Post-Impressionism" had just been joined. The best that even Sickert would say for Cézanne, in 1911, was that he was *"un grand raté,"* while Sargent called him a "botcher," and the director of the Tate Gallery refused to hang his pictures. Van Gogh was denounced every day almost as an incompetent and vulgar madman; M. Jacques-Emile Blanche informed us that, when cleaning his palette, he often produced something better than a Gauguin; and when Roger Fry showed a Matisse to the Art-Workers Guild the cry went up "drunk or drugs?" . . . Hark to Sickert: "Matisse has all the worst art-school tricks" . . . "Picasso, like all Whistler's followers, has annexed Whistler's empty background without annexing the one quality by which Whistler made his empty background interesting."[12]

We can easily see how, confronted with this kind of opposition, Bell would feel that an appeal to norms was out of the question. Clearly many people did not see the work of the Post-Impressionists in the same way as did he and Fry. An effort to establish a sameness of vision had to be launched. The most prominent results of this effort were *Art*, Roger Fry's "An Essay in Aesthetics," and the two Post-Impressionist exhibitions at the Grafton Galleries. For this first, and primary, task of bringing about a sameness of vision a non-normative criticism would be perfectly suited, since it makes the fewest assumptions about value. I believe that we can safely say that Bell expected, and hoped for, a community of feeling to follow upon sameness of vision.

We now have before us three powerful considerations counting for the view that Bell's position contains a non-normative theory of criticism: (1) the circumstance that "significant form" is not a descriptive term; (2) Bell's statements on the nature of criticism; and (3) Bell's historical situation. Let us say, then, that "art is significant form" is not used by Bell as a norm in criticism. Must we also conclude, along with Isenberg, that Bell is not committed to the general claim that to possess significant form is a value? We cannot go this far. Bell links significant form with art. Certainly, to be art is to have value, for Bell. This point is clear from Bell's distinction between something being a painting and being a work of art. So, we cannot conclude that possessing significant form (being art) is not a value. Bell does not have a normative approach to criticism, yet he is committed to the claim that to possess significant form is a value. In order to come to an understanding of this situation, we must abandon Isenberg's helpful lead at this point.

The link which Bell establishes between significant form and art is important for criticism, but not as a norm which mediates reason and judgment. There are several dimensions to this link as it operates in Bell's theory. One seems to be that it constrains the critic in his effort to bully and cajole his audience into a communication at the level of the senses. It indicates what kind of talk is most relevant to, is best for, establishing the communication—and hopefully the community—which Bell believes ought to be established. In this respect it is a norm which governs critical activity, rather than one which governs, or indicates, successful artistic production.

To explicate this understanding of Bell's position, let us begin by considering the claim that "art is significant form" should be construed as a platform for aesthetic reform, or as a disguised visual recommendation to look at paintings in a certain way. Both of these characterizations are truly dimensions along which Bell's position operates. The understanding of Bell's theory as an effort to reform vision conforms to much of what Bell says. He encourages us to look at the representational elements in painting in such a way as to concentrate on their more formal aspects. If we can do this, then the tide in the battle of Post-Impressionism will begin to run in favor of Cézanne and the

others, Bell believes. He characterizes significant form as "lines and colors combined in a particular way, certain forms and relations of forms. . . ."[13] Then he speaks of representation as follows:

> Let no one imagine that representation is bad in itself; a realistic form may be as significant, in its place as part of the design, as an abstract. But if a representative form has value, it [is] as form, not as representation. The representative element in a work of art may or may not be harmful; always it is irrelevant.[14]

Yet, simply to say that Bell desired to reform vision in a certain way leaves unsaid the reason for the reform. Knowing the reason will help us in this instance, because to draw attention to line, color, design, etc., does not by itself give us any real guidance as to how to order, compose, or structure these elements at the level of the senses where communication is to take place. Representation *per se* has now been set aside as of no importance to the critic in his work of guiding and animating; hence we know that lines, colors, and design are not to be ordered so as to stress the representational aspects of the painting. How are they to be ordered?

When we recall that the reason for recommending a visual reform is to gain acceptance for the Post-Impressionists, especially Cézanne, a positive answer to this question begins to emerge. In the course of *Art* Bell tries to show that the work of Van Gogh, Cézanne, Picasso, and the other Post-Impressionists, is art, and not junk, by linking their efforts with work which is unquestionably art—"since the Byzantine primitives set their mosaics at Ravenna no artist in Europe has created forms of greater significance unless it be Cézanne."[15] Artists such as Giotto, Cimabue, and Poussin and Chardin at their best, are also cited by Bell as creating paintings with aesthetic significance. Such examples—necessary, of course, when one is working with non-normative criticism—tell us much more than Bell's words could. These examples give us positive directions about how to order, compose, and structure the lines and colors of which Bell speaks. The directions which we now have tell us to attend to the design of these works in such a way as to discover what quality it is which they all possess at the level of the senses. (See part II.)

This is where we must begin in our effort to see and feel the significance of form.

The critic now has directions for finding his way along Bell's path, and for leading others along it, if he should find the path valuable. We have seen how the critic is to treat representation, and to which artists he might look to begin his grasp of significant form. Bell gives specific examples of how not to deal with paintings. Discussing Frith's *Paddington Station*,[16] he points out that "disentangling its fascinating incidents and forging for each an imaginary past and an improbable future" is anti-aesthetic.[17] Those who use paintings to recount anecdotes, suggest ideas, and indicate manners and customs cannot possibly experience the paintings as art. On the other hand, when speaking of Nicolas Poussin, Bell gives us some insight into how to approach his work aesthetically:

> [I]n the best works of Nicolas Poussin, the greatest artist of the age, you will notice that the human figure is treated as a shape cut out of coloured paper to be pinned on as the composition directs. That is the right way to treat the human figure. . . .[18]

Not only are we to overlook representation, but the critic, also, should not search for or discuss any ideational content. The emotion or feeling which for Bell is characteristic of the aesthetic is not one which is tied up with the discovery of meaning, or message, but one which comes from the perception of the "rightness" of the formal elements. (Of course, this "rightness" is a perceptual quality which the critic's language does not designate).

We are now in a position more fully to understand what Bell has in mind when he asserts that "art is significant form" is a definition. The definitional dimension of this phrase takes its place alongside the aesthetic-reform-visual-recommendation dimension and the constraint-upon-the-critic dimension when we notice that it expresses (1) Bell's belief that a quality common to all we call art (value term) can be discovered at the level of perception and feeling, and (2) Bell's hope that a community of valuation can be established. This definition does not state an accomplished fact, so to speak. It tells, in summary form, where and how one should direct his attention in order to discov-

er that which is uniquely aesthetic, and, at the same time, projects us into the future by indicating Bell's hope or belief that experience will justify us when we regard significant form as the locus of the aesthetic.

There is, finally, even a fourth dimension to "art is significant form." Not only does this expression contain a visual recommendation *vis à vis* particular paintings, it also makes a recommendation about how to "look at" the history of visual art. For example, there are many people who believe, and argue, that the Renaissance marks the pinnacle of development in the visual arts, particularly painting and sculpture, of the Western world. When one looks back upon pre-Renaissance work from this position, and notices its lack of linear perspective, for instance, it is easy to interpret the earlier works as inferior fumblings toward the Renaissance ideal. When one looks forward from the position of the Renaissance to the beginning of the twentieth century and Post-Impressionism, it is natural to regard the work of Cézanne and the others as degenerate art, if art at all. When Bell tells us that art is significant form, part of the force of that saying is to shift us out of the Renaissance perspective, to remove that cultural burden from us, so that we may take advantage of his specific visual recommendation. Perhaps we could call this dimension of the theory an effort to reform taste. By stressing the links between Cézanne and Ravenna, he makes us see and appreciate in ways foreign to the Renaissance. For example, our taste for space in painting might alter in such a way that we come to prefer the kind of space which can be created by means other than the convergence of sight lines at a definite, fixed point. We might come to feel that picture space created primarily by the latter means is sterile, fixed, and cold, while space such as that found in the Ravenna mosaics is dynamic, tense, vibrant, potentially charged with emotion, and the like. Without this more general alteration of taste with respect to the potentialities of non-Renaissance space Bell's particular recommendations will be of little help. As long as we continue to respond positively to the descriptive in painting, we will not be able to follow Bell's lead into the world of forms.

The understanding we now have of "Art is significant form" can be employed to show that certain objections which

have been raised to theorizing in aesthetics do not apply to Bell's position. It has been said that theory in aesthetics is improper for two main reasons: (1) because upon examination of various works of art we cannot, in fact, discover any common properties among them; and (2) because theory in aesthetics limits *a priori* those things to which the term "art" can be applied, foreclosing upon creativity in the arts.

William E. Kennick sees the first impropriety as arising from "the assumption that, despite their differences, all works of art must possess some common nature, some distinctive set of characteristics which serves to separate Art from everything else, a set of necessary and sufficient conditions for their being works of art at all."[19] Kennick claims that it is a fool's errand to search after some quality common to all art. If resemblances are discovered through examining some plays and pictures, they quickly disappear when one turns to poems and other plays and pictures. Centuries of fruitless searching should indicate to all of us by now that there is no common denominator to be found. Morris Weitz is another contemporary philosopher who appeals to this "fruitless-search" argument. Weitz suggests that the history of aesthetics "should give one enormous pause" before the question "Is a true definition, or set of necessary and sufficient properties of art possible?" We should pause before history because it makes clear to us that we are today no nearer the goal of a definition of art than we were in Plato's time.[20]

After articulating the fruitless-search argument both Weitz and Kennick move on to the conclusion that "art" is not the kind of word which has essential conditions for its application. The uses of "art" are so various that no formula such as "art is significant form" can possibly encompass them, Weitz and Kennick argue. Weitz says that "aesthetic theory—all of it—is wrong in principle in thinking that a correct theory is possible because it radically misconstrues the logic of the concept of art."[21] Kennick takes the same position when, after presenting the fruitless-search argument, he writes,

> The trouble lies not in the works of art themselves, but in the concept of Art. The word 'Art,' unlike the word 'helium,' has a complicated variety of uses, what is nowadays called a complex 'logic.'[22]

27

Certainly past failure does not by itself indicate that aesthetic theory is wrong in principle. This conclusion can only be drawn upon the basis of auxiliary hypotheses the most central of which, for Weitz and Kennick, is that "art" has the logic which they ascribe to it. The claim that "art" has a complex logic cannot be a conclusion from the fruitless-search argument. It is a premiss in that argument. The fact of past failure, together with this premiss, leads to the conclusion that aesthetic theory is impossible. Since Bell need not believe either (1) that "art" has a complex logic, or (2) that if "art" has a complex logic in ordinary discourse, it should then have a complex logic in theoretical contexts, the argument which Weitz and Kennick present is irrelevant to him. It is based upon assumptions which Bell does not employ, and therefore, as an argument directed to Bell's position, begs the question.

The belief that theory in aesthetics limits "art" *a priori* begins to appear in the following passage from Kennick:

> Imagine a very large warehouse filled with all sorts of things—pictures of every description, musical scores for symphonies and dances and hymns, machines, tools, boats, houses, churches and temples, statues, vases, books of poetry and prose, furniture and clothing, newspapers, postage stamps, flowers, trees, stones, musical instruments. Now we instruct some one to enter the warehouse and bring out all the works of art it contains. He will be able to do this with *reasonable success,* despite the fact that, as even the aestheticians must admit, he possesses no satisfactory definition of Art in terms of some common denominator, because no such definition has yet been found. Now imagine the same person sent into the warehouse to bring out all the objects with Significant Form, or all the objects of Expression. He would rightly be baffled; he knows a work of art when he sees one, but he has little or no idea what to look for when he is told to bring an object that possesses Significant Form.[23]

Let us call this the "warehouse argument." At first it might appear that the thrust of this argument is to show that notions like significant form are more obscure than the good old term "art," and that, generally, theories in aesthetics have led to darkness and confusion, rather than enlightenment. For, as Kennick says, one "knows a work of art when he sees one," but one simply has no idea how to recognize something with significant

form. Actually, no one needs to suppose that the average person will be able, without training and guidance, to understand Bell's theory or to recognize something with significant form. Bell's entire theory of criticism points in this direction. The institution of art criticism itself rests upon the belief that the average person, with reasonable sensitivity, requires guidance—at least in this culture at this time—concerning art. Using Bell as a critical guide—carefully reading *Art,* and carefully studying the pictures which are said to possess significant form—one should be able to discover what to look for. We shall attempt to do just this in the next section. If all Kennick is saying is that Bell's theory is hard to understand, he may be right, but that is no argument against Bell's position.

The warehouse argument presents a different face to us when we consider the situation which might develop when, in addition to the ordinary English-speaking person, we send Bell himself into the warehouse to bring out all of the works of art therein. (Bell speaks of visual art, primarily painting, so we may ignore things such as the musical scores and books on Kennick's list.) Bell might choose many of the same things as the ordinary man, with the exception of some "representational" works like Frith's *Paddington Station,* which he would leave behind. Now, according to Kennick, the ordinary man will be able to select the works of art with "reasonable success." Yet, what right does Kennick have to make this assertion in the light of Bell's selections? How does he know that Bell has not scored with better than reasonable success, and will continue to so score? How does Kennick know that the ordinary person will be successful in the first place? Any answer to these questions makes it clear that all the way through his argument Kennick is involved in the assumption that the rules which govern the actual and commonly accepted usage of "art" also constitute, or in some way display, the correct or true criteria for identifying works of art. Certainly this is not Bell's view, for he offers a special definition of art, and shows no inclination to be interested in the correspondence between his use of the term and the common man's. In effect, the warehouse argument when directed against Bell pits one definition against another to the advantage of neither side in the disagreement. Kennick waves an alternative definition before Bell. In doing so

he again begs the question, saying nothing which might cause Bell to abandon his own definition.

Although the warehouse argument is not successful against Bell's position, it might constitute the presentation of an alternative position which has advantages over the latter. The argument suggests that the ordinary-use-of-'art' approach in aesthetics is more subtle than the theoretical approach; that the ordinary-use analysis is more responsive to the shifting, delicate overlappings and contrasts which appear between works of art. The ordinary person, not bound by a theory, will remain more open and sensitive to art as a live, developing enterprise. He who is forced into the straitjacket of a formal, fully articulated, aesthetic theory closes out future possibilities without first giving himself an opportunity to respond to them fully. This is the point of Kennick's remark that "traditional aesthetics searches for the nature of Art and Beauty and finds it by definition."[24] Weitz makes much the same point in the following way:

> What I am arguing is that the very expansive, adventurous character of art, its ever-present changes and novel creations, makes it logically impossible to ensure any set of defining properties. We can, of course, choose to close the concept. But to do this with "art" or "tragedy" or "portraiture," etc., is ludicrous since it forecloses on the very conditions of creativity in the arts.[25]

Now, if the warehouse argument suggests that theories like Bell's somehow restrict, or limit, what we can call art in a way in which ordinary language does not, this is a real challenge, for surely Bell intends his theory to apply to all cases of art—past, present, and future. If it can be shown that Bell's position is not "open" enough to account for subsequent developments, convolutions, permutations, inversions, and contrapositions in the use of significant form, then it will be unacceptable.

I believe that we have enough evidence—and there is more on the way—to allow the conclusion that Bell's theory does possess the ability to expand and extend itself. In contrast to the implication by Weitz and Kennick that the notion of significant form is a rigid, closed concept having precise conditions for its application, Bell's writing indicates that it is a flexible concept, which, in turn, transfers flexibility to the concept of art itself. The

specific content, or application, of the notion of significant form is constantly open to critical review, as we have seen. It can hardly be described as something which is static or fixed. Given Bell's comments on the nature of criticism, we can see how the presence of significant form in a painting is something which must be seen, and cannot be foreseen. Nothing in Bell's theory limits what the artist can do. To say that the artist must create paintings which possess significant form is to say nothing, for until criticism with its hopes and beliefs, with its bullying and cajoling appears upon the scene, we will not know if the latest painting is art. In a sense we will never *know* if it is art, since, on Bell's view, criticism is relativistic and uncertain.

As I have shown, the presence of significant form as a property common to all art cannot be discovered in a simple look-and-see fashion. It is not there to be discovered, as we might discover the color red in the upper corner of a painting. The significant form of all, or any, paintings which are art is so bound up with how we see and feel, with the success of critic and communication, and with the creation of a community of feeling that we cannot employ any model for our understanding of this concept which does not take these factors into account. It is much too simple to regard Bell's link between art and significant form as a definition giving necessary and sufficient conditions analogous to saying that a square is a plane figure with four equal sides and four equal angles. "Art is significant form" is no common definition.

Once we acknowledge that Bell's aesthetic theory does not possess the characteristics which Weitz and Kennick ascribe to it, we can move away from regarding it as a necessary failure which can have only curiosity value for us today. Believing that aesthetic theory is logically doomed, Weitz and Kennick suggest that we understand Bell as formulating a visual recommendation, or a platform for aesthetic reform, instead of a definition of art. From viewing theories as recommendations or platforms, it is a natural step to the belief that they are passing fancies appearing as flashes of strong prejudice colliding with a larger cultural milieu. Aesthetic theories are, on this approach, cultural and historical oddities for which we might feel some bemused sympathy, but to which we can have no "cognitive" response.[26] In the

present these theories have only the curiosity value of reforms which are now dead issues. If this understanding of aesthetic theories is applied to Bell's position, then his theory of criticism is distorted. For Bell, criticism is an ongoing activity. Paintings continue to be produced, and arguments about their quality are continually presented. Each new work—and each new understanding of old work—is a challenge to the maintenance, or the possibility, of the community which Bell desires. In the face of the new and the old, it is a living question as to whether critical effort can establish a communication which may be employed at the foundations of a community of feeling and valuation. The existence of this living question is a manifestation of the hope which is one dimension of "Art is significant form." Bell's theory survives, and continues to be of interest, not as a curio, but as a viable stance with respect to the role and aim of criticism in the graphic arts because of Bell's belief in the power of significant form, and of his hope for the development of a community of feeling and value.

Some writers have tried to place Bell within the boundaries of a different kind of community—one which is delineated by conceptual connections. For instance, J.K. Johnstone in his book on the Bloomsbury Group concludes that G.E. Moore's *Principia Ethica* was the Group's bible.[27] Johnstone develops a Bloomsbury philosophy and a Bloomsbury aesthetics using Moore's work as its foundation. Certainly *Principia Ethica,* and Moore, played their role in the life of Clive Bell and his friends Thoby Stephen, Leonard Woolf, Saxon Sydney-Turner, and Lytton Strachey. However, the danger in attempting to impress a common doctrine upon all the writers, painters, and thinkers of Bloomsbury lies in the potential for systematically distorting and ignoring their individual efforts. For example, the only link which Johnstone offers as a justification for saying that both Bell and Fry adhere to a Bloomsbury aesthetics is that the latter adopts for his own use the expression "significant form."

The kind of community which is fundamental to Bell's idea of criticism is quite different from the highly structured one which Johnstone describes. Since the connection between Bell and the community which Johnstone describes is so tenuous, we may look directly at the relationship between Bell and G.E.

Moore. Moore would not have been able to understand Bell's community operating at the level of feeling. The differences between Moore and Bell must be made clear, for they indicate how *Principia Ethica* cannot be Bell's bible, and they suggest that Bell's notion of community may reflect more accurately what Bloomsbury was.

We know already that Bell's approach to criticism is audience-oriented. The critic does not render judgments on the basis of norms and reasons, rather he turns his attention to the audience, guiding and animating it. His language is designed to bring about an experience of significant form; to bring about aesthetic experience. Paradoxically, the critic's task is to bring about the end of criticism. If his use of language is successful, then his effort becomes irrelevant.

The paradox in critical activity illuminates a parallel between Bell's position and Moore's. Using Moore's language, we can say that the assertion that a painting possesses significant form is self-evident, and that a belief in the presence of significant form in a work is a matter of intuitive knowledge. Moore characterizes those propositions of which we have intuitive knowledge as incapable of proof; that is, they are self-evident.[28] Self-evident propositions are not, and cannot be, inferred from some other propositions. No logical reasons—reasons why these propositions themselves must be true or false—can be given in support of any claims about their truth value. We can discuss, however, whether we should *hold* these propositions to be true or false. So, intuitive knowledge does not concern itself with truth or falsity *per se,* but with our tendency to hold to the truth or falsity of some proposition. The proposition asserting that a painting possesses significant form is self-evident because the critic can offer no proof. His claim is not supported by logical reasons. The critic's task is to get people to hold to the belief—actually, have the experience—that some painting possesses significant form.

We must not assume that because propositions about the presence, or absence, of significant form are self-evident that either "significant" of "significant form" designates what Moore calls a non-natural property. George Dickie seems to suggest that since Bell employs intuition, he must also employ the notion of a non-natural property.[29] Rosalind Ekman points out, correctly,

that the recognition of significant form depends upon our feeling it; then she suggests that our knowledge of significant form comes through a mental apprehension analogous to visual perception.[30] This apprehension and Moore's intuition are identical for Ekman. Yet, these two approaches run aground of Moore's statement that for proposition X to be the object of intuitive knowledge there need not be anything special about its origin, or about the manner in which we grasp it.[31] Moore says that nobody can prove that this is a typewriter before my eyes; nobody can prove that proof itself is a warrant of truth; nobody can prove that pleasure alone is good as an end.

Intuitive knowledge is not incorrigible. At one time I might be convinced that proposition X is self-evidently true. I might come to hold that it is self-evidently false, if I am presented with considerations which change my thinking on the matter. According to Moore, Henry Sidgwick's intuition affirms that only pleasure is good as an end. Moore's intuition denies this connection. Moore admits that his intuition might change—he might come to agree with Sidgwick. It is not possible to prove that either of the intuitions is true. Says Moore, "I am bound to be satisfied if I can present considerations capable of determining the intellect to reject" Sidgwick's position.[32] Although the bullying and cajoling of Bell's critic might be somewhat less subtle than Moore's idea of determining the intellect, there can be no doubt that the processes are closely parallel.

Up to this point we have spoken only of Moore's method. My contention about the fundamental difference between Bell and Moore takes on substance when we attempt to ask whether significant form is a natural or a non-natural property of paintings. When Moore speaks of aesthetic value—he uses the term "beauty"—he deals with it in two ways. In the first place, he speaks of how we know beauty. Epistemologically, beauty is a quality of objects which we cognize, and, then, to which we respond with an appropriate emotion.[33] Secondly, beauty stands in a certain logical relationship with good. Moore gives a definition of beauty in terms of good—the beautiful is that of which the admiring contemplation is good in itself.[34] Bell fails to make the distinction between epistemology and logic. As a result, for him, knowing and being merge. It becomes impossible to say that significant form is either a natural or a non-natural property.

From the side of epistemology, Bell rejects the psychology which underlies Moore's thought. Bell finds no distinction between cognition and emotion in the aesthetic situation. Although when we are intellectually examining something, we may set aside emotional reaction, Bell insists that in instances where aesthetic values are involved we do not first cognize and then respond emotionally.[35] We must begin with a kind of emotional seeing if we are to approach an art object at all. Emotional seeing breaks down the split between object and subject. It is no longer a matter of finding beauty in a painting. It is a matter of emotionally encountering a painting so that beauty—significant form—becomes present.

Bell transforms Moore's logical relation between beauty and good into pseudo-causal terms. Accepting from Moore the self-evidence of the intrinsic value of the state of mind called aesthetic contemplation, Bell argues that the importance of art is as a means to this state of mind.[36] No doubt, Bell needs some justification for art. Having separated art from life, he must devise some reason with which to explain its importance. Yet, to offer as a justification the circumstance that art literally is a means to some further end undercuts the idea that we must look at paintings as ends in themselves, if we are to see them emotionally.

Bell's claim that art is a means to intrinsically good states of mind is not causal, nor is it strictly logical. Our interaction with works of art is associated with aesthetic emotion. This fact is the causal side of the situation. The logical dimension appears when we realize that being a work of art, and being in a state of aesthetic contemplation presuppose one another. A painting is not a work of art unless it can support emotional seeing. Emotional seeing is truly present only in connection with works of art.

So, Bell refuses to distinguish between (1) logic and causality, between (2) epistemology and logic, and between (3) subject and object. Significant form causes a state of mind; but, equally, the state of mind can be said to bring about the presence of significant form. In the merger of being and knowing, significant form is brought about by a complex interaction between artist, painting, and audience/critic. Aesthetic value is not even implicit, potentially, within the painting, or within the eye of the

35

beholder. It does not come to be until it is known. Since this is Bell's position, it is impossible, and inappropriate, to say that significant form is a property of paintings at all.

The community which Bell develops is founded squarely upon emotion. For people to be joined together through art it is necessary only that they feel in a certain way. Since cognition does not precede feeling, art can be the subject of direct emotional experience. Moore's community is founded upon reason and judgment. We do not feel beauty, but determine its presence. People are joined together through agreement at the level of determinant judgment. Moore's approach cannot capture the essence of Bell's community. In so far as Bell's view of community reflects the nature of Bloomsbury, *Principia Ethica* cannot be its bible.

Significant Form

The preceding examination of criticism and community offers an avenue by which we may now directly approach the notion of significant form. At this point, it is important to concentrate upon Clive Bell's eye, allowing it to be our guide when examining the paintings which he so enjoyed. Our vision must be tempered, however, by the recognition that no literalistic approach to significant form will be successful. In an analysis of this troublesome concept, Monroe Beardsley seems to have overlooked the complex role which it plays in Bell's theory, and thus to have an understanding of it which is simplistic. Before developing a positive position, it would be profitable to expose Beardsley's errors in order to avoid them. His characterization of significant form runs as follows:

> A painting can be said to have significant form if it is an intensely qualified and highly unified design; in other words, if it has unity and some fairly vivid regional qualities. . . . I do not believe they [Bell and Fry] wanted to lay any restrictions upon the qualities they had in mind: they praised works for their grace, solidity, power, radiance, delicacy, strength, and many other qualities. They found the same solidity in Cézanne's wine bottles and card players as in his mountains; they valued the brooding uneasiness of El Greco's view of Toledo, the *joie de vivre* in every line of Matisse's bathers, the vitality of Van Gogh's trees and flowers. The essential thing is that the work have some quality that stands out, instead of being vapid, characterless, nothing at all.[37]

According to Beardsley, a regional quality is a "property or characteristic, that belongs to a complex but not any of its

37

parts."[38] These qualities are dependent upon the parts and their relations; they disappear when the parts are separated. Beardsley himself admits that it is difficult to make sense of this notion of "emergent" properties, and we should note, also, that it is difficult to know when we have hold of a part rather than a whole. So, without either accepting or rejecting Beardsley's framework, let us see where his characterization of significant form leads.

First, Beardsley's view of significant form makes the concept very broad—too broad. It would include paintings which are unified and which have character—possess vivid regional qualities—but which, following Bell, either lack completely, or exhibit only slightly, a feel for the significance of form. The work of Titian, Veronese, Correggio, and even Michelangelo would fall into this category. Bell argues that the paintings of these men are designed to please as suggestions and mementoes which stimulate the emotions of life, while ignoring the feelings associated with aesthetic contemplation. In these paintings the women have rounded thighs, and kissable lips, and the men are noble animals with heroic muscles; there is a profusion of straining limbs, and looks of love, hate, envy, fear, and horror; there are bulging eyes, and hands which reach and clasp:

> The sixteenth century produced a race of artists peculiar in their feeling for material beauty, but normal, coming as they do at the foot of the hills, in their technical proficiency and aesthetic indigence. Craft holds the candle that betrays the bareness of the cupboard. The aesthetic significance of form is feebly and impurely felt, the power of creating it is lost almost; but finer descriptions have rarely been painted.[39]

Sixteenth-century paintings are not characterless. Obviously, however, Bell does not find their outstanding qualities of aesthetic interest. Nor can we say that they necessarily lack unity—the kind of unity which would characterize a fine description. Paintings can be unified at the level of craft by a repetition of motif, for example. Yet, these paintings lack a feeling for the significance of form.

Along with the artists of the sixteenth century, Bell classifies the Pre-Raphaelites as having missed the significance of form. This group rejected the High Renaissance in favor of

38

"primitive art," taking Giotto as their model. The result of their efforts is not description without artistry, but bad pictures and thin sentiment:

> They discovered in the primitives scrupulous fidelity to nature, superior piety, chaste lives. How far they were from guessing the secret of primitive art appeared when they began to paint pictures themselves. The secret of primitive art is the secret of all art, at all times, in all places—sensibility to the profound significance of form and the power of creation. The band of happy brothers lacked both; so perhaps it is not surprising that they should have found in acts of piety, in legends and symbols, the material, and in sound churchmanship the very essence, of mediaeval art.[40]

The paintings of John E. Millais, one of the founders of the Pre-Raphaelite Brotherhood, illustrate Bell's comments perfectly. Millais's painting *The Blind Girl*—a Pre-Raphaelite classic—is not characterless or vapid. It is heavy with sentiment. Nor does this work lack unity—the kind of unity which would characterize a child's morality tale. Bell's observation seems quite correct with respect to the work of the Pre-Raphaelites.[41]

Let us return to Beardsley's comment about the solidity of Cézanne's wine bottles, card players, and mountains. The solidity of these objects, and the character of the space in Cézanne's work, is dependent upon what could be called Cézanne's architectonic handling of slabs of color, as opposed to a linear perspective, for example. Yet, Bell insists that the mosaics at Ravenna also capture significant form to as great a degree as does Cézanne while lacking both the solidity and the architectonic space of the Cézanne paintings. The figures in the mosaics, being less solid, exist in a space which appears to be more tenuous and ambiguous than the space established in Cézanne's work.

Looking at the Ravenna mosaics, one is reminded of Bell's comments on Poussin, quoted earlier. Bell praises Poussin for treating the human figure as a shape cut out of colored paper to be placed as the composition directs. The figures at Ravenna could be seen, too, as cutouts placed to aid the composition. This approach seems fruitful—at least we have been able to link Poussin and Ravenna—but if we follow it, then the solidity which

Beardsley mentions in connection with Cézanne cannot be regarded as an essential or determining factor for the presence of significant form. So, setting aside solidity, could a link be established between the Ravenna mosaics, Cézanne, and Poussin on the basis of spatial or architectonic form? Such an approach seems to have promise in the case of Ravenna and Cézanne. However, this tack is less helpful when we come to look at Poussin's paintings, for this work exhibits a linear perspective which seems to challenge the force of his colored paper shapes. Of course, Bell states that Poussin is not as great as Cézanne or the creator of the mosaics. His failing might just be that touch of linear perspective.

Even if one can refine an approach to Cézanne, Poussin, and Ravenna which focuses upon a non-linear, architectonic space as the key to significant form, trouble enters as soon as we take into account Bell's comments in his review of the Matisse drawings. Matisse's plasticity is expressive and significant, and Bell is impressed with the volume which he achieves. Volume, Bell tells us, will always delight those who feel the significance of form.[42] Matisse's work is not architectonic, but perhaps we could see the solidity and architectonic space of Cézanne as establishing a kind of volume linking his work with that of Matisse. However, if we move in this direction, Bell's comments on Poussin and Ravenna come back to haunt us. Volume does not seem to be the characteristic which makes these latter works valuable. Moreover, volume *per se* is surely a quality of the works of the Pre-Raphaelites, and of the sixteenth-century artists. Hence Bell's notion of volume would have to be more fully characterized before it could be used as a key to the presence of significant form. Volume could be specified by its manner of production—Cézanne's way, or Matisse's way, but not Correggio's way—or by its effect in producing a work of a different kind, or character, from the Pre-Raphaelites and the sixteenth century, for example. The latter approach, of course, moves away from volume itself to "different character" as the key to significant form.

Many complications confront the effort to understand the significant form of a painting in terms of the possession of "some quality that stands out," or in terms of some kind of solidi-

ty, volume, or non-perspectival space. To try to list the modes of production—of volume, of space, or whatever—which would yield a work of significant form seems pointless, if not impossible. This conclusion, of course, confirms my earlier statements that significant form is a quality of paintings which cannot be foreseen, and that Bell's views in aesthetics in no manner foreclose upon creativity in the arts. Instead of searching for specific modes of production, we should turn our attention to that "different character" of works with significant form. This character may well be one no idea of which is transmitted to us by the critic's language, but which the critic leads us to see in the work *via* references to figures as cut-out shapes, and to certain uses of solidity and volume. If a search for that "different character" is to begin at all, we must move away from general considerations to an examination of specific paintings.

In the early 1940s Bell praised the work of the English artist Ivon Hitchens.[43] By looking at the Hitchens painting *Coronation* (plate 1) done in 1937, we may be able to gain some insight into Bell's vision. This work is totally abstract—no objects of any kind are discernible in it. The interpenetration of the planes and spaces established in the painting is immediately striking. In each instance where one section of the work seems to recede from, or advance toward, the spectator there is another section of the painting which acts as a counterforce to this movement. This condition tends to flatten the planes, and space, of the work in such a way as to establish a dynamic tension within the painting. For example, four panels of color occupy most of the surface area of the canvas. The narrowest of these panels, at the far left edge of the painting, appears to angle away from the other three (which seem to be on one plane) and slightly toward the observer. The outward movement is heightened by the dark color of this panel in contrast to the one on the right, and by the dark band which runs under both the lighter and darker panels. As the band leaves the lighter panel for the darker one, it bends outward toward the observer. However, this outward thrust of the darker panel is denied by the characteristics of the lower left corner of the work—that portion located directly below the two panels in question. This area of the work is fairly stable, remaining, as it were, on the canvas, and denying the advance of the

41

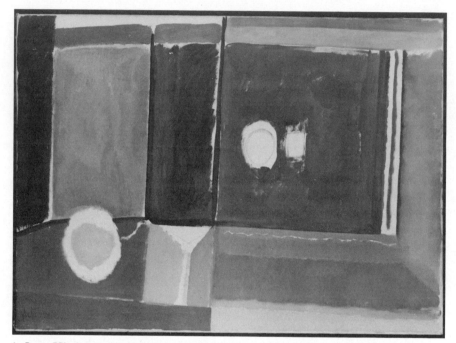

1. Ivon Hitchens, *Coronation.* BY PERMISSION OF THE TATE GALLERY AND
MR. IVON HITCHENS.

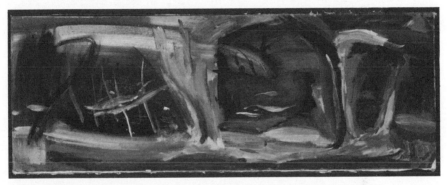

2. Ivon Hitchens, *Forest Edge No. 2.* BY PERMISSION OF THE TATE GALLERY
AND MR. IVON HITCHENS.

darker panel. The flatness of this area is accentuated by a bright spot which overlaps it and the second (lighter) panel. The bright spot advances, pulling with it the lighter panel, which was previously seen to recede *vis à vis* the darker panel. The total effect of these conditions denies the forward movement of the far, dark panel, and establishes a tension between it, and the lighter one.

Another clear example of this type of dynamism is to be found in the lower right area of *Coronation*. The relatively dark band which moves from the center of the painting almost to the right edge stands in a tension with the lighter area around it. This tension is increased all the more by the presence of the large, dark panel above this area. Omitting notice of the large, dark panel yields the impression that the band is advancing toward the spectator, while the lighter area around it recedes. Yet, when the large panel—which is even darker than the band—is brought into focus it overcomes the forward thrust of the band with a greater power of its own. The band is thus thrown back into the area of lighter color from which it was previously seen to advance. Dynamic tensions such as these are repeated throughout the work in such a way as to cause the entire picture to vibrate.

A Hitchens painting of 1944—*Forest Edge No. 2* (plate 2)—stands in striking contrast to the dynamism of *Coronation*. This work presents us with a stable depth. Across the painting are arrayed four areas of paint which stand in the foreground with defiant solidity. The areas between these shapes recede into the space of the painting without recall. The picture just sits there, so to speak. The dynamism apparent in *Coronation* is totally lacking. For example, there is a light vertical band just slightly to the left of the center of *Forest Edge No. 2*. To the left of this band is a dark area over which some lighter vertical and horizontal lines have been imposed. One cannot escape the impression that the artist placed these light lines—as well as the darker diagonal one which cuts across the upper left corner of the dark area—on the painting in a valiant effort to establish some kind of dynamic interplay between the vertical band and the darker area. The effort fails. The light lines tend to remain upon the same plane as the vertical band, while the dark area behind refuses to budge. A similar gap between foreground and background exists to the

right of the vertical band, and generally throughout the painting as a whole. This gap costs the work its dynamism, its potential for any vibrant tension.

In our further examination of particular paintings and mosaics we will use these two Hitchens works as paradigms of a sort. The hypothesis which I want to present is that Bell would regard *Coronation* as superior to *Forest Edge No. 2* because of the former's dynamism—its lack of a gap between foreground and background. I believe that the key to the presence of significant form may lie in the kind of ambiguous, vibrant space which we have discovered in *Coronation*. Our effort throughout the rest of this section will be to apply to other works which Bell praises the kind of analysis which was employed when examining Hitchen's paintings.

Let us begin, then, by applying our Hitchens method to the mosaics at Ravenna. It is Bell's opinion that the sixth-century work in the apse of S. Vitale, in the lowest zone of the walls of the central nave of S. Apollinare Nuovo, and in the dome of the apse of S. Apollinare in Classe is some of the greatest art ever produced, that perhaps only Cézanne has created forms of greater significance. Beginning with the dome of S. Apollinare in Classe (plate 3), one of the most striking characteristics of this mosaic is that it denies the shape of the dome upon which it is placed.

The large cross in the upper center, flanked by the figures of Moses and Elijah, moves forward in such a way as to exist virtually upon the same plane as the figure of Saint Apollinaris below it. The cross, within a circle of blue, is located on a golden background which forms a band across the upper part of the dome. The lower part of the dome contains a band of green. The lower part of the cross's circle just extends into this green band, tying the two together. In addition, there are eight trees (four on each side of the cross) extending from the green band onto the gold one. The cross's circle and the trees create nine links between green and gold. These links help to establish a tight dynamism between the two bands. If it were not for their presence the upper, golden band would advance toward the observer leaving the lower, green band permanently behind. The green band itself is not evenly colored. It becomes lighter, and

45

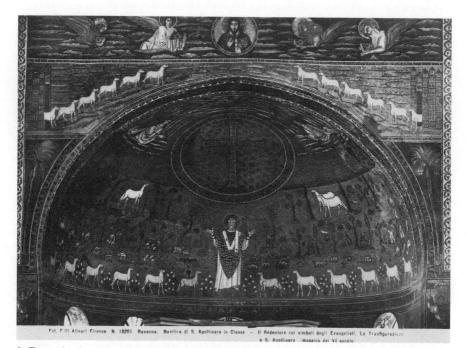

Fot. F.lli Alinari Firenze N. 18201 Ravenna, Basilica di S. Apollinare in Classe — Il Redentore coi simboli degli Evangelisti. La Trasfigurazione e S. Apollinare (mosaico del VI secolo)

3. Dome in the Apse, S. Apollinare in Classe. BY PERMISSION OF FRATELLI ALINARI.

46

tends to recede as it approaches the gold. Yet its attachment to the gold band throws the area in which they meet forward again. Focusing upon the cross allows the entire composition to advance, denying the physical shape of the dome; focusing lower upon the green band allows the composition to move back into space, retaining some of the physical shape of the dome.

The plane of the mosaic is flattened along the horizontal axis as well as the vertical. Beginning at the far sides of the dome, the mosaic gives the definite impression of the curved shape. This impression is lost, however, if one focuses upon the figure of Apollinaris; then only the very edges of the work appear to curve. The figure of Apollinaris, as well as the cross, advances in such a way as to bring the center of the composition almost to the forward edge of the dome. This is particularly true of the top of the cross where the golden band flattens the depth of the dome so that at its height the dome almost disappears. The fact that the cross and the figure of Apollinaris can be seen as on the same plane also brings the green band forward. This forward thrust is reinforced by other factors as well; for example, by the fact that the sheep lined around the lower edge of the green are all the same size.

A parallel between Hitchens's *Coronation* and the mosaics of S. Apollinare in Classe is apparent on at least two levels. First, the Hitchens work can be seen as similar to the dome along the horizontal axis. Selection of the proper focal points curves the space of the painting so that the two edges advance toward, and the center recedes from, the viewer. Just as in the dome, this situation is not permanent, for a shift in focus changes the spatial relationships, and the curvature is lost. This is the second parallel—more general and more important. In both works spatial values are ambiguous, so that the location of one area, line, plane of color, etc., *vis à vis* another is determined, in part, by the focal point of the viewer—by what area of the painting has captured the viewer's direct attention. Spatial ambiguity, with its attendant dynamic space, is achieved by virtue of the fact that no area in these works captures and holds the spectator's vision totally. No matter where one looks in the work, there is to the right or left, above or below, a vibration, a variance, a spot of excitement which calls him away from one focus to another. Each new focus

47

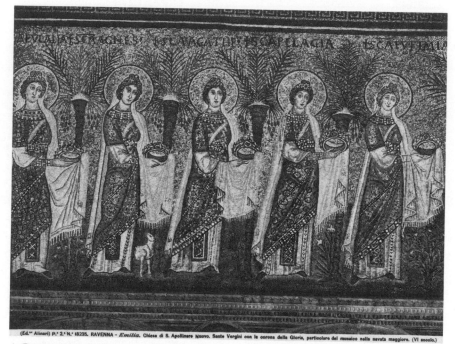

4. Procession of Virgins, S. Apollinare Nuovo. BY PERMISSION OF FRATEL-
LI ALINARI.

reveals new vibrations allowing for other spatial configurations in a seemingly endless array. Since there is no focus which presides by forcing itself upon us, ambiguity results.

The nave of S. Apollinare Nuovo also contains mosaics of the sixth century: the procession of Holy Virgins on the north wall, moving from the city of Ravenna toward the Virgin (plate 4) and the procession of Holy Martyrs on the south wall, moving from the palace of Thedoric toward Christ. Looking at these processions, one is reminded of Bell's remark about Poussin's figures appearing as cut-out, colored paper shapes. The Virgins and Martyrs are treated in this fashion.

Appearing on a background of green (lower) and golden (upper) bands, the figures seem pasted onto the green band—their feet do not even touch the "ground"—while cut out of the golden band as it advances toward the spectator from around them. In these processions the figures link gold with green in much the same way as do the cross and trees in S. Apollinare in Classe. As a result the dynamic of the figures varies with changes in focus. When one attends to the feet on the green band the figure advances, if attention shifts to the head against the gold the figure recedes. As shapes the figures aid the unity of the composition by establishing a vibrant relationship between gold and green in which neither band is permanently separated from the other. Yet, the figures are not constructed in such a way as to lock attention on themselves. It is not possible for them to preside by forcing themselves upon us because where, what, and how they present themselves depends upon whether the spectator focuses upon figure-over-green, or figure-in-gold. Whichever focus is selected, there is a spot of excitement either above, or below, which draws the focus away. Ambiguity is introduced, and the figure *per se* exists nowhere in the space of the mosaic. The ambiguity of the figures is enhanced by the stylized palm trees which separate them. The palms link gold with green in the same way as do the figures. Similarity of linkage gives the impression that the palms and figures exist on the same plane, establishing a further tension by virtue of the ambiguity of the figures *vis à vis* the gold and green bands. However, this planar similarity is denied when at certain points the palms disappear behind the figures.

The phenomenon of multiple ambiguity illustrated above in the two processions applies equally well to the depictions of the city of Ravenna, the palace of Thedoric, and the throned figures of the Virgin and Christ. In each case the flatness of figure (whether human or otherwise) together with the use of gold—or, better, partly established by the use of gold—leads to an indeterminacy of spatial quality. There is established an interlocking of vibrating planes which jump forward or back depending, to a great extent, upon the focus of the viewer.

These mosaics in S. Apollinare Nuovo illustrate, too, the presence of what I have come to call spatial ambiguity. This same ambiguity is present in Hitchens's *Coronation* and the work in S. Apollinare in Classe. We can now begin to see the intent of Bell's comments about Poussin's figures, and to relate these comments to other work which Bell praises. It would be premature, and unfair, to say he requires that figures must always be used as they were at Ravenna, for their placement in the mosaics might be only one of many possible roads to unity. Yet, we may be able to understand the "Poussin phenomenon" if we remember that when figures are used they should contribute to the total painting by interacting dynamically with their surroundings so as to send the eye away from themselves with as much force as they use to arrest it. They should not draw our vision inescapably to themselves.

Not all the mosaics in S. Apollinare Nuovo possess the qualities of the processions which I have discussed. There is a series of mosaics between the windows on each side of the church showing male figures in a frontal position, each holding a scroll or book. These figures have a greater modelling which gives them a volume not seen in the figures of the processions, and which gives one some feel for the body, and placement of the limbs, beneath their white robes. These figures stand out from their golden background; their feet are planted firmly on a patch of green; their location in space is clear, a shift in spectator focus does not alter it. Bell would be less happy with this part of the mosaic. The figures between the windows may also be from the sixth century. More important than the exact date of the window figures, or of the two processions, is the fact that the window figures fall into what is now described as the Hellenistico-Roman

artistic tradition, while the processions are of Byzantine composition.

Perhaps a clearer example of what Bell regards as the loss of an understanding of the significance of form is available to us when we examine Madonnas by Giotto (plate 5) and Cimabue (plate 6). In Bell's opinion, Giotto heads a movement toward "scientific picture making." Giotto tends toward a coarse heaviness of forms in his *Madonna di Ognissanti.* Cimabue, on the other hand, retains significant form in his work, eschewing the scientific. The differences between the Giotto and the Cimabue work are clear. Notice the flatness of the Cimabue. This flatness both allows for, and is created by, just the kind of changing spatial relationships which were so apparent in the mosaics, and in *Coronation.* Although the Madonna dominates the composition in the Cimabue work, her location in relation to the other figures, and to her throne, is ambiguous. She is a cut-out, a figure placed onto, and into, the composition. As dominating as she may be, the spectator's focus is pulled away from her by other vibrations in the composition. A shift in focus from her to the figures below the throne alters her position with respect to the other objects in the work. By contrast, the Giotto Madonna is more fixed in the space of the work. The figure of the Virgin is highly modelled, giving it a substance and stability. Here we have a definite awareness of the woman's body beneath the robes. The impression created is of a body in space standing out from its surroundings in the work. It dominates the composition, and is constructed so that once the spectator focuses upon it his vision is caught. No other surrounding vibrations exist upon the same plane as the Virgin, so the focus remains on her. Even if one forces a shift in focus, the spatial location of the Virgin does not alter *vis à vis* the other areas of the painting. As in *Forest Edge No. 2,* there is a fixed relationship between what stands out and what recedes. I believe that this fixed relationship is what Bell has in mind when he speaks of scientific picture-making. Scientific pictures, containing elements which grasp and hold the focus of vision, can more easily tell stories, or present the sentimental and allegorical. Works which present an ambiguous space do not allow for the clarity of spatial relationships necessary for story-telling; in works where space is fixed, relationships between char-

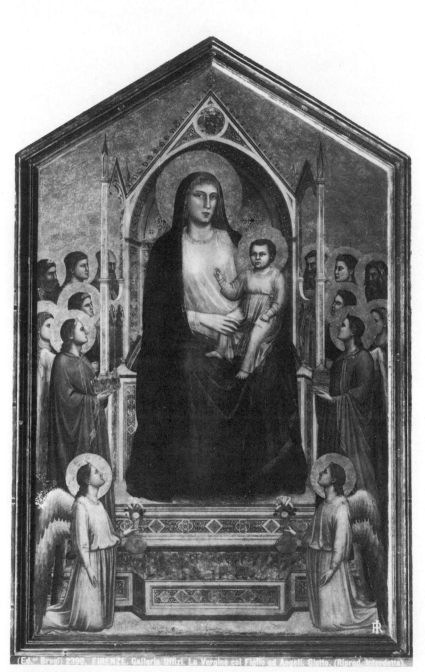

(Ed.° Brogi) 2390. FIRENZE. Galleria Uffizi. La Vergine col Figlio ed Angeli. Giotto. (Riprod. Interdetta).

5. Giotto, *Madonna di Ognissanti.* BY PERMISSION OF FRATELLI ALINARI.

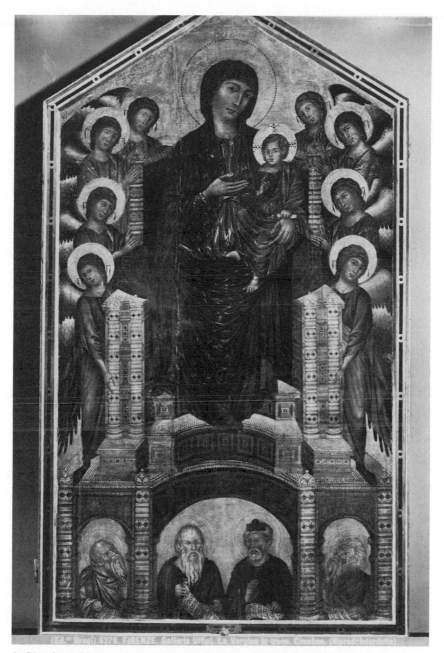

6. Cimabue, *Madonna in trono.* BY PERMISSION OF FRATELLI ALINARI.

53

acters and events can become clear. Bell's objection to paintings which bring into play the emotions of life might rest, then, more upon the circumstance that such paintings require a non-aesthetic space, than upon some objection to the emotions of life alone. The kind of space which Bell values is characterized by ambiguity, not by clarity.

The development of scientific picture-making can be traced, along one of its dimensions at least, by following the development of perspective through medieval times. Miriam Bunim argues that by the end of the fourteenth century the space employed in paintings had been transformed from a series of planes running parallel to the picture plane to a single space which found its final realization in the mathematical perspective of the Renaissance.[44] By the fourteenth century a focused system of perspective is apparent in the work of such men as Piero della Francesca and Paolo Uccello. This focused system allowed for a clear presentation of the mathematical relationship between distance and size. It is established by such devices as foreshortened squares in ceilings or pavements. Such a system, as it was developed in the Renaissance, creates a space which is, theoretically, measurable in relation to the location of a spectator, Bunim points out. The effect of this mathematical perspective focused upon one point is to fix the spectator upon that point, and to fix the elements of the picture around that point in a stable relationship. This type of relationship requires a space whose skeleton is a series of invisible paths which the lines of the paving and roofs, etc., will follow to the vanishing point. The space of the painting is not established, in any fundamental way, by interaction between the planes, elements, or areas within it. It has an existence apart from the figures and objects which it contains. This is why, and how, figures, objects, and spectator become fixed.

In the works which Bell admires for their grasp of significant form, the space and the figures cannot be separated. Even the vanishing-axis technique, which tends to establish a skeletal space, does not have the same effect as focused perspective. When the invisible paths travel only to an imaginary vertical axis, and are distributed along it more or less uniformly, instead of to a point, then the space of the picture still tends to flatten out so that the spectator is not locked into a fixed perspec-

tive. He may roam about the painting more freely, and will find there visual interactions not available when focused perspective is employed.

This argument with respect to focused, mathematical perspective might appear as coherent and convincing. Yet, with respect to scientific picture-making it can be regarded as only a half-truth, for Bell writes:

> [T]he movement that produced Masaccio, Masolino, Castagno, Donatello, Piero della Francesca, and Fra Angelico is a reaction from the Giottesque tradition of the fourteenth century, and an extremely vital movement. Often, it seems, the stir and excitement provoked by the ultimately disastrous scientific discoveries were a cause of good art. It was the disinterested adoration of perspective, I believe, that enabled Uccello and the Paduan Mantegna to apprehend form passionately.[45]

Mathematical perspective alone is not necessarily disastrous. Still, its potential as a method for producing art is limited, while the road it establishes toward scientific picture-making is easy and broad. True scientific picture-making employs not only mathematical perspective, but also those characteristics of sixteenth-century art which Bell despises: rounded thighs, kissable lips, heroic muscles, and so on. Poussin, too, is a scientific picture-maker insofar as he employs the gestures of classical rhetoric. We must conclude, I think, that Bell objects to scientific picture-making on two grounds: it refers to the emotions and gestures of life, and it presents a space which encourages the viewer to focus upon these aspects of the work.

Of all the English painters who were his contemporaries Bell thought Duncan Grant to be the best. In 1920 Bell believed that there was yet to be an English painter who possessed the sensibility and intelligence necessary for the creation of paintings with significant form. He saw Grant as an artist of great talent and potential who is in the tradition of Picasso and Piero della Francesca.[46] We can see how Grant's early work falls within the tradition which includes the sixth-century mosaicists at Ravenna, Cimabue, and Giotto's work in the Scrovegni Chapel in Padua. His *Queen of Sheba* (plate 7), for example, is painted in a fashion which resembles a mosaic. More importantly, it pos-

7. Duncan Grant, *The Queen of Sheba*. BY PERMISSION OF THE TATE GAL-
LERY.

8. Duncan Grant, *Bathers*. BY PERMISSION OF THE TATE GALLERY.

9. Duncan Grant, *Lemon Gatherers*. BY PERMISSION OF THE TATE GALLERY.

sesses the same kind of spatial qualities exhibited by the Byzantine work at Ravenna. Grant's *Bathers* (plate 8) employs a stripe motif instead of the dot effect appropriate to mosaic work, but it still achieves the type of spatial vibrations and tensions found in the work of Ciambue, Hitchens, and at Ravenna.

Grant's *Lemon Gatherers* (plate 9), perhaps one of his best known works, exhibits in interesting and subtle ways the kind of spatial ambiguity which may be the key to the presence of significant form. Although parts of the background—particularly the deep area on the right—may not be successfully tied in with the rest of the composition in terms of securing an ambiguous space, the placement of the female figures of the lemon gatherers themselves exhibits strong similarities to other work which Bell prizes. Consider the group of two, or possibly three, figures at the far left of the canvas. If the viewer's attention is focused upon the midsection of this area, just below the folded arms, the woman on the left appears to advance in the space of the painting while the one on the right recedes. However, if focus is shifted to the area of the heads of the women, the figure on the left recedes while the one on the right advances, owing to the lighter, fuller face on the figure at the right, and the darker side view of the head at the left. At this point, too, we see what might be part of the head and basket of a third figure pushing its way into view between the other two. This third head, moving forward, accentuates the reverse motion of the head at the left, and, yet, tends to stabilize it at the same time. Against the generally lighter ground the darker head recedes, tending to become a hole in the canvas. This power of dark over light is counterbalanced by the fact that the light area in this case is a head thrusting forward. So, the tendency of the dark area to appear as a hole is thwarted, establishing a tension. One other area of tension in this group of figures should be noticed. It exists in the lower area, around the knees. At this point both the folds of the women's garments and their tonal values combine to present the impression that the knee of the figure on the right extends further forward than the knee of the figure on the left—the figure on the right seems to be beginning to enfold, to move in front of, the figure on the left. The effect of the interactions between this group of figures is to dislocate them in the space of the painting. Focusing upon any

59

one of the three areas we have mentioned gives a spatial location to the figures which is denied when the locus of attention is shifted. No one area captures and holds attention permanently, so a high degree of ambiguity is introduced into the group.

The single figure located approximately in the center of the painting accentuates the spatial indeterminacy of the entire work. The foot on the left side of the central figure appears as closest to us, and upon the same plane as the foot of the left-most figure in the group discussed above. The knee to which the latter foot is attached is essential to the dynamic tension in the group on the left. The foot takes part in this tension because it is physically impossible for the knee and the foot to be part of the same leg. What happens is that the knee becomes dislocated from the foot. The location of the foot is indeterminate. This indeterminacy causes the location of the middle figure's foot to be indeterminate also. In addition, when one focuses upon the middle figure, it appears to move in space in a fashion opposite to that of the group on the left. Focusing upon the middle figure brings to the fore tensions in the group on the left which are not so apparent when that group is taken as the focal point. Thus, the waist of the middle figure recedes while the mid area of the group on the left advances as a whole—even though within that mid area there are other tensions which we discussed above. The shoulders of the middle figure advance toward the spectator, bringing the right shoulder of this figure onto the same plane with the upper section of the group on the left. However, the fact that the tree growing from the bank in the upper middle of the painting touches on the middle figure's basket, so as to be on the same plane with it, makes it impossible for the shoulder of the middle figure to exist on the same plane with the upper section of the group on the left. These relationships can be made to work only if we disassociate the middle figure's head from her shoulders. Again, as with the feet, we have a complex spatial ambiguity created.

A line is established from the outthrust hip of the middle figure to the bent back of one of the two figures grouped at the right of the painting. This line tends to place the figure on the right on the same plane with the middle figure. Yet, other cues—the placement of feet, the dark area of skirt, the kneeling figure to her right—indicate that the bent woman is further back

in space than the middle figure. Further tension is introduced internally into the group at the right by the fact that the kneeling figure appears to be leaning back toward us—her shoulders are closer to us than are her hips. Yet, when the kneeling figure is considered in conjunction with the bending figure, the latter's spatial location is rendered ambiguous. The bending figure cannot both be on the same plane as the middle figure, and also maintain her position behind the kneeling figure, for the kneeling figure is on a plane which is further into the picture than the plane of the middle figure.

Again and again we have seen how it is impossible to give a precise location for any of the figures in *Lemon Gatherers*. Spatial vibrations within groups, and between groups, of figures makes this impossible. These same vibrations make it impossible for the spectator's eye to settle upon one focal point within the painting. One's eye is continually presented with new vibrations which either come forward to lead it into the work, or which move back into the work to draw the eye toward the surface, as it were. No plane or area is stable enough to capture and hold attention; we are invited and repelled by each. Other objects also contribute to the dynamism of the composition. The light bank of rock or earth, mentioned earlier, ties together the three groups of figures, and is itself tied into them by the tree which extends from it to the middle figure. On the right there is a vista of some depth whose interaction with the rest of the composition is achieved by various devices, for example, the buildings which are visible between the two figures on the right. All of these elements, and more, combine in this painting to produce an effect similar to that in Hitchens' *Coronation,* the work at Ravenna, and the Cimabue *Madonna in trono.* Yet, what we have come to call the Poussin phenomenon is not present in *Lemon Gatherers*. The figures are not cut-outs; they are not pasted onto the composition; they do not tie the composition together in the manner of the figures at Ravenna. At first glance we seem to be able to say many things about these figures which we could also say of the figures in an example of scientific picture-making. Just as in the Giotto *Madonna di Ognissanti* and in the sixteenth century work of Titian, Veronese, and the others, we have a sense of the physical bodies of the women in Grant's painting. The modelling of the

faces and feet together with the lines of the garments, which mirror the anatomy beneath, give the figures substance. Yet, this work is not another example of scientific picture-making because Grant uses the substance of the figures to create his vibrating, ambiguous space. We have seen that throughout the work there are many instances of distortion among the figures. Some of them are posed in positions which would be difficult, if not impossible, for normal humans. Others are warped or twisted by their surroundings within the space of the picture. These figures look as if they should be human figures in human poses, but they are not. Any impression we might have of bodies under garments is canceled by the space which is encountered as one moves through the picture. The figures do not at first appear as cut-outs, but just as the cut-outs at Ravenna are absorbed into a dynamic composition, these figures are absorbed into the dynamic space of Grant's painting. The methods of Grant and the mosaicists are different, but the end results are similar. The figures interact with their surroundings so as to send the eye away from themselves with as much force as they use to arrest it.

From Bell's point of view Cézanne is one of the greatest artists the world has known—"since the Byzantine primitives set their mosaics at Ravenna no artist in Europe has created forms of greater significance unless it be Cézanne."[47] Cézanne's work does exhibit in the most masterful way the dynamic space which can be brought about by creating tension between planes or areas in a painting. Bell is able to say that the work of Cézanne, and the others, possesses significant form because the space in these works is organized in such a way as to achieve a sense of depth in a work while still maintaining a dynamic relationship between foreground and background planes, which flattens the entire work. Cézanne and the other artists whom Bell most admires avoid mechanical perspective and any other devices which stabilize the space in a painting, thereby rendering their work unfit for reproducing nature. Paradoxically, one wants to describe this work as being flat, and as possessing considerable depth. This is not to say, however, that the presence of significant form depends upon the existence of a deep space within the work together with a successful solution to the problem of how to connect depth to surface. This falsifies the situation by

separating the two areas in the first place. Hitchens's *Forest Edge No. 2* contains these two planes which are never successfully united. Using Bell's criterion of success, if they were successfully united they would disappear. It is not a matter of uniting two distinct planes, rather it is a matter of creating a work each segment of which stands in a dynamic relationship with all the other segments. In such a work there are no holes, or dead spots, and no area is definitely "background."

Erle Loran's extensive analysis of Cézanne's paintings documents Cézanne's ability to deal with a dynamic space.[48] Almost every work of Cézanne's maturity offers examples of a space which becomes dynamic as a result of shifting spectator focus. The famous *Mont Sainte Victoire, Seen from Bibemus Quarry* (plate 10) exhibits the effects of a dynamic space. In this work the interplay of green and white shapes is essential to its dynamism. The green trees knit the painting together from front to back, while the white rock, beginning in the rear with the mountain itself, operates in the opposite direction. The green trees predominate in the foreground and are linked to the trees atop the quarry cliff—standing in the midground—by overlapping (along the right side of the painting, for example), and by pointing (at the left side we see a small tree, then move to a larger one growing from it, then move from that single tree to the group of trees on top of the cliff). The group of trees on the left links directly to the mountain. On the right the connection is less direct, running down the outline of the mountain to a clump of trees on the cliff, which in turn attach themselves to the tree on the extreme right, the trunk of which leads back to the foreground. The white rock ties the painting together through the center. The white of the mountain is linked to the cliff *via* the smaller white rocks located along its edge. The downward thrust of the mountain is dissipated across the cliff by these smaller rocks and, through them, to the trees below, which reach up to meet it. The result of the connections is a tight composition in which apparent relations of foreground and background are rendered ambiguous, unstable. We can see illustrated over and over again in Cézanne's work this kind of dynamic space which is also a characteristic of Hitchens, Grant, and the mosaics at Ravenna.

In the course of his analysis of Cézanne's work Loran

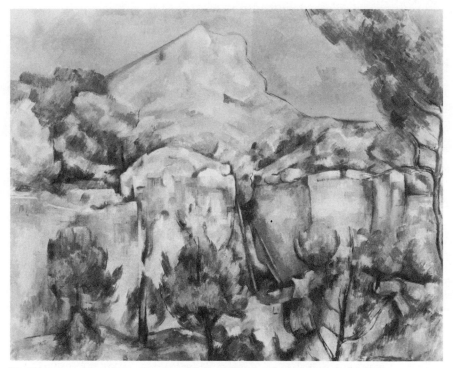

10. Cézanne. *Mont Sainte Victoire, Seen from Bibemus Quarry.* The Cone Collection. BY PERMISSION OF THE BALTIMORE MUSEUM OF ART.

makes three observations which bear upon our understanding of significant form. The first of these is that in many of Cézanne's paintings there is at least one axis around which the composition is structured. The presence of an axis allows a circular path, or line, of sight from foreground to background, and return, to revolve about it. By Loran's analysis, this circular motion is an essential factor in the unification of Cézanne's work. What Loran has to say about these lines and their effect may well be true. (It is noteworthy that he finds certain disturbing elements in *Mont Sainte Victoire*, as a result of the circular-path analysis[49] which do not appear as weaknesses when one employs the type of analysis presented here.) However, these comments could not apply to all of those works which Bell would regard as possessing significant form—perhaps to *Lemon Gatherers,* but not to *Coronation* or the work at Ravenna.

Loran's second observation concerns Cézanne's respect for the two-dimensional picture plane. Cézanne's contribution to modern art is the production of a space which has depth—potentially unlimited—but which retains a feeling for the fundamental two-dimensionality of the surface of the painting:

> Cézanne did achieve some kind of solidity and three-dimensionality. Often, however, three-dimensionality is regarded as a self-contained, sculptural problem, without consideration for the complicated necessity of relating it to the two-dimensional picture plane. Complete control of pictorial space, as Cézanne achieved it in his greatest work, involves, first, the creation of space illusions through the overlapping of planes. By varying the distance (the space interval) between these planes, rhythmic tensions are developed. *But all these forces are bound within the picture frame, and they find ultimate balance or equilibrium in relation to the picture plane.*[50]

The respect for the picture plane, which produces flat paintings with depth, and deep paintings which are flat, is a characteristic of the work which Bell admires. It applies equally to the Post-Impressionists, to the mosaics at Ravenna, and to Cimabue. Although not always achieved in Cézanne's way, it remains a common characteristic among works which possess significant form, I believe. It is noteworthy, too, that Loran sees Cézanne's use of space as a modern rebirth of what he calls the classical ideal of pictorial space in which three-dimensionality is

65

conceived in relation to the two-dimensionality of the picture plane. Loran finds that the space in the works of Giotto and of the early Christian and Byzantine artists is strikingly similar to Cézanne's. It is Loran's opinion that all great art avoids the tunnels and dead ends in space which are the result of blind acceptance of scientific perspective. Cézanne revolutionized painting by turning attention toward structure, and away from the inartistic illustration and imitation which the development of perspective had fostered.[51]

I must conclude that Bell would agree with Loran's judgment: Cézanne represents a rebirth in the production of art. Cézanne has recovered what is great in Giotto's work at Padua. Bell makes a point of the fact that the forms which artists use are infinite. There is continual change in the appearance of art, and in the ways in which the artist is true to the two-dimensionality of the picture plane. Although the essential quality—significance—is constant, in the choice of forms there is perpetual change, he believes.[52] The common characteristic is not something in the work, but the way in which the work is constructed.

One point of disagreement between Bell and Loran is with respect to some of the sixteenth-century painters whom, we have seen, Bell condemns. Loran makes the following comments in connection with an article by Thomas Hart Benton:

> There are some excellent diagrams of El Greco and Rubens. But the keynote of Mr. Benton's approach to painting is found in his statement that, 'in three-dimensional painting, sculpture offers the technical precedent.' He gives no hint of understanding the nature of the picture plane, the architectural absolute so faithfully and masterfully preserved by all the old masters he analyzes. Furthermore, Benton never meets the problem of controlling movement, of organizing three-dimensional space illusions so that they achieve balance in relation to the two-dimensional picture plane. Indeed, these essays by Mr. Benton are a revealing explanation of the disturbing effects to be observed in his own paintings, and in those of certain other famous American painters, too. It is true that Rubens, El Greco, Tintoretto, indulged in violence, bombast, and muscular heroics, as many of their latter-day American admirers have done; but in contrast to the work of these same Americans, the deep-space-volume compositions of the earlier masters are balanced. Generally speaking, their paintings 'hold to the wall.'[53]

It is difficult to take seriously Bell's sweeping condemnation of the work of the sixteenth century. Early in *Art* we learn that the representative element in a painting is, at best, neutral *vis à vis* aesthetic value. So, rejecting muscular heroics *per se* does not seem necessary. Then, we learn later that working familiar objects into the design of a painting may have a positive value: it aids the spectator's efforts when attempting to grasp the form of the work. We learn, too, that as long as the muscular heroics are "fused" with the design, a successful painting might result.[54] Bell recognizes that he has exceeded theoretical bounds in his rejection of the sixteenth-century work. His admission of excesses can be found in the preface to the new edition of *Art*:

> Anyone who reads this book will see that, being angry, I speak absurdly and impertinently of the giants of the High Renaissance, that I under-rate the eighteenth century, and that I think it necessary, for ridiculous doctrinaire reasons, to qualify my admiration for the Impressionists. The tone of the book, as I said, is too confident besides being aggressive. The generalisations are too sweeping; the history of fourteen hundred years . . . is told, not as it should be told if it is to be told so briefly, in black and white, but in violently contrasted colors: also some of the colors are false.[55]

There is no reason to suppose that in a calmer moment Bell would not agree that there is some painting containing muscular heroics, straining limbs, and looks of love which is art. Such works might not move Bell himself. Yet, given what he says about criticism, it would be presumptuous for him to say that such work should not move any critic who was following his path.

Loran's third observation, which is germane to our discussion of Bell, is that line plays a key role in Cézanne's composition. He notes that this understanding of Cézanne runs counter to many interpretations which lay stress upon Cézanne's use of individual patches of color as being the fundamental building blocks of this work. Loran supports his claim through his extensive analysis of Cézanne's work. His juxtaposition of Cézanne's *Mont Sainte Victoire,* and Renoir's painting (plate 11) by the same name, presents an eloquent argument for his view.[56] By Loran's criterion, and Bell's too, I believe, the Cézanne work is clearly superior to the Renoir with respect to a mastery of space. Renoir

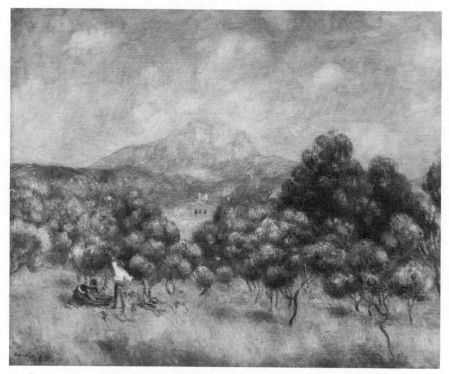

11. Renoir. *Mont Sainte Victoire*. Copyright © by the Barnes Foundation, Merion, Pa. REPRODUCED BY PERMISSION.

employs aerial perspective in such a way as to cause the mountain in the deep space of the painting to fade away. In addition, there is a tunnel in the middle of the Renoir, running from the foreground to the midground and ending abruptly at the foot of the mountain. No tension exists in the Renoir between the foreground and the deep space of the painting. Once into the deep space, one remains there. In contrast, the sharp line tracing the mountain in the Cézanne work causes the deep plane upon which the mountain exists to stand in tension with the forward plane of the work. There are many points of contact between the two planes made possible by their tension. In the Renoir, the foreground stands away from the background in an almost stereoscopic fashion. No connection, and no tension, exists between the planes.

This contrast between Cézanne and Renoir is only one particularly striking instance of Cézanne's use of line in bringing about a tense relationship between the three-dimensionality and the picture plane of a painting. I have made a point of Loran's discussion because it seems that line (as opposed to color) is also of fundamental importance for Bell, as these remarks on the Post-Impressionist movement indicate:

> Insistence on design is perhaps the most obvious characteristic of the movement. To all are familiar those circumambient black lines that are intended to give definition to forms and to reveal the construction of the picture. . . .
>
> To say that the artists of the movement insist on design is not to deny that some of them are exceptionally fine colorists. Cézanne is one of the greatest colorists that ever lived; Henri-Matisse is a great colorist. Yet all, or nearly all, use color as a mode of form. They design in color, that is in colored shapes. Very few fall into the error of regarding color as an end in itself, and of trying to think of it as something different from form. Color in itself has little or no significance. The mere juxtaposition of tones moves us hardly at all. As colorists themselves are fond of saying. 'It is the quantities that count.' It is not by mixing and choosing, but by the shapes of his colors, and the combinations of those shapes, that we recognize the colorist. Color becomes significant only when it becomes form.[57]

It is clear, I believe, that Hitchens (in *Coronation*), Grant (in *Lemon Gatherers*), and Cézanne employ line to approxi-

mately the same end. It is Bell's belief that Giotto and the Byzantine work at Ravenna also approach color as form. In many of the mosaics the "circumambient black lines" appear, and, if they are not clearly visible in Giotto and Cimabue, the effect which they create is present still due to the Poussin phenomenon of cut-outs. In all of these works "the design seems to spring upwards, mass piles itself on mass, . . . there is a sense of strain, and strength to meet it."[58]

These masses and strains are made available to us through what Bell calls design, that is, the formed relations of color. His criticism of the theoretical side of Impressionism can, then, be seen as an objection to the Impressionists' refusal to deal with formed color. To avoid "the polychromatic charts of desolating dullness,"[59] which characterize Impressionism at its worst, one cannot follow the Impressionists' theory that what is to be painted are our immediate sensations of light vibrations, Bell argues. Work of this kind is poor, soft, and formless, says Bell. Renoir's *Mont Sainte Victoire* is probably one of the best examples of soft, formless work which we will find among the masters of Impressionism. I believe that it is safe to say that Bell would find in this painting too much theory, and not enough form.

In addition, Bell has very little regard for those whom he labels as "critics of the Impressionist age."[60] These critics prefer pretty patches of color and are shocked by the appearance of the black lines which are the naked bones and muscles of Post-Impressionism, he says. On the other hand, whoever would understand Post-Impressionism must admire formal relationships, insistence upon design, and exhibitions of the bare construction in painting. Each of these qualities can be directly linked to a strong use of line, I believe. So, we can say that Loran's analysis of Cézanne in terms of line is something with which Bell can agree in principle, and that, generally, works which exhibit significant form will achieve their tension—their strain and counterstrength—through the explicit use of line, or through its implicit employment as in the work of Poussin and the mosaics at Ravenna, where the cut-out figures operate just as if they were surrounded by a line.[61]

We can not begin to see what it means to say that the position which Bell articulates in *Art* is a formalism. It is formal-

istic because what Bell calls the design of a work is an important locus of aesthetic value. That which is structured by the design— colored patches or areas of black and white—and that which is depicted by the design—any kind of representation however vague or specific—are, at most, secondarily relevant to the aesthetic quality of a work of art. In order to understand this we must spell out more fully what Bell's formalism is *not*. Shortly, we will speak again of what it is.

In the context of aesthetics and philosophy generally, to classify a theory as formalistic carries with it certain implications or suggestions about the theory which are not true of Bell's position. In three areas Bell's position runs counter to what might be seen as a standard formalism:

1. Frequently formalistic theories arise as a reaction against positions which lay stress upon what Bell calls the representational element in painting. Theories stressing what is called content (sometimes) or subject matter (other times) often concern themselves with the connections which can be established between the content of a work and other areas of life. Thus, such theories speak of a communication of ideas, Ideals, or feelings from artist to audience *via* the work of art, or of a community which can be created through one kind of artistic practice or another. Those who fear loss of the work among external interests may try to turn attention away from these interests back to the work and in so doing may appear as formalists, particularly if they stress the design aspects of the work. From this perspective Bell is a formalist; his comments about representation make this clear. They also make clear that representation may be a positive aid to the realization of aesthetic value, although not its locus; that the representative element may be a clue to a complex and subtle design, leading us into, and through, the structure of a painting; and, finally, that no subject matter—representational element—is forbidden. The only requirement is that the representational be fused with the design. I have argued that representational elements in a painting are fused when there are no dead spots, no tunnels, and when any depth established in the work is ultimately related to the two-dimensionality of the picture plane. These principles I have illustrated in connection with works containing representational elements, by Grant and Cézanne. It

71

does not follow on Bell's theory that non-objective or non-repre-
sentational art is to be preferred. It does not follow on Bell's
theory that we must approach paintings in a certain way, elimi-
nating from our consideration of them any connections which
they might have with the world around them:

> Certainly the essence of a boat is not that it conjures up visions of
> argosies with purple sails, nor yet that it carries coals to Newcas-
> tle. Imagine a boat in complete isolation, detach it from man and
> his urgent activities and fabulous history, what is it that remains,
> what is that to which we still react emotionally? What but pure
> form, and that which lying behind pure form, gives it its signifi-
> cance.[62]

In the next section we shall speak of that which lies
behind form. At this point it is important to notice that all Bell's
formalism requires of us is careful attention to the work at hand.
We must exclude from our interaction with it cognitive connec-
tions between the forms in the painting and forms we find in life.

2. A second tendency against which formalism is fre-
quently a reaction is one which places the locus of the aesthetic
within the personal emotional (or cognitive) reaction of the artist
or the spectator. Such theories suggest, for example, that the aes-
thetic qualities and value of a piece of art are somehow the result
of spectator projection. On such views, aesthetic qualities and
value are not "objective" characteristics of works of art but, in
one way or another, are read into the work. In reaction, formal-
ists generally argue that a work's aesthetic qualities are just as
much qualities of the work as are its weight, its physical dimen-
sions, or the area of red in the lower corner. In the course of
pushing this approach, the formalist tends to minimize the role of
the spectator. Concepts such as empathy, an aesthetic attitude,
and aesthetic distance are avoided by formalists because they feel
that the use of such notions promotes an undesirable overempha-
sis upon the spectator. As in our first point, we again see a stress
upon the work itself cut off from its environment.

Bell deviates from our general characterization of for-
malism by including the idea of aesthetic emotion as a compo-
nent of his position. The full power, value, of a work of art is not
available to anyone who fails to respond to it emotionally. As we

have seen from Bell's discussion of criticism, not every one can be expected to respond to every successful work of art. Some viewers will be captured by, and swept up into, an exhibition of formal structure which will leave others unmoved. It is possible to study and recognize formal structure without being moved by it. Yet, it is not until we are moved that works become aesthetic objects. There is an irreducible element of audience response within the domain of the aesthetic. Recognition of significant form is not a totally "intellectual" exercise. It is emotional, thrilling, a discovery of connections, not to a further goal, but with a song of their own.

3. Finally, formalism in aesthetics and elsewhere is frequently taken to include the belief that there are definite models or patterns which can be employed as paradigms for proper procedure. In logic, for instance, one knows that a correct move has been made because that move conforms to a pre-established pattern which delineates what is appropriate. So, in aesthetic theory formalism might indicate that there is some definite pattern or formula by which art is created. Such a view is particularly attractive when one desires to avoid the problems of dealing with audience reactions and artists' intentions. This final point is thus closely related to but more general than point 2.

If one asks whether Bell is a formalist in the sense of employing paradigms or formulas, the answer might be both "Yes" and "No." As we have seen, Bell believes that although significant form is the essential quality of all art, there is no limit to the ways in which this quality can be achieved. There can be no formula for creating significant form. Each artist must work out for himself his own method of producing it. How he produces it will be a function of the time during which he works, and of his own personal reaction to that time. He will be influenced by "strange powers in the air from which no man can altogether escape," and by "his sense for the significance of form."[63] It is not possible to specify beforehand how these two forces can or will combine. This is the negative side of our answer.

A positive answer to the question might be derived from our observation that for a work to exhibit significant form its dynamism must be channeled in such a way that whatever occurs within the confines of the picture is ultimately related to

73

the two-dimensional picture plane. Is this not a formula? I do not believe that it is. This characterization of significant form gives us a criterion for successful painting. It does not tell how to produce successful painting. As I have insisted, Bell's is a theory of criticism, not of creativity. I have argued that as a theory of criticism Bell's position is non-normative: we cannot regard the notion of significant form as providing a formula or paradigm in the area of criticism any more than in the area of creativity.

Is it possible to say anything more positive about Bell's formalism? Can we say something which would summarize its content? Frankly, I hesitate to attempt any such summary. If it is done at all, it must be done inadequately. The concept of significant form is at the heart of Bell's formalism. To grasp the significant form of a work of art requires vision and emotion. To grasp the concept of significant form itself requires vision, at least. To offer a purely verbal or linguistic characterization of significant form would be to violate all our conclusions about the nature of this concept. One must see significant form and, perhaps, see it anew in each new painting which is art. He who sees significant form may guide others toward it by using words, but description of it is out of the question. We can say that a painting possesses significant form when the forces which it contains are balanced, controlled *vis à vis* the two-dimensional picture plane. Yet, to see, experience, know significant form one has to experience the tensions controlled in a painting.

The Metaphysical Hypothesis

The formalist works hard to free art from its creators and consumers so that we may examine it for what it is. When successful he can do us a great service; yet, in so doing, he loosens the bonds which tie art and men. Regarded as distinguishable and separable from its human context, art begins to look irrelevant, and arguments over the value of works of art begin to appear as empty exercises for the pointlessly employed. Placed in the context of Bell's theory, the question becomes, "If art has nothing to do with life, why should we want to have anything to do with art?" The formalist seems to be caught in the dilemma of either admitting that art is only the object of idle curiosity, or of attempting to put back together somehow that which he has already torn apart. Rudolf Arnheim, writing on film, recognizes this dilemma:

> Something more hopeful and helpful might have been written, the reader may feel, if there had been less insistence on "art" and more gratitude for useful and enjoyable evenings spent in the movie theater. Indeed there would be little justification for an indictment that charged violation of this or that aesthetic code. The issue is a more real one. Shape and color, sound and words are the means by which man defines the nature and intention of his life. In a functioning culture, his ideas reverberate from his buildings, statues, songs, and plays. But a population constantly exposed to chaotic sights and sounds is gravely handicapped in finding its way.[64]

Once the formalist has come along and spoilt everyone's evening by refusing to countenance any talk of fear,

trembling, and the suffering of the artist, how are we to put it all back together? Arnheim offers a suggestion, but it is vague, and very distant. After all, what does my liking for *The Blue Angel* have to do with culture?

Aestheticians who do not insist upon freeing art from audience and creator do not seem to be presented with the formalists' dilemma. If one believes that art communicates some important message from creator to viewer *via* the work, then the message seems to be a natural locus for a link which binds all three parties to the interaction. Perhaps, then, art could teach us something which we need to know. So, we ignore the works of artists at our own risk. Leo Tolstoy in his *What is Art*[65] seems to offer such a theory. For Tolstoy the very best art communicates to us a Christian religious perception which unites people. Art supplies real, important, necessary spiritual food which nourishes each for the benefit of all.

Tolstoy offers us a striking image. No longer is culture a distant thing. The communication from the artist comes through the work and through *me* into the culture. Because Tolstoy has the notion of communication available to him, he can offer us an understanding of art which places me in a close relationship with it and with something beyond it. Of course, my focus has moved away from the work toward me and my culture. The formalist desires to avoid this change in focus, yet the alternatives which his opponents are offering are couched in powerful images which are deeply appealing. Bell must present some strong counter-suggestions; and I hope to show that he does.

The first link which Bell forges between works of art and the outside world is *via* aesthetic emotion. Only those who have experienced aesthetic emotion are in a position to take up the central question of aesthetics: the discovery of a quality common to all art. Aesthetic emotion constitutes a link which justifies art, for with only few exceptions it is art alone which allows us to experience this kind of emotion, of which we are all capable.

Bell writes as follows about aesthetic emotion: The starting-point for all systems of aesthetics must be the personal experience of a peculiar emotion. The objects that provoke this emotion we will call works of art. All sensitive people agree that there is a peculiar emotion provoked by works of art. I do not

mean, of course, that all works provoke the same emotion. On the contrary, every work produces a different emotion. But all these emotions are recognisably the same in kind. . . .[66]

Many people today reject the idea that there is an aesthetic emotion. Such a claim, they say, does not conform with our experience. If this complaint is directed against the notion of *an* aesthetic emotion, then it cannot be regarded as effective against Bell's position. Bell does not say that there is *an* aesthetic emotion which can be seen as a genus of which each of our emotions are species. There is no core, no central similarity, to aesthetic emotion which will enable us to talk of *an*, or *the* emotion, as I understand Bell. The stress in the quotation above draws our attention to different emotions with similarities, not to the same emotions with different tinges.

Bell's claim is thus much more difficult to challenge than the heavy-handed claim that there is *an* aesthetic emotion. To challenge Bell one must claim that there are no similarities between situations in which one has a passionate, exciting—as opposed to an "academic" or analytic—interaction with a work of visual art. Since this question is a matter of sensitivity to one's own emotional states, it parallels other questions of visual sensitivity which surround the recognition of significant form. Such issues cannot be easily solved by simple appeal to experience, for the nagging uncertainty "Is he insensitive, or am I imagining something?" remains. This uncertainty illustrates a tension which is inherent in both art criticism and aesthetic theory as Bell conceives of them. The tension springs from the circumstance that these two disciplines both contain "subjective" and "objective" moments; neither is wholly one nor the other. Theory in aesthetics begins within, or springs from, the personal, the emotional, in one's life. It assumes its public moment when one articulates the personal, shaping it into claims where it can be challenged by the sensitive perception of others. In Bell's case, at this level, we ask if this emotion is recognizably the same in kind as that one. The answer to this question has its personal aspect but, as an answer, is formulated and evaluated at a public level. Obviously, finality in such a situation cannot be achieved—"Is he blind, or am I overdoing it?" reappears in one-thousand-and-

one variants in such a situation. Disputes over such matters may go on for a very long time. Their character offers us another reason for not regarding Bell's position as a fossilized curiosity.

A situation of tension exists at the foundations of art criticism as well. We know Bell believes that no critic can be expected to respond to every work of art. There is no way to tell before the argument begins if any particular response can finally be regarded as legitimate. The critic's response is in part personal, emotional. His claim about the presence of art, and his justification of the claim, are public. Here, again, discussion may go on and on, for it is addressed to a personal, emotional-visual set, understanding, or recognition. Changing this recognition requires talk. It is the kind of talk which may leave all parties to the discussion up in the air as to what it is that they see before them.

For those who seek, and believe that we can find, certainty or finality in matters related to art, Bell's position must appear wrongheaded. I submit, however, that if one reflects upon the history of changes in taste with respect to that which is great art, then Bell's opinions begin to appear reasonable. His work in *Art* itself offers us an illustration of how taste can be, and was, affected by talk. Although we may feel certain now that so-called primitive art can rival, if not exceed, the work of the Renaissance in value, we cannot say that in the future the term "primitive" will not again be regarded as an expression of disdain. Bell's claim that "Art is significant form" is an aesthetic hypothesis. We can now see what sense it makes to call it an hypothesis. Bell might be wrong; only time and talk will decide the issue.

Thus, both aesthetic theory and claims about what is art, and what not, link the private with the public in such a way that you or I become intimately involved in any discussion we have about these topics. Our involvement in aesthetic discussions stands in contrast to the manner in which we perform mechanical procedures which are considerably more public, if not totally so. So, in the course of dealing with a problem in mathematics or logic, for example, personal involvement is totally eliminated, purposively, by the use of paradigms and formulas for decision making. Recognizing whether a particular argument is a substitution instance of *modus ponens* stands at the depersonalized end of a continuum which stretches all the way past the private reveries

of a person who is led into a musing about his own childhood when confronted with a painting. I believe that we must place Bell closer to the personalized than to the depersonalized end of this continuum. I say this because Bell finds an irreducible element of the personal at the foundation of aesthetic theory and of criticism. It is not only present, but it is the starting point of both these enterprises. Only later is this initial, personal response articulated and made public within a theoretical framework. In the first part of this essay I criticized Weitz and Kennick for misunderstanding Bell's position, for assuming that the presence of significant form could be established in a simple look-and-see fashion. We can see here, again, how the simple model—which readily accommodates recognizing *modus ponens*—will not accurately reflect Bell's approach.

It is the complexity of Bell's position, his refusal to reduce either art or aesthetics to a formula, which both thwarts the attack of Weitz and Kennick, and provides a challenge to Tolstoy. Earlier I spoke of the difficulty which confronts the formalist once he has separated art from creator and audience in a way in which communication theories, for example, do not. The irreducibly personal in Bell's position allows him to offer us an image of our involvement with art which can begin to rival Tolstoy. Tolstoy would have have us reach into the art work and come up with a message. The sort of message of which we speak here is one which can be found in many works of art—all of them successful. We seem to be called upon, then, to recognize when we are being presented with an instance of a certain general type. Apparently we have here the same depersonalized recognition as in our case of *modus ponens*. On the other hand, it seems to me that Bell offers us the exciting opportunity of bringing what is most personal in us into contact with a painting. Upon making this effort, quite possibly we will experience a peculiar emotion, and see a work of art emerge before our eyes. None of this is conclusive, of course. What I want to suggest is that we are not being confronted with a sterile formalism which casts aside all appeal to the human within the aesthetic situation. Bell uses the notion of aesthetic emotion in a double thrust which brings audience and art into close relationship. This is the foundation of his humanistic formalism.

Technically, Bell's opinions on aesthetic emotion are

part of his aesthetic theory proper. They are introduced along with what he refers to as the aesthetic hypothesis. The content of the metaphysical hypothesis is a separate issue, althouth it is an extension of themes from the aesthetic area. Having established a first link between art and nature (in the form of persons), Bell goes on to forge a further union. This new development Bell refers to as the metaphysical hypothesis. The following quotation suggests what he has in mind:

> It is possible that the answer to my question, 'Why are we so profoundly moved by certain combinations of lines and colors?' should be, 'Because artists can express in combinations of lines and colors an emotion felt for reality which reveals itself through line and color?'
>
> If this suggestion were accepted it would follow that 'significant form' was form behind which we catch a sense of ultimate reality. There would be good reason for supposing that the emotions which artists feel in their moments of inspiration, that others feel in the rare moments when they see objects artistically, and that many of us feel when we contemplate works of art, are the same in kind. All would be emotions felt for reality revealing itself through pure form.[67]

The metaphysical hypothesis does present a way in which a "formalist" may establish links between art and other segments of the world. In Bell's case, we have a complex relationship between audience, artist, and something called "reality," or "ultimate reality." This latter expression does not denote a realm of being different from the world which we ordinarily encounter. It denotes a way of looking at ordinary objects so as to see them as ends rather than as means. If we look at a chair in an attempt to decide how confortable it is, or in an attempt to recall exactly where it was located in Grandmother's house, we are not looking at the chair as an end, as what Bell calls a thing-in-itself. When we look at the chair as a concatenation of forms, of lines and colors and planes, then we are looking at the chair as an end, and as ultimate reality. If we can catch a glimpse of the chair as a thing-in-itself behind all the associations and uses which the chair has, then we cannot fail to have an emotional response to our vision. Bell describes our reaction as a thrill which we feel for ultimate reality. As we can see in the quotation just above, the

response to ultimate reality is similar to an aesthetic emotion. So, from the perspective of the metaphysical hypothesis, aesthetic emotion and the thrill felt for reality become one:

> Who has not, once at least in his life, had a sudden vision of landscape as pure form? For once, instead of seeing it as fields and cottages, he has felt it as lines and colors. In that moment has he not won from material beauty a thrill indistinguishable from that which art gives? And, if this be so, is it not clear that he has won from material beauty the thrill that, generally, art alone can give, because he has contrived to see it as a pure formal combination of lines and colors?[68]

Although it is possible for any of us to have a vision of the physical world as pure form, as ultimate reality, it is the artist who can consistently attain to such vision. Artists stand out as possessing "the power of surely and frequently seizing reality," and of just as surely expressing in pure form the thrill of vision.[69] This is to say that creativity must be understood in terms of vision, emotion, and embodiment. The artist's creative act begins with a vision of reality accompanied by the thrill of which Bell speaks. The act ends with the successful embodiment of the vision, and of the thrill, in a work of art which exhibits significant form. Yet, Bell refuses to associate the artist's expression of an emotion with aesthetic value. Throughout the discussion of the metaphysical hypothesis, he claims that, in presenting it, he is going beyond aesthetic theory to offer his "fancies" about why we have aesthetic emotions. We must keep creativity and aesthetic value separate:

> Let no one imagine that the expression of emotion is the outward and visible sign of a work of art. The characteristic of a work of art is its power of provoking aesthetic emotion; the expression of emotion is possibly what gives it that power. It is useless to go to a picture gallery in search of expression; you must go in search of significant form. . . . Right form, I suggest, is ordered and conditioned by a particular kind of emotion.[70]

Bell is enough of a formalist to want to avoid the kind of expression theory suggested by his understanding of creativity. He is fearful that if we are led to speculate upon the artist's vision of reality, and the artist's expression of that vision, our attention

81

will slip from the work itself to either the artist's emotional life, or to ultimate reality. No critic who desires to achieve recognition for works which oppose popular taste can afford to avoid the look of the work in order to speak about the artist. Talking of the artist might be easier than confronting hostile reception of the work, but it is dangerous, for it allows one's audience to dismiss the work on the basis of something in the personality of the artist. Since it is always easy to think of artists as crazy, the burden of responsibility quickly shifts from audience to artist, and the battle to reform taste is lost without a skirmish.

Even though Bell refuses to compromise his formalism with a discussion of creativity, the metaphysical hypothesis forms a link between audience and artist. Already we have seen how Bell's view of criticism rests upon a community of feeling surrounding audience and work. Now we can see the possibility of allowing the artist to enter into this community, also. When Bell tells us that right form, that is, significant form is ordered by the emotion which the artist feels for reality, we can no longer overlook the possibility that when a work of art is successful the audience is responding to the artist's emotion and to significant form at the same time. We might say that the artist's emotion is part of what significant form is, so the community which surrounds the work embraces audience and artist. Bell is not willing to propose such a move. Later in this essay I will attempt to show how such a move would have strengthened Bell's theory without taking attention away from the work itself. First, however, we must attempt an evaluation of the metaphysical hypothesis as separable from the aesthetic theory, and we must explore further Bell's views about creativity.

Art did not require the metaphysical hypothesis. What could be gained by including it? Since the hypothesis does not offer argumentative support for Bell's aesthetic theory, its inclusion creates the risk of obscuring the latter. If a reader rejects the metaphysical hypothesis, rejection of the aesthetic hypothesis, although unjustified, might follow by a sort of halo effect. Bell simply could not resist talking about the role of the artist in the creation of paintings. In his later work this interest becomes ever more pronounced. (See below, part II.)

Practically speaking, the metaphysical hypothesis does

allow Bell to offer a challenge to other types of aesthetic theory. Without endangering the formalism of the aesthetic hypothesis, Bell can employ the metaphysical hypothesis as a defense against attacks accusing him of elitist, ivory-tower, or art-for-art's-sake leanings. The defense is a mixed blessing, however, for all Bell can do is hope that we will be impressed enough with his metaphysics to neglect the fact that it is not logically a part of his position. He is only offering a possible extension of his aesthetic theory which might appeal to someone who is attracted to formalism, but who finds it just a little arid. If Tolstoy can grip me with a theory which shows art as important spiritual food nourishing me, and through me nourishing my culture, Bell, too, can reach out to something beyond art itself. He reaches toward a spiritual understanding of nature as an end in itself. Cultures may rise and fall. The uses to which we put physical objects may vary. Yet, nature *per se* remains a constant; it offers a spiritual base from which we may approach human concerns, and toward which we may retreat from them in times of spiritual need. That Bell sees religious emotion as closely tied with the thrill generated by ultimate reality indicates that the connection he desires to make through art to a wider world is spiritual, and is therefore more enduring than cultural connections. This is a powerful image with which to confront theories such as Tolstoy's, and with which to capture an audience long enough for them to take a good look at some very unusual paintings.

In order to expand upon Bell's views upon creativity and religion, let me quote two passages in which he speaks about Cézanne:

> From that time forward Cézanne set himself to create forms that would express the emotion that he felt for what he had learnt to see. Science became irrelevant as subject. Everything can be seen as pure form, and behind pure form lurks the mysterious significance that thrills to ecstasy.[71]

> Cézanne is a type of the perfect artist. . . . He created forms because only by so doing could he accomplish the end of his existence—the expression of his sense of the significance of form. . . . His life was a constant effort to create forms that would express what he felt in the moment of inspiration. The notion of uninspired art, of a formula for making pictures, would have appeared

83

to him preposterous. The real business of his life was not to make pictures, but to work out his own salvation.[72]

One of the things which comes clear in these comments on Cézanne is the anti-formalistic tendency in Bell's thought. We have seen this tendency before in the idea of significant form as something which must be seen and created anew in each of its instances. Now we learn that a formula for art is impossible because a successful painting must have been created under certain conditions. The fact that the artist creates in a highly emotional response to reality certainly indicates that the spirit, the motive force, prompting Bell to develop his position is far from an interest simply in the incorporation of mathematical, mechanical, formal relationships into wholes with aesthetic value. Bell is continually sensitive to the emotional states of both creator and audience. In this respect the basis of his work is humanistic rather than formalistic. The humanism appears in the metaphysical hypothesis through the discussion of the artist's emotion, and in the aesthetic hypothesis through the idea of an aesthetic emotion. Art does not come about without both of these necessarily human activities. The humanism also appears in the suggestion that the activities of artist and audience might bring them together into a community of feeling and value. Of course, from this latter dimension of humanism Bell's position is fractured, for he includes in the aesthetic theory only one party—the audience—to the interaction.

Bell's comment about Cézanne (or any artist) working out his own salvation gives a clue to the kind of community which might be established if aesthetic and metaphysical hypotheses are allowed to function as interlocked. The artist must create. Having been confronted by ultimate reality, and moved to emotion by it, the artist sees as the goal of existence the expression of this experience. The artist is saved by an ability for expression: by the very nature of the response to ultimate reality one remains unfulfilled unless reality's demand for expression is met. Bell is offering an image of the artist as possessed, and as striving to be rid of the emotion which is possessing him.

Creating a painting not only rids the artist of emotion, but creates an object which reaches toward an audience, creating

an emotion in the viewer. The painting has this power because it was created by a person undergoing certain emotions and successfully dealing with them. The audience is responding just as much to the artist's emotion as to significant form. If we deny the distinction between the two hypotheses, then artist's emotion and significant form fuse, and the artist's salvation becomes tantamount to drawing an audience to him which may commune using the painting as the center of attention. We might picture the situation as follows: I am an important part of the aesthetic situation, yet I am not alone. I make statements about the community which is established between me and the artist. When I attempt to lead you to an experience of this community, I engage in the public activity of critical communication. Critical communication transforms a personal experience of communion (my response to significant form and to the artist's emotion) into the public development of a community of feeling and value. The role which I play in the aesthetic situation is mine and all of mankind's at the same time. The artist and I are linked, personally, and if the linkage can stand up to critical examination, it becomes a community. If the connection dissipates upon examination, then I will have to give it up. We have seen already that the community which develops is extra-cultural; its focus—the painting—is nature spiritualized.

Bell's comments on religion support his generally spiritual approach to art:

> [A]rt has a great deal to do with life—with emotional life. That it is a means to a state of exaltation is unanimously agreed, and that it comes from the spiritual depths of a man's nature is hardly contested. The appreciation of art is certainly a means to ecstasy, and the creation probably the expression of an ecstatic state of mind. Art is, in fact, a necessity to and a product of the spiritual life.[73]

Bell believes that both art and religion lead to ecstasy. There is a "family alliance" between aesthetic emotion and "man's religious sense" because they lead to similar states of mind.[74] These states of mind are also similar to the emotion which the artist feels for ultimate reality. We can see now why Bell never questioned the significance of the thrill which one can

85

feel for ultimate reality. This thrill is one manifestation of a state of mind which he regards as intrinsically valuable. If the metaphysical hypothesis is true, then artist and audience are joined in a community which Bell would regard as religious:

> Religion, like art, is concerned with the world of emotional reality, and with material things only in so far as they are emotionally significant. . . . Religion, as I understand it, is an expression of the individual's sense of the emotional significance of the universe.[75]

Another indication of Bell's commitment to the spiritual, humanistic dimension of art is that in his enthusiasm for the link between art and religion he totally overlooks the tentative nature of his commitment to the metaphysical hypothesis. He asserts with gusto the discovery that art and religion are in a family alliance, seemingly unaware that the ecstasy of the aesthetic emotion is guaranteed merely through the existence of works of art while the religious spirit, to be real, depends upon the viability of the metaphysical hypothesis. For a family alliance to be established two conditions must be met: (1) the gap between significant form and artist's emotion has to be bridged, and (2) our thrill before ultimate reality must be genuine. Neither of these conditions can be met unless Bell is willing to give up his insistence that aesthetic and metaphysical hypotheses remain separate. The idea that there is a religious spirit which manifests itself in both art and in particular religious institutions is, given Bell's ground rules, irrelevant to aesthetics. Certainly it must have been frustrating to him not to have been able to develop his ideas on the spiritual nature of art as part of a total theory. As I have indicated, it seems that Bell might well have thought it strategically unsound for one who desires to change taste to deal with anything more than "formal" qualities of painting. Once he saw the tide of the battle turn toward Post-Impressionism, Bell became more relaxed in his ideas about how to approach art criticism. I will elaborate this idea when speaking of his work after *Art*.

Any difficulty which Bell may have with the connection between art and religion does not vitiate several important comments about perception which occur in this section of *Art:*

The habit of recognising the label and overlooking the thing, of seeing intellectually instead of seeing emotionally, accounts for the amazing blindness, or rather visual shallowness, of most civilised adults. . . . [T]hey use their eyes only to collect information, not to capture emotion. This habit of using the eyes exclusively to pick up facts is the barrier that stands between most people and an understanding of visual art.[76]

There is nothing unnatural about perceiving emotionally. Only scientific bigotry, as Bell calls it, leads people to distrust their emotions, and to believe that once a thing is labeled we have said all that we can about it. The contemporary emphasis upon the scientific unjustly places on the defensive those who believe in the legitimacy of emotional perception, Bell seems to argue. I do not believe that it would be just to Bell's position to understand his notion of emotional perception as some kind of a projection of emotion from the spectator into the work as in the theory of George Santayana, for example.[77] We do not project, we use our eyes to capture emotion. The significant form of work of art is a characteristic of the work. We see it there. Yet, we would not see it there if we were looking at the work scientifically in order to classify it. To see it there we must be ready to see it; we must be looking for it, emotionally. We must have a perceptual set of a certain kind before it will be possible for us to experience aesthetic emotion.

I believe that some of the work which Virgil Aldrich has done in aesthetics may be of use to us in understanding Bell's emotional perception. In *Philosophy of Art* Aldrich introduces the notion of prehension as a certain way of seeing.[78] Prehension stands in contrast to observation. The latter is the perceptual mode in which we experience physical objects in physical space. From Bell's point of view, this is the mode employed by the person who labels things. According to Aldrich, observation is the hallmark of science. Prehension, on the other hand, is a perceptual mode in which we come into contact with aesthetic space and the characteristics which it contains. In the case of Duncan Grant's *Lemon Gatherers,* for example, we *observe* that the painting has a certain weight and certain dimensions, and we *observe* that certain colors are arrayed upon the canvas in a measurable way. In connection with this painting we *prehend* the vibrant space, the

87

tense relationships between planes, and the dynamism of the relationship between two- and three-dimensionality. In short, we prehend the significant form of the work. Aldrich puts it as follows:

> The aesthetic space of things perceived thus [by prehension] is determined by such characteristics as intensities or values of colors and sounds. . . . Take for example a dark city and a pale western sky at dusk, meeting at the sky line. In the purely prehensive or aesthetic view of this, the light sky area just above the jagged sky line protrudes toward the point of view. . . . This is the disposition of these material things in aesthetic space with respect to their medium alone. . . . Thus prehension is, if you like, an 'impressionistic' way of looking, but still a mode of perception, with the impressions objectively animating the material things—there to be prehended.[79]

Aldrich describes here a phenomenon upon which Bell's view of criticism is based, and the occurrence of which I have taken for granted when discussing significant form. When you follow the critic's words you enter into the space, the world, of the painting. The critic leads you about within the space of that painting, pointing out to you what is to be found there. As you move through the world present within aesthetic space, you encounter forces, shapes, and tensions which are unavailable to observation, in Aldrich's sense. None of these encounters can be measured with ruler or spectrograph. The balance established by the thrusts of force and the counter-movements of . hapes can never by calculated by swinging beams. All of these phenomena are available to prehension only. These tensions and balances cannot be observed. To treat them as qualities of physical objects would destroy the tenuous interaction between art work and prehender.

In Bell's position, the notion of prehension includes an emotional vector. Interaction between audience and work is, according to Bell, always emotional. One who is prehending cannot passively catalog the contents of any aesthetic space. To catalog in this way is to label, to avoid true encounter. Passing through aesthetic space is an emotional experience. The viewer must come to the work open to the possibility of encountering it emotionally. Emotional encounter can be blocked by the viewer's

interest in such things as whether the picture is accurate to its model, or how much it will be worth in twenty-five years. If the viewer is ready, and if the work is capable of sustaining an emotional response, then we have the grounds for aesthetic interaction. So far as I can tell, Aldrich's notion of prehension does not include any emotional aspect. In both observation—scientific measurement—and prehension we look and catalog. What we see is different in the two cases, but how we see it is the same. Bell refuses, in effect, to distinguish between how and what we see. He seems to be saying that how we look will affect what we see, and what we want to see will play its part in our decision about how to look. Aldrich seems to accept the latter, but not the former, characterization of the relationship between viewer and viewed. In prehension the impressions which animate the aesthetic space of a work of art are just as objective as the qualities possessed by physical objects. Aldrich apparently believes that in order to preserve the objectivity of aesthetic qualities he must eliminate from prehension any factors within the viewer which do not also exist in cases of observation. Since in observation, states of the viewer are irrelevant, Aldrich must insure that they are irrelevant in prehension in order to achieve the parallel which he desires between the two. Prehension, then, is characterized totally in terms of what is seen—aspects which animate aesthetic space. It is distinguished from observation by this characterization, not by any inherent differences between prehension and observation themselves.

We have seen that Bell would add to Aldrich's notion of prehension the proviso that prehension does differ from observation with respect to the condition of the viewer. Bell's viewer is emotionally active in a way that the scientific observer is not. This emotional activity is in response to characteristics of paintings. These characteristics, together with the emotional response to them, establish the painting as a work of art—as possessing significant form. Bell takes as objective claims that (1) a painting has the formal properties capable of sustaining aesthetic emotion—those properties we spoke of in the previous section—and (2) the existence, in general, of aesthetic emotion, and its existence at any specific time. Since both of these aspects of the aesthetic situation are objective for Bell, he can present us with

an objective characterization of significant form. To speak of an "objective" characterization of significant form could be misleading, however, for there are significant differences between Bell and Aldrich with respect to the notion of objectivity, I believe. I want to develop this theme, and, at the same time, to point to differences in the formalisms of Bell and Aldrich.

In the course of developing his own position Aldrich articulates in detail a model for the aesthetic situation which he finds to be both widespread and unacceptable. The model which he attacks is instantiated in many different ways, but has as a central feature a dualism between the world of art and the world of fact, which places the locus of the aesthetic within the viewer and the locus of fact in the external world. Some of the theories which employ this model do not attempt to bridge the dualism, with the result that claims about, or evaluations of, works of art are purely subjective expressions of emotion, or, at most, they are reports about the viewer's psychological condition. They are never about anything called a work of art. Those theories which attempt to bridge the dualism employ such concepts as empathy, illusion, objectification, or aesthetic distance in an effort to reconnect what is inside of the viewer with what is external to him, and to give judgments, and claims, in aesthetics some cast of objectivity. Aldrich presents his position against this background, and as a reaction to it. He attempts to forestall the appearance of the dualism with its attendant difficulties. Aldrich sets out to do this *via* his notions of prehension, and of aspects animating a material thing. Aldrich refers to aspects as objective impressions which truly belong to a material thing. They are not read into or projected into it by any activity of our minds, wills, or whatever. Aldrich includes within the notion of prehension, then, no idea that it is an active state which itself plays a role in the occurrence of aspects animating things. He must do this in order to avoid the evils of the dualistic model and its attendant subjectivism, which turns attention away from works of art to the audience of art. Aldrich is enough of a formalist to find this situation unacceptable. Unfortunately, in his effort to maintain his formalism, Aldrich cuts off any consideration of the viewer's response to art. The net result, as we have seen, is the claim that the perception of qualities—scientific observation—and the perception of aspects—prehension—are identical except for their objects.

Identity of observation and prehension creates a problem for Aldrich for which I can find no answer in his position. He does not seem to be able to offer an adequate explanation for the function and the importance of art throughout the history of man. Clearly, observation is very important and useful to me. By observation I can avoid pain and secure pleasure; I can move about in the physical world with some modicum of grace and comfort. What can one say for prehension? By Aldrich's characterization prehension cannot give me information of physical qualities and physical space. Can it give me *any* useful information? Perhaps it can give me information about the nature of man; of the human condition; of interpersonal, or interracial, interaction.

I do not see how Aldrich could allow that prehension gives me information about anything except the contents of one aesthetic space or another. Observation gives me no information about aesthetic space, by parity prehension gives me no information about physical space. Yet, problems of the nature and condition of man ultimately have their locus in physical space, so I cannot rely upon prehension to give me information relating to these matters. On the other hand, suppose that it would be possible to rely upon prehension to give me information about man and his condition, for example. If I can do this, then a second problem arises for Aldrich: how far will he be willing to bend his formalistic tendencies to accommodate the new issues which arise when art is seen to communicate information? If art communicates information, then one wonders, immediately, if what is communicated is true or accurate, or if it is false or misleading. Such questions obviously lead us away from the work of art itself to the non-aesthetic world in which we might test art's assertions. We can now see a reason for engaging art, for we might pick up information which will help us from day to day, but we have now moved close to Tolstoy's position, close to admitting things which are foreign to the formalist position. Aldrich is caught in the dilemma of either being unable to offer us any explanation or justification for the value or importance of art, or of having to give up his formalism by offering a justification which moves our attention away from the art itself. Aldrich places himself in the dilemma through his insistence that the emotional life of art's audience has no place in the aesthetic situation.

Bell avoids Aldrich's dilemma. We have seen that he avoids it by grasping one of its horns. Bell explains, or justifies, the value and importance of art in terms of the notion of aesthetic emotion. Aldrich avoids such concepts as aesthetic emotion because, he feels, they tend to reinforce a dualism between the aesthetic and the non-aesthetic to the detriment of the former. The aesthetic winds up being all in one's head while the non-aesthetic is the only thing which is really "out there." The dualism which so bothers Aldrich does not affect Bell because of the latter's implicit assumption that few, if any, experiences are either wholly in our own heads or in the external world. Parallelling Aldrich's types of perception—running from observation to prehension through holophrastic (a nonspecial perception of day to day living)—Bell would offer an analysis of the emotional side of man which would, in a simplified way, run from the detachment of one who labels things in order to place them upon shelves to one who is experiencing aesthetically through some kind of "holophrastic emotional state" combining elements of all the distinguishable emotional states which we can experience. Bell refuses to distinguish between what is internal and what is external with respect to a given phenomenon. He does recognize that scientific labeling requires the internal to be minimized, and he seems to feel that this makes science less than human. Experiences which involve the complex formed by the formal characteristics of a painting and by aesthetic emotion which yield, together, a work of art with significant form are just as objective as situations in which an object is labeled. We have seen that claims about the presence of significant form involve a community of criticism; claims about the appropriate application of a label are adjudicated by the community of science.

Bell's position with respect to the importance and value of art successfully solves Aldrich's dilemma, I believe. It relies upon a principle which many philosophers are coming to recognize as viable; that it is overly simplistic to develop a philosophical position upon the doctrine that a group of phenomena are wholly either one thing or another. Philosophical systems grounded in the external never seem to be able to account for the personal; philosophical positions grounded in the internal never seem to be able to account for the external; and positions which

attempt to combine these two grounds have proven to be, in the long run, incoherent. Bell—along with many contemporary European philosophers—is able to avoid these issues through his refusal to cut up phenomena into definite segments completely divisible from one another.

Bell's own position is not free of difficulty, however. It, too, confronts a difficulty centered upon Bell's inability within the confines of the aesthetic hypothesis to offer any explanation for the fact that art moves us while natural objects do not. In the long run Bell runs the risk of giving up his formalism by moving our attention away from the works themselves to the creative process of the artist in order to establish a distinction between art and nature. At first it does not appear as if Bell is actually confronted with this problem, for he does say that people can have aesthetic reactions to nature—artists have them in the course of successful creation; other persons can have them if they are able to set aside all unaesthetic matter which might clog their perception of the formal structure of nature (ultimate reality). These comments indicate that Bell makes no distinction between paintings and natural objects with respect to their ability to arouse aesthetic emotion. The problem which I have in mind arises when we attempt to take into account some other comments by Bell. Tension begins to develop when we consider the following points:

1. Bell believes that "an absolutely exact copy" of a work of art cannot be as moving as the original. As an explanation he claims that the lines and colors and spaces in a work are caused by something in the mind of the artist which the imitator does not possess. Good copies are not necessarily exact. Rather the copyist must translate the original into his own language to capture that which makes the work aesthetically moving.[80]

2. When speaking of Cézanne's creative accomplishment, Bell finds it important to stress not only Cézanne's contributions to composition but the fact that Cézanne was in the process of working out his own salvation. Technical accomplishment alone is not enough.[81]

3. We noticed earlier in our discussion that Bell is confused as to whether we are (a) responding to the ultimate structure of reality as it is presented to us through the formal

structure of the work, or (b) responding to the artist's emotional response to ultimate reality when we, as spectators, have aesthetic emotion. Bell seems to suggest to us that we can look at the situation in aesthetics in either way. We may see the task of the artist as either creating significant form or as expressing an emotion toward reality. Yet, the situation is not so simple, for if we stress the former, then nature can be art; if we stress the latter, then art must be an artifact created by a person who is feeling, or has felt, certain emotions. It would not appear that Bell can swing both ways on this issue. Either nature can be art or it cannot; either it can offer us full aesthetic emotion or it cannot.

At this point one might be inclined to brush aside all these difficulties with the comment that all of the issues fall within the purview of the metaphysical hypothesis, and thus are irrelevant to Bell's aesthetic position. Unfortunately we cannot do this, for the aesthetic and metaphysical hypotheses have now become too interlocked. The fact that they are interlocked belies Bell's claim about their independence, and gives his work in *Art* a ring of incoherence. The interlocking is also responsible for many humanistic elements in Bell's position. Bell's position on copies is clear. He cannot maintain that position without employing the metaphysical hypothesis. Dealing with natural objects, Bell is less precise than when he speaks of copies and originals. On one interpretation of the metaphysical hypothesis, Bell seems to be saying that the spectator's aesthetic response comes about, at least in part, as a response to an emotion felt by the artist for ultimate reality. On this interpretation, Bell's reluctance to recognize natural objects as works of art dovetails with his stand on copies, and with his comments about Cézanne working out his own salvation. In all three of these areas the creative, emotional life of the artist plays a role in making a painting a work of art. These three facets of Bell's position can be made coherent. Our other interpretation of the metaphysical hypothesis could not even accomplish this much.

I believe it is clear that Bell fails to live up to his announcement about the independence of the metaphysical and the aesthetic hypotheses. It is also clear, I believe, that as soon as considerations of the kind which fall within the purview of Bell's metaphysical hypothesis are brought into the realm of the aes-

thetic, our attention begins to turn away from the work of art itself toward things external to it—in this case to the conditions under which it was created. Bell is quite right in believing that to maintain his formalism he must keep metaphysical and aesthetic hypotheses separated. He fails to do this as a result, I believe, of the latent humanism in his position. The value of a work of art comes about partly as a result of the work's intensely personal origin.

As I have said, Bell's position is incoherent in the long run. By this I mean that in developing his position Bell violates rules which he himself lays down as criteria for his own success. He violates his stipulation that the metaphysical hypothesis has nothing to do with aesthetic value. This, in turn, is tantamount to violating his formalist stance as it is articulated in the famous passage to the effect that one need bring nothing from life to art in order to understand the latter. So, I would say that as an articulation of a philosophical position Bell's effort is unacceptable. Still, its ultimate unacceptability cannot be allowed to blind us to the important aspects of the effort. Bell throws before us in a very vivid way the problems which surround the development of a humanistic formalism in aesthetics.

In attempting to develop a position which preserves formalism and introduces humanism, Bell works out a very sophisticated connection between the work of art and the spectator. Fundamental to the connection is the idea that the presence of significant form is constituted in an interaction between audience and art work. Art criticism supports an examination of the interaction by creating a community of feeling which has the art work as its focus. Yet, instead of pushing on to include the creator within this community Bell set aside as non-aesthetic all discussion of the artist. I believe that this decision ran contrary to Bell's natural inclinations, and certainly he was unable to maintain it. The vital question which his theory poses, then, is whether it is possible to develop a coherent humanistic formalism which includes artist as well as spectator in the aesthetic situation. It is a question of whether the formalist will be able to present us with an image of the aesthetic situation in which the work of art occupies the center of attention within a human context. Or, will the formalist eventually be forced to accede to the demands of

95

philosophers who offer images of the aesthetic situation in which the individual, the society, or the creator occupy the center of attention? I would like to turn, finally, to a consideration of the possibility of humanistic formalism.

Toward a Humanistic Formalism

Although it may be a grim irony, Bell's situation is ironic, for in the chapter entitled "Simplification and Design" in *Art* he lays the groundwork, I believe, for the successful joining of decisions with respect to aesthetic value, and of considerations with respect to the creative process of the artist. If Bell had not insisted upon keeping these two considerations separate, I believe that he could have brought them together with ease. In the following pages I will attempt to show how this might be done. Let us begin with these comments from Virgil Aldrich:

> For the formalists in philosophical aesthetics, form is everything. It is of the essence of the work of art. Their primary concern is that perception or experience be diverted in art from its subject matter to its content on the one hand, and from its bare materials or material basis to its medium and form on the other. They are not wrong about that. What has induced them into an overstatement in favor of form is their inadequate conception of the content animating the medium, when the medium takes on the right form in a good composition. Also to blame for their overemphasis of form is their failure to distinguish content from subject matter.[82]

Aldrich believes that he has achieved in his own theory the balance between form and content which is lacking in Bell's formalism. He attempts to indicate how this balance is achieved in a brief but sensitive discussion of Derain's *Still Life with a Jug*. Aldrich concludes his comments on this painting by remarking that the "composition expressively portrays not only the subject matter indicated by the title, but presents a space

97

which also harbors elemental affection for the staples of human life, as a part of the content."[83] According to Aldrich the form and the expressive portrayal fuse to provide us with a painting which does everything which can be done in the art of painting.

Formalism fails because it lacks a notion of the possibility of a fusion of form and content. Aldrich calls the form/content fusion third-order form (he really is a formalist at heart), and defends his notion of fusion *via* a distinction between physical and aesthetic space. Aldrich's attack on formalism may be true on some formulations of that position, but it cannot be directed against Bell with any effectiveness. Bell holds a fusion theory of his own which brings Aldrich into substantial agreement with him. In this connection, Bell makes the following comments:

> If he [the artist] give to his forms so much of the appearance of the forms of ordinary life that we shall at once refer them back to something we have already seen, shall we not grasp more easily their aesthetic relations in his design? Enter by the back-door representation in the quality of a clue to the nature of design. I have no objection to its presence. Only, if the representative element is not to ruin the picture as a work of art, it must be fused into the design. It must do double duty; as well as giving information it must create aesthetic emotion. It must be simplified into significant form.[84]

Bell's discussion of symbolism reveals, again, his position on the fusion of subject matter and form:

> The representative element, if it is not to injure the design, must become part of it; besides giving information it has got to provoke aesthetic emotion. That is where symbolism fails. The symbolist eliminates, but does not assimilate. His symbols, as a rule, are not integral parts of a plastic conception, but intellectual abbreviations. They are not informed by the artist's emotion, they are invented by his intellect.[85]

The organization of symbol, or representative element, into a fused, significant whole is what Bell refers to as "design." I believe it is what Aldrich refers to as third-order form.

Bell's comment to the effect that a design is not successful unless the entire work is "informed by the artist's emotion" gives us a clue to the possibilities inherent in a fusion

theory. Aldrich is willing to speak of sadness as fusing with the bent back of a figure in a painting, so that the figure is animated with an emotion. If the aesthetic space in which the figure is located "harbors an elemental affection" for the emotion animating the figure, we have a fusion at the level of third-order form, which represents a highly successful painting. Aldrich's position contains no notion that form at the third level might also be animated by an emotion. It seems to me that the power of Bell's description of successful design allows for just that possibility. For Bell, artist's emotion informs form at Aldrich's third level. Yet, why does Bell refuse to grasp this possibility of bringing into the work something of the artist? It seems to be because he believes that to talk about these matters is to attempt to account for why design stirs our emotions, rather than to account for the nature of (good) design. His attitude seems mistaken, given his comment that design requires a fusion of the representational with the formal, and that the fusion will be successful only if informed by the artist's emotion.

Design is animated—Aldrich's term—by emotion. Bell makes that clear in passages such as the following:

> But on all sides we see interesting pictures in which the holes in the artist's conception are obvious. The vision was once perfect, but it cannot be recaptured. The rapture will not return. The supreme creative power is wanting. There are holes, and they have to be filled with putty. Putty we all know when we see it—when we feel it. It is dead matter—literal transcriptions from nature, intellectual machinery, forms that correspond with nothing that was apprehended emotionally, forms unfired with the rhythm that thrilled through the first vision of a significant whole.[86]

When content and form are successfully fused the whole is animated in such a way as to eliminate dead spots, and tunnels of space within the work. Successful fusion of form and content gives rise to a work which is animated with the excitement which Bell describes, and, from the side of the creator, the emotional vision with which the artist begins is responsible for the successful fusion of form and content. It is not possible to separate the animating emotion, which itself is fused to the form/content complex, from the work and to say of it that it is either

99

the cause or the effect of the successful fusion of form and content. It is no more possible to do that than to separate the form (aesthetic space) and the content in the Derain still life, and to say of one or the other that it alone is responsible for the total effect of the painting.

When we follow this line of argument, seeing that (good) design involves a fusion of form and content in an emotional context, it is clear that a successful fusion is not something which can be described, but is something to which the critic must lead us without being able to speak of it directly. Although design and significant form are not one and the same, design is significant form as it is presented to the spectator in the painting. (Significant form itself comes about, as we have seen, as a result of an interaction between the painting and the emotion of the audience.) Thus, it is precisely (good) design which the critic tries to bring to our attention when he attempts to have us respond to a painting as a work of art.

The Hitchens painting, *Forest Edge No. 2,* is our clearest example of a work which fails. In a sense we can see how Hitchens's once-perfect vision has been lost to him, and how the holes, mentioned before, appear in the painting. Hitchens's efforts to bring the holes between "trees" in the painting into some kind of dynamic relation are clear enough in his use of the thin light lines between the "trees." The end effect, however, is not to bring the holes forward or the "trees" backward into a dynamic tension; the end effect is that the light lines appear as a grillwork laid over the holes in the painting. At one time he conceived of a forest space in dynamic tension. Yet, the vision failed. The thin, light lines, and thus the spaces beween the "trees," are "unfired with the rhythm that thrilled through the first vision of a significant whole."

To see the holes in a painting is not a mechanical task. As Bell says, we become aware of the putty in the Hitchens's work when we feel it. One feels oneself plunging into those spaces between the "trees," and, searching for a way to return to the surface of the painting, finds nothing of substance upon which to grasp. It is through experience of this kind—and not through situations which involve calculations or measurement—that we come to discover the strengths and weaknesses of paintings. Con-

trary to Aldrich's view of prehension, which is essentially seeing "objective" characteristics of the work of art, Bell's notion of aesthetic perception is an emotional experience. We have seen that the spectator's apprehension of significant form is an emotional experience. We can now see how that which the spectator perceives is not simply out there to be seen "objectively." Although Aldrich speaks of characteristics such as the sadness of a painting as aspects which animate the work, there does not seem to be anything significantly emotional about the situation of animation—no more emotional than it is for the quality of brown to be a property of a table. In Bell's case, on the other hand, I am tempted to describe the situation in the following way: The spectator moves beyond mere observation of the painting to an involvement with the work which allows him to feel its rhythm, and thus to feel any dead spots in it; he is engaged with the work in such a way as to be following ebb and flow of the artist's creation of it. He follows the artist through his choices, from one point to the next, one move to another. To make a choice involves a risk. Choosing is an emotional process, so it is inevitable that the work should exhibit—should have as one of its aspects— some of the emotion of choice. In the Hitchens *Forest Edge No. 2* we see those lines between the "trees" as striving to unify the composition, or we can say that we see that the artist is striving to unify the composition with those lines. Whichever form of expression we choose, we are indicating an awareness of the emotional content of the work. Such feelings are required before we can understand it as possessing or lacking significant form.

Yet, to say either that the spectator follows the path on which the artist moved through the work, or that he follows a path which the artist must provide for him—and which he must follow—seems to me to be going well beyond any data which I have presented in the course of this essay. As I think that it would be a mistake to attribute a view of this kind to Bell, I hope that we can avoid it. For this reason I do not believe that we should make use of the circular lines which Loran finds moving through each of the Cézannes which he discusses. The spatial dynamics of both Cézanne and the mosaics at Ravenna do not depend upon the spectator following such paths. The emotion which fully animates the successful painting does not have to be grasped by the

spectator in any particular sequence. I do not see that for Bell, or for a humanistic formalism generally, we need to say that the spectator relives, or recreates, the process, or path, followed by the artist. To bring the artist within the purview of the aesthetic situation it is simply necessary to specify that in order to interact with a painting as an aesthetic object one must perceive—feel— the creative rhythm which animates the design of the work. Following this line of argument, a humanistic formalism begins to emerge when we keep in mind that (1) a spectator must respond emotionally to a painting before significant form can become manifest, and (2) even if the spectator is emotionally sensitive, a painting will fail to achieve the status of a work of art if it is not animated by a unifying conception. We must remember here that "animated" is an emotionally loaded term. A unifying conception is something which must be felt. We enter into the space of a work, and we feel that space to have certain dynamic characteristics and a certain coherence—which would include the fusion of symbol and form—*and* in addition to, and because of, these other characteristics we feel that space to be animated by a guiding force, a directional emotion.

Bell omits the possibility of the work of art being animated by a guiding emotion. As we have seen, this omission gives him a problem when he comes to deal with copies, and with the issue of whether a machine can create art. Bell refuses to employ any notion similar to the one which I have introduced here because of his belief that upon doing so he would enter into the area of creativity, which is external to any aesthetic theory proper. I have argued that Bell is mistaken on this point, for he fails to distinguish between the conditions necessary for the presence of (good) design and the conditions necessary for the creative act to begin and to sustain itself. A characterization of design may contain a reference to something the artist has done without including a statement of the conditions under which the work was created. The emotional aura which characterizes good design is a prehendable quality of the art work. Bell's notion of fusion is available to insure that when we speak of the artist's emotional input in this context we must be speaking of the work at the same time.

What becomes of Bell's metaphysical hypothesis under

the conditions which I have just described? I suppose that if a choice were put to him, Bell would opt for the statement of his position which would see the artist as presenting not an "objective" representation of ultimate reality, but a presentation of it which is necessarily, and properly, intertwined with his own emotions. I believe that Bell would take this line first because of his generally negative attitude toward representation, and, secondly, because of his position—taken from G. E. Moore[87]—that the only things of absolute value are certain states of mind. If Bell did take this approach, regardless of its justification, some of the force of the metaphysical hypothesis could be preserved in a humanistic formalism. On this analysis the metaphysical hypothesis would read, roughly, "We are moved by significant form because it expresses the emotion of its creator." This, in fact, is Bell's first formulation of it, which becomes confused only later when he introduces the notion of ultimate reality. Because of the relationship which we have discovered between significant form and design, the metaphysical hypothesis could be rewritten as, "We are moved by design because it expresses the emotion of its creator." The latter statement is not a hypothesis at all about the nature of creativity. It is about the nature of successful design. By employing Bell's own idea of fusion we can see how the main thrust of the metaphysical hypothesis can be transferred into the domain of the aesthetic without requiring that we turn our attention away from the painting itself. Under these conditions the metaphysical hypothesis *per se* disappears. It is no longer present to be judged as a persuasive support for the aesthetic hypothesis. It is now to be judged—along with the other facets of the aesthetic hypothesis—*via* critical interchange and sensitive perception.

What I have said so far about formalism and fusion may sound strange to many who are familiar with contemporary work in aesthetics. It is the opinion of Monroe Beardsley, for instance, that formalism in aesthetics always yields what he calls a divergence theory. "The gist of the Divergence Theory," says Beardsley, "is that though a painting may both be a design and have a subject, its subject and its design are always either irrelevant to, or in conflict with, each other."[88] Beardsley believes that Bell holds a divergence theory. When Bell speaks of *Paddington Station* as, and condemns it because it is, a painting in which line

and color are used to recount anecdotes and indicate customs, we might think that we were encountering a divergence theory. This impression is strengthened when Bell tells us that the representational element in painting is always irrelevant, and frequently detrimental to, aesthetic value. Comments such as these, which occur early in *Art,* certainly seem to justify the application of the following image which Beardsley offers us:

> For imagine a man juggling plates in the air and whistling 'Yankee Doodle.' He is doing two things at once, but there is no connection between them; they remain two acts, not one. However, if you sing a waltz while waltzing, there is a rhythmic connection between the two acts, which draws them together, and keeps them from being totally irrelevant and merely simultaneous. The Divergence suggests that the representational painter's task is more like the juggling and whistling. And it holds that the same is true in the spectator's experience.[89]

At the beginning of *Art,* the image of the artist as whistling juggler might seem to apply. Yet, that image itself cuts against what even Beardsley understands to be one of Bell's problems, that is, securing a sympathetic understanding for Post-Impressionism. For Bell to present Cézanne as a whistling juggler is unthinkable. Obviously Bell's admiration for Cézanne was too great, and Bell's understanding of the ins and outs of the battle for Post-Impressionism too deep, for him to be employing a divergence view of Cézanne's work. Cézanne brought all the elements in the aesthetic situation—he successfully worked out his own salvation—into a coherent whole. Cézanne's accomplishment is not a *tour de force* or a freak of skill, as Beardsley suggests it would have to be if one accepts the divergence theory. His paintings were all that art should be, from Bell's point of view. The final thrust of Bell's theory is not to wrench apart form and content (or subject matter) so that form alone (whatever that could be) becomes the bearer of aesthetic value. Insofar as Bell was aiming at an alteration of perception and taste he was trying to put form and content back together in an age when art was admired primarily for its content (or subject matter). Cézanne's greatness lies in his fusing of form and subject into an emotionally significant whole. The representative elements in his work are not there as trees and houses and mountains which are somehow

104

connected with places or events external to the paintings themselves. The representational elements in the paintings are integrated into the coherent rhythm—into the aesthetic space—of the painting; it is as objects which have been integrated that we must approach them. The representational element is irrelevant when it is used as signs or symbols which draw our attention away from the painting; but, when integrated, the representational element may be invaluable to us in orienting our focus with the painting. Once integrated, the elements of a painting lose their representational status; that is, as parts of the painting they no longer point, or push, or call us away from the work itself. Thus, when Bell tells us that every form in a work of art has to be made a part of a significant whole he is not espousing a divergence theory. In a successful painting content must be fused with form.

I believe that we should reject Beardsley's attribution of a divergence theory to Bell. Bell's own use of the notion of fusion is probably the strongest reason for this rejection. Yet, Bell's treatment of Cézanne, and Bell's broad notion of design, also militate against ascribing a divergence theory to him. Some may feel that the argument which I have presented here amounts to an admission that Bell's position is incoherent in a way in which I have so far failed to mention. That is to say, an incoherence appears in Bell's position between the first statement of the aesthetic hypothesis and his final discussion of design some one-hundred-and-fifty pages later. I do not believe that this is so. Bell's early formulation of the aesthetic hypothesis tells us that significant form is composed of lines and colors combined in a particular way. He does not specify the way. We have seen that the way cannot be specified with any definiteness. The introduction of combinations of lines and colors as fundamental to significant form should not be taken as indicating that lines and colors are *significant* form. Bell stresses lines and colors to draw our attention away from houses and bridges, or symbols and messages. Art is not symbols combined in certain ways, nor is it pictures of people and places so combined. What is fundamental to art (painting) is what the artist gets down on the canvas—lines and colors—and not what we are led to imagine or remember when we confront a painting as an historical artifact.

105

I believe that as a theoretician—rather than as a reformer—Bell's point is that art must remain in touch with its sources. There are four of them: (1) the artist; (2) the two-dimensional picture plane; (3) the lines and colors on the plane; and (4) the spectators, the critics. The fact that a painting is fundamentally a two-dimensional presentation leads Bell to reject scientific picture-making. It is only the scientific picture-makers who may take symbols, or pictures of people and places as a fundamental source for art. In so doing they are forced to violate what Bell sees as another fundamental source for painting which is art, the picture plane. Thus, points (2) and (3) above move together hand in glove. We cannot infer that they exhaust the aesthetic situation, however. The artist's contribution gives us the *particular* in the way in which lines and colors are put together. The artist's options are limitless within the confines of (2) and (3). He must transform the plane, and the lines and colors into a dynamic, rhythmic space. This space with its dynamic is infused with, animated by, an emotion—or perhaps emotional excitement or presence—which is the visible trace of the hand of the artist in the act of forming the aesthetic space and its contents. We know, too, that the spectator, or critic, must be one of the sources for art. To say of a painting that it possesses significant form—that it is art—is to make a value judgment about it. No such judgments would exist unless art had an audience, capable and sensitive. Spectators cannot simply see (the presence of) significant form. It must be felt, experienced. One must move through the dynamic space of the work, sensitive to the emotional tone which animates it, in order to capture significant form. Borrowing Aldrich's term, to prehend significant form in this way is not simply to observe it—even with some kind of emotional observation. For Bell prehension is one of the elements which brings significant form into existence.

The strengths of the position which Bell articulates in *Art* lie, first, in its recognition of the two-dimensional picture plane, lines and colors, and the audience as fundamental components in the aesthetic situation, and second, in his feeling for the necessity of a humanistic aesthetic. It is unfortunate, but not surprising when one considers the cultural forces operating upon him, that Bell was unable to see his way clear to including the

artist within the aesthetic situation. As we have seen, his theory is capable of it.

NOTES

1. Arnold Isenberg, "Critical Communication," *Aesthetics and Language,* ed. William Elton (Oxford: Basil Blackwell, 1959), pp. 131–46.

2. *Ibid.,* p. 137.

3. Clive Bell, *Art* (London: Chatto & Windus, 1914, 1948; rpt. Capricorn Books, New York: G. P. Putnam's Sons, 1958.) All page references are to the Capricorn reprint.

4. Bell makes this distinction in "Flowers and a Moral," *Nation* (London), No. 41, 4 June 1927: 303–4; and "Pre-Raphaelites," *Nation* (London), No. 38, 19 December 1925: 433–35.

5. Bell, *Art,* pp. 15–16.

6. Clive Bell, "Critic as Guide," *New Republic,* 26 October 1921: 259.

7. *Ibid.,* p. 259.

8. Clive Bell, "De Gustibus," *New Republic,* 18 May 1921: 343.

9. Bell, *Art,* p. 18.

10. Isenberg, p. 139.

11. *Ibid.,* pp. 137–38.

12. Bell, *Art,* p. 11.

13. *Ibid.,* p. 17.

14. *Ibid.,* p. 27.

15. *Ibid.*, p. 94.

16. *The Railway Station*—Bell calls it *Paddington Station*—was painted by William Powell Firth (1819–1909) in 1862. It hangs in the Picture Gallery, Royal Holloway College, Egham, Surrey. A reproduction of it can be seen in Anthony Bertram, *A Century of British Painting, 1851–1951.*

17. Bell, *Art*, pp. 22–23.

18. *Ibid.*, p. 119.

19. William E. Kennick, "Does Traditional Aesthetics Rest on a Mistake," *Mind*, 67, no. 267 (July 1958): 317.

20. Morris Weitz, "The Role of Theory in Aesthetics," *Problems in Aesthetics*, ed. Morris Weitz (New York: Macmillan Co., 1959), p 146.

21. *Ibid.*

22. Kennick, p. 320.

23. *Ibid.*, pp. 321–22.

24. *Ibid.*, p. 318.

25. Weitz, p. 152.

26. See, for example, the position of Beryl Lake in "A Study of the Irrefutability of Two Aesthetic Theories," *Aesthetics and Language*, ed. William Elton (Oxford: Basel Blackwell, 1959), pp. 100–133.

27. J. K. Johnstone, *The Bloomsbury Group* (New York: Noonday Press, 1954).

28. G. E. Moore, *Principia Ethica* (Cambridge: Cambridge University Press, 1903), pp. x–xi, 143–44.

29. George Dickie, "Clive Bell and the Method of *Principia Ethica*," *British Journal of Aesthetics*, 5, no. 2 (April 1965): 139–43.

30. Rosalind Ekman, "The Paradoxes of Formalism," *British Journal of Aesthetics*, 10, no. 4 (October 1970): 350–58.

31. Moore, p. x.

32. *Ibid.*, p. 75.

33. *Ibid.,* pp. 189–90.

34. *Ibid.,* p. 201.

35. Bell, *Art,* pp. 60–61.

36. *Ibid.,* p. 83.

37. Monroe C. Beardsley, *Aesthetics: Probems in the Philosophy of Criticism* (New York: Harcourt, Brace & World, Inc., 1958), p. 298.

38. *Ibid.,* p. 83.

39. Bell, *Art,* p. 114.

40. *Ibid.,* p. 127.

41. The Pre-Raphaelite Brotherhood was founded in 1848–49. The original leaders were D.G. Rossetti (1828–82), John Millais (1829–96), and W. Holman Hunt (1827–1910). They were united primarily by their reaction against Royal Academy style, which was dominated by the ghost of Joshua Reynolds. They desired to present nature as they saw it, i.e., as designed and moral. *The Blind Girl* was painted in 1856. A reproduction of it can be found in Bertram, *A Century of British Painting, 1851–1951.*

42. Bell, "Black and White," *New Statesman and Nation,* 15 February 1936: 227.

43. Clive Bell, "Two Shows," *New Statesman and Nation,* 3 August 1940: 110; and "Fame and Promise," *New Statesman and Nation,* 17 July 1943: 40.

44. Miriam Schild Bunim, *Space in Medieval Painting and the Forerunners of Perspective* (New York: Columbia University Press, 1940).

45. Bell, *Art,* p. 105.

46. Clive Bell, "Duncan Grant," *New Statesman and Nation,* 19 May 1937: 763–64; and "French and English," *New Statesman and Nation,* 22 July 1939: 141–42.

47. Bell, *Art,* p. 94.

48. Erle Loran, *Cézanne's Composition* (Berkeley: University of California Press, 1946).

49. *Ibid.,* pp. 62–65.

50. *Ibid.,* p. 32.

51. *Ibid.,* p. 131.

52. Bell, *Art,* p. 139.

53. Loran, *Cézanne's Composition,* pp. 3–4.

54. Bell, *Art,* pp. 150, 152.

55. *Ibid.,* p. 11.

56. Loran, *Cézanne's Composition,* p. 100.

57. Bell, *Art,* pp. 155–56.

58. *Ibid.,* p. 156.

59. *Ibid.,* p. 128.

60. *Ibid.,* p. 157.

61. In *Art* Bell makes a footnote reference (p. 25) to the art of China. Although he never develops the theme, he hints that his theory could apply to the Ku K'ai-chih, as a specific example. For an excellent analysis of this scroll, quite in keeping with Bell's approach, see Wilfrid H. Wells, *Perspective in Early Chinese Painting* (London: Edward Goldstone, Ltd., 1935).

62. Bell, *Art,* pp. 142–43.

63. *Ibid.,* pp. 146, 141, respectively.

64. Rudolf Arnheim, *Film As Art* (Berkeley: University of California Press, 1958), pp. 6–7.

65. Leo N. Tolstoy, *What is Art?* trans. Aylmer Maude (New York: The Bobbs-Merrill Co., 1960).

66. Bell, *Art,* pp. 16–17.

67. *Ibid.,* pp. 45–46.

68. *Ibid.*, p. 45.

69. *Ibid.*, p. 47.

70. *Ibid.*, p. 50.

71. *Ibid.*, p. 140.

72. *Ibid.*, pp. 141–42.

73. *Ibid.*, p. 59.

74. *Ibid.*, p. 68.

75. *Ibid.*, p. 62.

76. *Ibid.*, p. 62.

77. For example, see George Santayana, "The Nature of Beauty," *A Modern Book of Aesthetics,* ed. Melvin Rader (New York: Holt, Rinehart and Winston, 1964), pp. 34–50.

78. Virgil C. Aldrich, *Philosophy of Art* (Englewood Cliffs: Prentice-Hall, Inc., 1963).

79. *Ibid.*, p. 22.

80. Bell, *Art,* pp. 49–50.

81. *Ibid.*, part IV, chapter 1.

82. Aldrich, *Philosophy of Art,* p. 44.

83. *Ibid.*, p. 65.

84. Bell, *Art,* p. 150.

85. *Ibid.*, p. 152.

86. *Ibid.*, p. 153.

87. *Ibid.*, pp. 66–67.

88. Beardsley, *Aesthetics,* p. 296.

89. *Ibid.*, p. 297.

PART II
Clive Bell's Work after *Art*

Introduction

The focus of this section is a group of eleven articles written by Clive Bell between 1919 and 1950. They stand by themselves as typical of the direction of Bell's thinking as it evolved over thirty-odd years. In the comments which follow, I attempt to place the twelve articles against *Art*.

The first three essays presented here deal directly with the nature of criticism. They span a period of two years and indicate a trend in Bell's thinking that modifies his earlier position in *Art*. The change during these years is slight; but between the image, in "Criticism," of the critic as a person who is "good at jumping," who has feelings he cannot describe, who emotes in an effort to infect his audience with emotion, and who eschews analysis, and the notion in "The Critic as Guide" that impressionistic criticism, although useful, must be tempered, and that both biographical and analytic work can be of great value, there is a shift. The critic is still seen as a guide, and throughout Bell avoids introducing norms or standards for critical judgment. Still, his view of the content and manner of the critic's utterances alters between 1919 and 1921. "The Critic as Guide" no longer presents the critic as a person possessed by an emotion which he cannot adequately describe, but which he desperately wants others to share. In this later work criticism is presented as a much less emotional process. For the first time the possibility is introduced that one might do criticism—analytic or biographical—without feeling anything for the work of art under examination. Previously the parameters of criticism were the critic's emotional response to the work and the formal properties of the work itself.

115

Analytic criticism opens the way for the elimination of the former parameter; biographical criticism requires neither.

"The Critic as Guide" appeared in 1921. *Since Cézanne* was published in 1922; the titular essay introducing the book throws further light upon the position which began to emerge with "The Critic as Guide." Bell begins by pointing out that during the years 1905 through 1922 theory played a very important role in the emerging influence of Cézanne and the development of Post-Impressionism. He suggests too that now (1922) the necessity for a strong emphasis upon, and presentation of, theory is past. He sees a second phase appearing in which critical attention should turn away from doctrine toward practice, toward the study of artists and works of art. *Since Cézanne,* which does contain a great many articles related to theory, is presented to us as a farewell to, and as a summation of, a necessary step in the battle of Post-Impressionism. A necessary step, but one which must now be left behind, for the disadvantages of standing upon it have become manifest. Bell speaks almost wistfully of the doctrinaire period between 1905 and 1922.

> [W]e were unjust to the past. That was inevitable. The intemperate ferocity of the opposition drove us into Protestantism, and Protestantism is unjust always. It made us narrow, unwilling to give credit to outsiders of merit, and grossly indulgent to insiders of little or none. Certainly we appreciated the Orientals, the Primitives, and savage art as they had never been appreciated before; but we underrated the art of the Renaissance and of the eighteenth and nineteenth centuries.[1]

Reflecting upon words such as these, we cannot escape the impression that things will be different after *Since Cézanne.* A glorious time has drawn to an end. The theoretical fights are over. Post-Impressionism has been recognized. The notion of art as significant form has performed its function as a tool for the reformation of taste. The warriors in the battle may now safely leave their fortifications knowing that they will emerge to walk upon accepting, if not sympathetic, ground. Some new rapprochement with old enemies seems appropriate.

Rapprochement did not occur all at once, however. We can see from the fourth selection—"The 'Difference' of Liter-

ature" (1922) that Bell was not about to turn his back upon every challenge to his position as it was articulated in *Art*. "The 'Difference' of Literature" gives us some idea of how passionately Bell felt about the distinction, which he made from the first, between art which derives its value from formal characteristics, and art which requires attention to "cognitive and suggestive" elements; and of how seriously he expects to be taken when he claims that *Art* is about painting (graphic art) only. Certainly, if we take "The 'Difference' of Literature" seriously, biographical criticism of painting, and criticism which draws attention to the literary aspects of painting, would be illegitimate. "The Critic as Guide" and "The 'Difference' of Literature" are in conflict. The latter is a relic, a leftover; the former, as it turns out, indicates the direction which Bell was to take. Yet, the doctrine of the "purity" of painting was in Bell's position from the first. It continued to be exhibited in such articles as part one of "Art and Politics" of 1920:

> To say that work is aristocratic or democratic, moral or immoral, is to say something silly and irrelevant, or, rather, silly if meant to be relevant to its value as art. In the work of Renoir and of Picasso, and, indeed, in all works of art, the essential quality, as all sensitive people know, is the same. Whatever it may be that makes art matter is to be found in every work that does matter. And though, no doubt, "subject" and to some extent "attack" may be conditioned by an artist's opinions and attitude to life, such things are irrelevant to his work's final significance. Strange as it may seem, the essential quality in a work of art is purely artistic. It has nothing to do with the moral, religious, or political views of its creator.[2]

There seems to be a constant conflict, however, in Bell's thinking between the purity theory which we find in the two articles just mentioned, and Bell's interest in the creative aspect of the aesthetic situation. In *Art* Bell would not allow talk of the artist's creative process as relevant to aesthetic theory and value. Yet, in *Art* he returns again and again to the creative process, and speaks of how questions about its nature come naturally to mind during the development of an aesthetic theory. (In part I, I commented at length about this situation.) Bell's interest in the artist's creative processes continued during the

period just before *Since Cézanne.* The next two articles reproduced here illustrate this continued interest. "The Artistic Problem" and "Order and Authority, I" were both written in 1919. Certainly they expand upon comments which Bell made in *Art.* There, Bell had to apologize for such comments. By 1919 they come naturally, and perhaps they indicate that Bell is taking more seriously the expressionistic tendencies within his own theory of art.

From the moment that Bell insisted upon distinguishing between an original painting and a copy, and between the beauty of painting and of natural objects, he relied upon notions appropriate to an expressionistic aesthetic theory. There can be no question that Bell sees a work of art as a production of a certain state of mind. The fact that the artist creates under the influence of that state of mind is something which a discerning critic can see in a painting. (See the second and third paragraphs of "Order and Authority, I.") In part I, I tried to describe this situation and incorporate it into Bell's position, employing Aldrich's notion of third-level form. Judging from Bell's work after *Since Cézanne,* I do not believe that he was particularly interested in whether this expressionistic aspect of his position was coherent with the rest of his formalism.

Interest in the artistic problem led Bell to push away from the pure-art theory as in "The 'Difference' of Literature" to a position which legitimates critical talk about the processes and experiences of the artist. Reading the introduction to *Since Cézanne* one might expect to find a considerable difference in the style of Bell's critical writing before and after 1922, but this is not the case. I have reproduced here three of Bell's critical essays. The first—"Duncan Grant"—was done in 1920; the second—"The Two Corots"—in 1926. I believe it to be evident that between these two critical pieces there is no great difference in the manner in which Bell approaches his subject. The new type of criticism which Bell both calls for, and announces at the beginning of *Since Cézanne,* either does not appear at Bell's hand or is already with us from the outset. I would opt for the latter alternative. After the year 1922 Bell comes closer to legitimating the kind of criticism he had been doing all along. His position in *Art* and in such articles as "The 'Difference' of Literature" does not

support as viable most of the work which we see in both "Duncan Grant" and in "The Two Corots." Bell's critical work with Matisse in "Black and White" (1936)—the ninth essay—seems to be much closer to the kind of criticism we would expect to see from an advocate of the primacy of design. Yet, "Black and White" is an anomaly. In this review Bell spends proportionately more time dealing with an analysis of particular works than in any other of his critical essays. Yet, it is just this type of anlysis one would expect of a "formalist." From the first, Bell's theoretical position and his critical practice are at variance. The kind of criticism which he wanted to write, and which he did write when he was not bothering his head with theory, is biographical and would rest comfortably upon an expressionistic theory for its justification. His desire to write this type of criticism probably acted as a continual stimulant, prodding Bell away from his theoretical position of *Art,* and the articles on theory written in 1919 and 1920. However, it was not until 1924 that Bell issued a theoretical paper which justified the growing corpus of his criticism aimed away from a discussion of the formalistic elements in art.

"The Bran-pie and Eclecticism"—the tenth article— appeared in June 1924. The publication of this piece makes it clear, I believe, that there has been a major shift in Bell's position. The implications of the "The Critic as Guide" are now embraced completely. The boundaries which originally guided Bell's conception of successful criticism have now been abandoned. The eclecticism which Bell introduces touches upon, spreads itself through, not only the kinds of criticism—analytic, impressionistic, biographical, etc.—which are legitimate, but now reaches also to the reasons for which a work can be valued. Even under the doctrine of "The Critic as Guide" it would have been necessary for any type of criticism to be legitimate that it be designed to put the audience in the way of works of art as formal structures. With "The Bran-pie and Eclecticism" Bell seems to be allowing us to dredge up from the pie works which we value for reasons which are not allied with either their formal structure, or our response to that structure. This is the point at which biographical criticism, for instance, is given full status. A study of history and biography need no longer be seen as accidentally related to aesthetic value *via* their potential for cajoling an audi-

ence into a frame of mind which is receptive to formal values. History, biography, literary content in general, can now be linked directly to aesthetic value. All this goes a long way toward a theoretical justification of Bell's actual critical practice both before and after 1922.

Perhaps the best way to illustrate how I have come to understand the change in Bell's position from 1920 to 1924 is to bring back to mind questions which were raised in part I about the expression "art is significant form." I inquired as to whether this expression constitutes either a norm in criticism, or a directive for creating successful works of art. The answers offered for these questions were in the negative. An understanding of Bell's position on criticism was developed, using Isenberg's approach, which accounted for the negative answers. The approach to criticism which I developed, and applied to Bell, involves the notion of a community of feeling which is, at the same time, a community which is not based upon adherence to a precise and external standard. The notion of a community which arises from a common perception or experience, will, I believe, stand necessarily in tension with a position which attempts to characterize art—no matter how vague the characterization. It is very difficult to preserve the freedom of the members of a community to decide upon the fate of their community—to come to their own decisions within the realm of the aesthetic—if one insists at the same time that the only really viable aesthetic interaction is one within the parameters of the formal structure of the work, on the one hand, and the emotional reaction of the viewer to the work, on the other. To mitigate this tension inherent in Bell's position, I offered an interpretation of "art is significant form" which regards this expression as a declaration of hope for the creation of a community, and not as an external standard to be imposed upon a group which would then become a community as a result of the imposition.

In more general terms, the problem is one of the relation of the individual to the society. At some moments when Bell is telling us that art is significant form, he seems to be saying that there are certain standards which community members are required to meet. These standards are not to be voided in the face of individual rights. At other moments when Bell is speaking of

the nature of criticism, it would appear that the community of feeling which grows up around shared aesthetic experience is a democratic one. Every person has a right to introduce to the community that which he finds emotionally significant. The community then decides, after listening to an individual bully and cajole the members into a frame of mind receptive to his experience, whether to accept the new experience as legitimate. No community member need be told what or how to feel. It is a *community* of feeling and thus of value.

My discussion of how Bell's position might be developed overcame the tension between individual and community *via* a democratic notion of a person's role in the aesthetic situation. I called my suggestion for overcoming the tension a humanistic formalism. Clearly Bell's statements in "The Bran-pie and Eclecticism" stand in sharp contrast to the notion of humanistic formalism toward which I have pushed the doctrine in *Art.* By 1924 instead of continuing any attempt to hold together the opposition of individual and general norm, Bell opts for, or falls into, a situation in which a few individuals impose norms or values upon the rest. The idea of a democratic community of feeling has disappeared, along with the notion that there are constraints to criticism composed of the aesthetic response of the critic, and the formal structure of the work of art. Individual and group have split apart. Oligarchy has replaced democracy.

It is virtually impossible to determine whether Bell's urge to include reference to the creative process within the domain of the aesthetic contributed to his abandonment—in "Bran-pie and Eclecticism"—of the effort to hold together individual and community. We have seen how Bell believed that his position in *Art* did not allow him to speak of the creative process of the artist; after the Bran-pie Doctrine he was free in theory to do so, as he had already been doing in practice. Bell's short book *Proust* [3] is an excellent illustration. Throughout this work Bell links Proust's creative process with the structure of his writing style. Proust's work is, says Bell, as a shrimping party into the subconscious. Proust brings to light the past in the present by employing a certain form, a certain understanding of time. [4] This work is successful because Proust has fused his creative process of shrimping with a form, realizing the supreme quality of art. In

121

addition, *Proust* exhibits Bell's willingness to speak of literature as possessing significant form.[5] The Bran-pie Doctrine not only permits discussion of creativity, but also permits Bell to drop the purity doctrine of "The 'Difference' of Literature." *Proust* is further evidence that this article of 1922 is not typical of Bell's thought during this time.

Still, to introduce a discussion about the artist's creative processes did not require Bell to turn so sharply toward elitism and eclecticism as he does in the Bran-pie Doctrine. The strong emergence of these two elements has to be traced beyond his views about art into his thinking about civilization as it is developed in *Civilization*, published in 1928. Bell argues that for a society to be civilized it must be permeated through and through by the values of a leisure class of civilized persons. This elite class will be supported by the society, but it need not justify itself, nor feel any other obligation toward its supporters. In *Civilization* the group to whom Bell refers as "the cultured" civilizes a society just as he describes the process in "The Bran-pie and Eclecticism." "The cultured" have values. Through liberal education they have come to "value art and thought for their own sakes and knowledge as an instrument of culture."[6] Knowledge, or reason, operates as an instrument of culture *via* the tolerance which it promotes. A civilized person is totally tolerant. The use of reason has eliminated all taboos, prudery, superstition, false shame, and sense of sin from the civilized life. This life is thus open and highly susceptible to a wide variety of aesthetic impressions. Dredging through the pie again and again, the cultured come up with new experiences with each new effort.

Although Bell seems to have been quite serious about the nature of civilization, he never carried the Bran-pie Doctrine to its full extreme. It is a far broader theory than his critical practice requires. Perhaps Bell realized that it was, for by 1934 a new notion replaces it—the notion of enthusiastic analysis—marking a return to constraints upon criticism and a move away from the necessity of elitism:

> Enthusiastic analysis, which becomes possible only after aesthetic ecstasy, is a conversation between a work of art and an aesthete about the work of art and the aesthete. The picture is revealing itself in detail and we are trying to express why it makes us feel.
>

All the happiness that art can give is given only to those who have attained the appropriate, that is the aesthetic, mood. Only in that mood are we perfectly receptive. Further, the mood is induced only by a peculiar experience which I have attempted to indicate, and I have tried to seize it at its extreme intensity because so it is most comprehensible and most distinct. But plenty of pictures which give genuine aesthetic emotion give something less emphatic. Though but moderately charged with the gunpowder stuff, they are charged sufficiently to provoke a small explosion; and this explosion suffices to bring on the aesthetic mood.[7]

The aesthetic thrill or ecstasy of which Bell speaks seems to be the general aesthetic emotion as we found it in *Art.* It is a response to the formal significance of the painting, and we again see it taking a fundamental place in the aesthetic situation. A new dimension is the aesthetic mood which persists after the initial explosion of aesthetic emotion. Bell seems to suggest that while we are in an aesthetic mood we round out a truly successful interaction with a painting. Once the critic has brought his audience into contact with a work of art and guided them through ecstasy, *via* a consideration of the significant form of the painting, he is permitted to employ the mood which follows ecstasy to lead his audience around and through the painting as he sees fit. In the course of this activity there are two parameters which he must respect: the audience must be in the proper mood; each item to which the critic guides the audience must be one which enhances the critic's own aesthetic enjoyment of the work under consideration. The formal structure of the work, the emotional life of the audience, and the emotional life of the critic are thus seen to be elements in the aesthetic situation. In addition, biographical and historical facts may now be introduced into criticism as the critic works to extend the audience's aesthetic mood. Bell feels that there may be a scale upon which paintings can be rated from those which are quite self-contained to those which lend themselves to historical and/or biographical discussion. The following comments appear in *Enjoying Pictures:*

Here, then, it seems, we have a possible method of classification. Far be it from me to suggest that it is the only method. But it might give interesting results if amateurs would make the experiment of seeing how far their preferences amongst pictures, all admittedly works of art, depend on the quality of

123

food provided for enthusiastic analysis. It will have to be borne in mind, however, by anyone making the experiment, that whereas the grand aesthetic thrill is absolute, the pleasure-giving capacity of the content (all that is not matter of purely aesthetic detail) will be conditioned by the experimenter's private likes and dislikes, and not only by his preferences and prejudices in pictorial style and method, but by his literary and philosophical leanings, by his general taste in life.[8]

In *Enjoying Pictures* Bell comments at length upon the work of Raphael which is to be found in the Vatican. His analysis of Raphael illustrates, I believe, the high quality and quantity of "food" in Raphael's work. Bell takes pains to point out characteristics of the design of these works, analyzing with sensitivity Raphael's ability to describe human relationships using line and color alone. As Bell sees it, there is no way to translate the significance of these relationships into any non-visual language. On the other hand, when discussing *The School of Athens,* for instance, Bell pauses to mention the names of the figures in the painting and to comment upon their appearances.[9] Raphael is a master who provides a balanced diet for the palate of the aesthete. When Bell guides us through the fresco of Saint Christopher by Mantegna his analysis does not focus as much upon the formal elements of the work as upon other aspects such as the humanistic—the beauty of certain figures, the historical—the influence of Roman sculpture on Mantegna, and the entertaining—an infidel with an arrow piercing his eye.[10]

One final example of analysis, which carries us just about as far away from Raphael as we can go, is drawn from *An Account of French Painting:*

Thoroughly to appreciate a picture by Masaccio or Raphael, an acute and infinitely rare sensibility to form and color in subtlest combination is essential. Thoroughly to appreciate a Boucher, some sensibility to form and color is necessary, absolutely necessary, but that sensibility need not be of the kind that is rare. . . . [T]o fill to the brim one's capacity for enjoyment with Boucher, one needs a little culture, one should be able to situate the picture in its artistic and social circumstances. And even when you have extracted all the aesthetic and quasi-aesthetic pleasure—and it is much—that the picture can afford, still you will find room for a few additional drops, derived from your knowledge that the blunt

little body and tip-tilted frimousse which haunt Boucher's pictures . . . pertain to La petite Murphy—*La petite Morphil* the Parisians called her—whom the Pompadour stole from the painter. . . . And if you feel a little envious of the king you will still be within your rights, within the circle, I mean, of legitimate reaction to the picture.[11]

It is a long way from the formal significance of the dark, skeletal lines which suddenly began to appear in paintings late in the nineteenth century to a concern for the sex life of an artist's model, yet enthusiastic analysis allows these things—and a great many in between—to be relevant in the aesthetic situation. As I have tried to suggest, we should not be surprised at this development in Bell's thought as the seeds of it were already present in *Art*, and in Bell's early critical practice. Enthusiastic analysis allows the critic to introduce biographical as well as historical information. Much of the former will be concerned with the expression in the painting:

> Thus we can note the bridge between the model and the amateur of painting: what the model felt induced a peculiar look or movement, which look or movement made the artist feel something; what the artist felt stung him to expression; and that expression provoked aesthetic excitement in the amateur. All the bridges you perceive are purely visual. The whole transaction is carried through in the domain of visual art.[12]

This is the most straightforward statement of Bell's expressionism that I have come across. Clearly it travels hand in hand with the notion of enthusiastic analysis, and, just as clearly, it is foreshadowed in *Art*. Perhaps "foreshadowed" is too weak a word. Better to see it as a restatement of those passages where Bell explains that bad drawing is due to a lack of an emotional conception on the part of the artist.[13] Any failure in design, in the effort to produce significant form, could be a failure at this link in the expressionistic chain. For this reason I suggested that Bell could easily have included the artist within the purview of the aesthetic situation even as early as *Art*. It is no surprise that he has done so by 1934.

Now it is not at all mysterious why Bell asks in "Black and White" (1936) if Matisse has kept his eye upon the model during his work. If the painter has not done so, then we would

have, at best, decoration totally lacking any possibility of posses-
sing the significance of form. In cases of decoration, rather than
painting the forms with which he is presented the artist paints
the forms as he thinks they should look. He intellectualizes, caus-
ing the labels for objects to take the place of the objects them-
selves. This is the situation when scientific observation replaces
emotionally laden perception, and the artist loses touch with the
world which confronts him. The artist's connection with his mod-
el is one of degree. At one point we find such highly visual artists
as Raphael and Cézanne, to whom one responds with a sensitivi-
ty toward color and line. At another point (far removed) we find
the Pre-Raphaelites, whose maudlin emotionality completely ob-
scures the model. Between these extremes lies a host of painters—
Boucher is as good an example as any.

 We can see that there is no clear criterion for de-
termining whether an artist has kept his eye upon the model.
Successful expression requires that a painter touch an audience.
His inability to do so could be his fault. Or it could be the fault
of the audience, for we know that no critic—no audience mem-
ber—can be expected to appreciate all works of art. The pleas-
uregiving power of a work of art depends upon the audience's
philosophical leanings and general taste in life. In cases where
the audience remains unmoved the reason for the lack of re-
sponse cannot be located automatically and unequivocally. The
critic who is trying to mediate between a work and an unrespon-
sive audience will forever have to admit that he is caught be-
tween two possible loci—artist failure and audience failure. As
Bell says, to sustain his role the critic must have a sense of humor.
He cannot afford to be dogmatic.

 The last of the articles reproduced here is "Art Teach-
ing" (1950). Reading this article, we can see how far Bell seems
to have moved toward incorporating historical and biographical
elements into the foundations of critical practice. This attitude
stands in contrast to the dogmatic statements in *Art* which tell us
"to understand art we need know nothing whatever about histo-
ry,"[14] and which insist that significant form as the essential quali-
ty of art manifests itself across historical contexts. If one were to
go by the excerpts from *Art* which are to be found in popular
anthologies, [15] no conclusion but that Bell had undergone a radi-

cal transformation between 1913 and 1950 would be possible. We have seen that he did not. It would be fair to say that Bell moves away from much of the ivory-tower flavor which characterized *Art.* Yet, he makes this move not by abandoning any of the substantive doctrines of that book, but by combining them. Juxtaposing the eternality of significant form and the contingency of successful expression by the artist, we can formulate as a whole Bell's view of criticism as I have developed it, and his notion of enthusiastic analysis as we see it emerge in the 1930s.

NOTES

1. *Since Cézanne* (London: Chatto & Windus, 1922), p. 18.

2. "Art and Politics, I,"*Athenaeum,* 5 November 1920: 623.

3. *Proust* (New York: Harcourt, Brace & World, 1929).

4. *Ibid.,* p. 84.

5. *Ibid.,* p. 67.

6. *Civilization* (New York: Harcourt, Brace & Co., 1928), p. 98.

7. *Enjoying Pictures* (London: Chatto & Windus, 1934), pp. 31–32.

8. *Ibid.,* pp. 42–43.

9. *Ibid.,* p. 78.

10. *Ibid.,* pp. 39–40.

11. *An Account of French Painting* (London: Chatto & Windus, 1932), pp. 103–4.

12. *Enjoying Pictures,* p. 79.

13. *Art* (New York: Capricorn Books, 1958), pp. 154–55.

14. *Ibid.,* p. 73.

15. For example, see the selections from *Art* in: *Aesthetics,* ed. John Hospers (New York: The Free Press, 1969); *Art and Philosophy,* ed. W. E. Kennick (New York: St. Martin's Press, 1964); *Philosophy of Art and Aesthetics,* ed. Frank A. Tillman and Steven M. Cahn (New York: Harper & Row, 1969.

Criticism

Critics do not exist for artists any more than paleontologists exist for fossils. If both critics and artists could recognize this how much poorer the world would be in malice and rancor! To help the artist is no part of a critic's business: artists who cannot help themselves must borrow from other artists. The critic's business is to help the public. With the artist he is not directly concerned: he is concerned only with his finished products. So it is ridiculous for the artist to complain that criticism is unhelpful, and absurd for the critic to read the artist lectures with a view to improving his art. If the critic reads lectures it must be with a view to helping the public to appreciate, not the artist to create. To put the public in the way of aesthetic pleasure, that is the end for which critics exist, and to that end all means are good.

Connoisseurs in pleasure—of whom I count myself one—know that nothing is more intensely delightful than the aesthetic thrill. Now, though many are capable of tasting this pleasure, few can get it for themselves: for only those who have been born with a peculiar sensibility, and have known how to cherish it, enjoy art naturally, simply, and at first hand as most of us enjoy eating, drinking and kissing. But, fortunately, it is possible for the peculiarly sensitive, or for some of them, by infecting others with their enthusiasm, to throw these into a state of mind in which they, too, can experience the thrill of aesthetic compre-

Reprinted from the *Athenaeum*, 26 September, 1919: 953–54 by permission of the *New Statesman*, London.

hension. And the essence of good criticism is this: that, instead of merely imparting to others the opinions of the critic, it puts them in a state to appreciate the work of art itself. A man blest with peculiar sensibility, who happens also to possess this infecting power, need feel no more shame in becoming a critic than Socrates would have felt in becoming a don. The vocations are much alike. The good critic puts his pupil in the way of enjoying art, the good don or schoolmaster teaches his how to make the most of life; while bad critics and pedagogues stuff their victims with those most useless of all useless things, facts and opinions.

Primarily, a critic is a sign-post. He points to a work of art and says—"Stop! Look!" To do that he must have the sensibility that distinguishes works of art from rubbish, and, amongst works of art, the excellent from the mediocre. Further, a critic has got to convince, he has got to persuade the spectator that there is something before him that is really worth looking at. His own reaction, therefore, must be genuine and intense. Also, he must be able to stimulate an appreciative state of mind; he must, that is to say, have the art of criticism. He should be able, at a pinch, to disentangle and appraise the qualities which go to make up a masterpiece, so that he may lead a reluctant convert by partial pleasures to a sense of the whole. And, because nothing stands more obstructively between the public and the grand aesthetic ecstasies than the habit of feeling a false emotion for a pseudo-work-of-art, he must be as remorseless in exposing shams as a good schoolmaster would be in exposing charlatans and short-cuts to knowledge.

Since, in all times and places, the essence of art—the externalizing in form of something that lies at the very depths of personality—has been the same, it may seem strange, at first sight, that critical methods should have varied. One moment's reflection will suffice to remind us that there are often ten thousand paths to the same goal; and a second's may suggest that the variety in critical methods is at any rate not more suprising than the variety in the methods of artists. Always have artists been striving to convert the thrill of inspiration into significant form, never have they stuck long to any one converting-machine. Throughout the ages there has been a continual chopping and changing of "the artistic problem." Canons in criticism are as

unessential as subjects in painting. There are ends to which a variety of means are equally good: the artist's end is to create significant form; that of the critic to bring his spectator before a work of art in an alert and sympathetic frame of mind. If we can realize that Giotto, with his legends,[1] and Picasso, with his cubes,[2] are after the same thing, surely we can understand that when Vasari talks of "Truth to Nature" or "nobility of sentiment" and Mr. Roger Fry of "planes" and "relations" both are about the same business.[3]

Only a fool could suppose that the ancients were less sensitive to art than we are. Since they were capable of producing great art it seems silly to pretend that they were incapable of appreciating it. We need not be dismayed by the stories of Apelles and Polygnotus with their plums and sparrows.[4] These are merely the instruments of criticism: by such crude means did ancient critics excite the public and try to express their own subtle feelings. If anyone seriously believes that the Athenians admired the great figures on the Parthenon for their fidelity to Nature, I would invite him to take into consideration the fact that they are not faithful at all. More probably a sensitive Athenian admired them for much the same reasons as we admire them. He felt much what we feel: only, he expressed his admiration and thus provoked the admiration of others, by calling these grand, distorted, or "idealized" figures "lifelike." Reading the incomparable Vasari, one is not more struck by his sensibility and enthusiasm than by the improbability of his having liked the pictures he did like for the childish reasons he is apt to allege. Could anyone be moved by the verisimilitude of Uccello? I forget whether that is what Vasari commends: what I am sure of is that he was moved by the same beauties that move us.[5]

The fact is, it matters hardly at all what words the critic employs provided they have the power of infecting his audience with his genuine enthusiasm for an authentic work of art. No one can state in words just what he feels about a work of art—especially about a work of visual art. He may exclaim; indeed, if he be a critic he should exclaim, for that is how he arrests the public. He may go on to seek some rough equivalent in words for his excited feelings. But whatever he may say will amount to little more than steam let off. He cannot describe his feelings, he

can only make it clear that he has them. That is why analytical criticism of painting and music is always beside the mark: neither, I think, is analytical criticism of literary art more profitable. With literature that is not pure art the case is different, facts and ideas being, of course, the analyst's natural prey. But before a work of art the critic can do little more than jump for joy. And that is all he need do if, like Cherubino, he is "good at jumping.[6] The warmth and truth of Vasari's sentiment comes straight through all his nonsense. Because he really felt he can still arrest.

Take an artist who has always been popular, and see what the ages have had to say about him. For more than two hundred and fifty years Poussin has been admired by most of those who have been born sensitive to the visual arts.[7] No pretexts could be more diverse than those alleged by these admirers. Yet it would be as perverse to suppose that they have all liked him for totally different reasons as to maintain that all those who, since the middle of the seventeenth century, have relished strawberries have tasted different flavors. What is more, when I read, say, the fantastic discourses on the pictures of Poussin delivered by the Academicians of 1667, I feel certain that some of these erudite old gentlemen had, in fact, much the same sort of enthusiasm, stirred by the monumental qualities of his design and the sober glory of his colors, that I have myself. Through all the dry dust of their pedantry the accent of aesthetic sensibility rings clear.[8]

Poussin's contemporaries praised him chiefly as a preceptor, an inculcator of historical truths, more especially the truths of classical and Hebrew history. That is why Phillipe de Champaigne deplores the fact that in his "Rebecca"[9] "*Poussin n'ait pas traité le sujet de son tableau avec toute la fidélité de l'histoire, parce qu'il a retranché la représentation de chameaux, dont l'Ecriture fait mention.*"[10] But Le Brun, approaching the question from a different angle, comes heavily down on his scrupulous colleague with the rejoinder that "*M. Poussin a rejeté les objets bizarres qui pouvaient débaucher l'oeil du spectateur et l'amuser à des minuties.*" [11] The philosophic eighteenth century remarked with approval that Poussin was the exponent of a wholesome doctrine calculated to advance the happiness of mankind. But to the fervid pages of Diderot, wherein that tender enthusiast extols Poussin to the skies, asserting that one finds in his work "*le charme de la nature avec les incidents*

ou les plus doux ou les plus terribles de la vie,"[12] our modern sensibility
makes no response. And we are right. The whole panegyric rings
hollow. For to visual art Diderot had no reaction, as every line he
wrote on the subject shows.

That devout critic who, in the reign of the respectable
Louis-Phillipe, discovered that *"Nicolas Poussin était doué d'une foi
profonde: la piété fut son seul refuge"* is in the same boat.[13] And for
companion they have Mr. Ruskin, who, being, like them, incapa-
ble of a genuine aesthetic emotion, is likewise incapable of infect-
ing a truly sensitive reader. So far as I remember, Ruskin's
quarrel with Poussin is that to his picture of the *Flood* he has
given a prevailing air of sobriety and gloom, whereas it is notori-
ous that an abundance of rain causes all green things to flourish
and the rocks to shine like agate.[14] But when Ingres attributes the
excellence of Poussin to the fact that he was a faithful disciple of
the ancients we feel that he is talking about the thing that mat-
ters, and that he is talking sense. And we feel the same—what
instance could more prettily illustrate my theory?—when Dela-
croix passionately asserts that Poussin was an arch-revolution-
ary.[15]

The divergence between the pretexts alleged by our
ancestors for their enthusiasm and the reasons given by us, mod-
erns, is easily explained by our intense self-consciousness. We are
deeply interested in our own states of mind: we are all psycholo-
gists. From psychology springs the modern interest in aesthetics,
those who care for art and the processes of their own minds find-
ing themselves aestheticians willy-nilly. Now art-criticism and
aesthetics are two things, though at the present moment the for-
mer is profoundly influenced by the latter. By works of art we are
thrown into an extraordinary state of mind, and, unlike our fore-
fathers, we want to give some exacter account of that state than
that it is pleasant, and of the objects that provoke it some more
accurate and precise description than that they are lifelike, or
poetical, or beautiful even. We expect our critics to find some
plausible cause for so considerable an effect. We ask too much. It
is for the aesthetician to analyze a state of mind and account for
it: the critic has only to bring into sympathetic contact the object
that will provoke the emotion and the mind that can experience
it. Therefore, all that is required of him is that he should have

sensibility, conviction, and the art of making his conviction felt. Fine sensibility he must have. He must be able to spot good works of art. No amount of eloquence in the critic can give form significance. To create that is the artist's business. It is for the critic to put the public in the way of enjoying it.

NOTES

1. Virtually every one of Giotto's (1276?–1337) works is based upon a Biblical theme; hence Bell's reference to legends.

2. Picasso gave birth to cubism in 1906/7 with the painting of *Les Demoiselles d'Avignon*. He continued to produce cubist works into the early 1920s.

3. Georgio Vasari (1511–74) was critic as well as biographer of artists. Although both Vasari and the English critic Roger Fry (1866–1934) desired to create sympathy for art among their audiences, it is by no means clear that they would have agreed about much else. In the introduction to part 2 of *Lives of the Artists*, Vasari says that he prefers Giotto to the Byzantine mosaics at Ravenna because Giotto's work imitates nature. We have seen that Bell admires Giotto just to the extent that Giotto's work is similar to the Ravenna mosaics. Fry's discussion of aesthetics in *Vision and Design* indicates that he would side with Bell on this point.

4. I have been unable to locate the exact plum-and-sparrow story to which Bell seems to refer here. It is possible that he intended a reference to the Greek painter Zeuxis (420–390 B.C.), whose rendering of grapes was reportedly so lifelike that the birds flew at it to pluck the fruit. Both Polygnotus (mid-5th century, B.C.) and Apelles (second half of the 4th century, B.C.) were known for the lifelike quality of their work. Pliny (*Natural History*, XXXV. 79–97) tells several stories of Apelles' ability as an artist, each emphasizing the verisimilitude of his paintings. Pausanias (*Description of Greece*, X. 25–31) does the same for Polygnotus. Bell's point is that even in cases where adherence to life seems to be the critic's criterion, other considerations are actually operating.

5. Vasari comments that Paolo Uccello (1397–1475) spent too much time perfecting the fine points of perspective while failing to devote sufficient attention to the drawing of men and animals. Uccello's ability

at perspective may be what Bell refers to in his comment about verisimilitude. Yet, Vasari complains about Uccello's fresco of the Holy Fathers in San Mineato because the "fields were blue, cities red and buildings variously tinted."

6. Cherubino is the page in Mozart's *The Marriage of Figaro*, who jumps from the window of the Countess's room to the garden below, in order to avoid discovery by the Count (act 2).

7. Nicholas Poussin (1593/4–1665) is regarded as the founder of French classical painting. Reproductions of all the Poussin paintings which Bell mentions may be found in *The Paintings of Nicolas Poussin* by Anthony Blunt (London: Phaidon Press, 1966).

8. As Bell tells us in a footnote, the history of Poussin criticism which is given in the next three paragraphs comes from *Poussin* by Paul Desjardins, published in Paris by Librairie Renouard. Bell draws primarily on pages 12–19. The Academicians of 1667 to whom Desjardins refers are members of the French Academy of Painting and Sculpture founded by the French painter Charles LeBrun (1619–90) in the 1650s. In 1667 a conference took place at the Academy—then located in the Louvre— on the work of Poussin. The participants were LeBrun himself, Sebastien Bourdon (1616–71), one of the original members of the academy, and a painter, André de Félibien (1619–95), architect, historian and critic, and Phillippe de Champaigne (1602–74), the Flemish portrait painter. The proceedings of the conference were published by Jouin of Paris under the title of *Conférences*. The quotations which Bell gives from Champaigne and from LeBrun are taken from this publication. Champaigne and the others were critical of Poussin for his lack of historical fidelity. LeBrun opposed this line of criticism on the ground that total historical fidelity would force the artist to include in his work so much detail that its aesthetic power would be lost.

9. *Elizer and Rebecca* is in the Louvre.

10. "Poussin has not treated the subject of the painting with total historical fidelity, because he failed to represent the camels which are mentioned in the Scriptures."

11. "Poussin rejected the bizarre objects which would distract the eye of the spectator, and which would amuse the spectator with trivialities."

12. In tracing the history of Poussin criticism, Desjardins reports that by 1699 with the publication of Roger de Piles's (1635–1709) *Abregé de la vie des peintres* Poussin's reputation had declined. De Piles found his work too calculated, too subdued—even cold—emotionally. By the time

Bell again picks up the history, Poussin is on the rise with Denis Diderot (1713–84)—taken as an example of the philosophic 18th century—who praises Poussin's *Serpent* as a very emotional work embodying "the charm of nature together with the sweetest, or the most terrible, incidents of life." This quotation is from Diderot's *Salon* 1767.

13. The critic in question here is Albert Jules Jacquemart (1808–75). The quotation—"Nicolas Poussin had a deep faith; piety was his only refuge"—is from Jacquemart's preface to a folio of engravings (done by Texier of Paris, 1843) of Poussin's *Sept Sacrements*. Bell indicates that an understanding of Poussin in quasi-religious terms might have been natural during the reign (1830–48) of a King who was so bourgeois; but, ultimately, it is no more successful than understanding Poussin as a historian.

14. Poussin's *Flood* (also known as *Winter*) was painted between 1660 and 1664. The English critic John Ruskin (1819–1900) makes these comments in criticism of it in *Modern Painters* (Everyman ed., 1907), 4:237.

15. The comments by the two French painters Jean Auguste Dominique Ingres (1780–1867) and Eugène Delacroix (1798–1863) illustrate Bell's theory in that, although appearing opposed to each other, taken together they indicate that at the time of Poussin the truly revolutionary painter had to rediscover painting by turning to the past. Bell feels that the same thing happened with Cézanne, who revolutionized painting and rediscovered the past at the same time. Ingres's comments were found among his papers after his death, Desjardins tells us. Delacroix wrote a three-part article—"Essai sur la Poussin"—which appeared in *Moniteur* on June 26 and 29, and July 1 of 1853. Following Desjardins (p. 19), the quotation upon which Bell draws runs:

> It has been said so often that he [Poussin] is the most classical of painters that it would, perhaps, be a surprise to see him treated in this essay as one of the boldest innovators in the history of painting. Poussin appeared at the height of the mannerist schools which preferred technique to the intellectual dimension of art. He has broken away from all that error. . . .

De Gustibus

It is becoming fashionable to take criticism seriously or, more exactly, serious critics are trying to make it so. How far they have succeed may be measured by the fact that we are no longer ashamed to reprint our reviews; how far they are justified is another question. It is one the answer to which must depend a good deal on our answer to that old and irritating query—is beauty absolute? For, if the function of a critic be merely to perform the office of a sign-post, pointing out what he personally likes and stimulating for that as much enthusiasm as possible, his task is clearly something less priestlike than it would be if, beauty being absolute, it were his to win for absolute beauty adequate appreciation.

I do not disbelieve in absolute beauty any more than I disbelieve in absolute truth. On the contrary, I gladly suppose that the proposition—this object must be either beautiful or not beautiful—is absolutely true. Only, can we recognize it? Certainly at moments we believe that we now can. We believe it when we are taken unawares and bowled over by the purely aesthetic qualities of a work of art. The purely aesthetic qualities, I say, because we can be thrown into that extraordinarily lucid and unself-conscious transport wherein we are aware only of a work of art and our reaction to it by aesthetic qualities alone. Every now and then the beauty, the bald miracle, the "significant form"—if I may venture the phrase—of a picture, a poem or a piece of music—of something, perhaps with which we had long

Reprinted from the *New Republic*, New York, 18 May 1921: 343–44.

believed ourselves familiar—springs from an unexpected quarter and lays us flat. We were not on the look-out for that sort of thing and we abandon ourselves without one meretricious gesture of welcome. What we feel has nothing to do with a pre-existent mood; we are transported into a world washed clean of all past experience aesthetic or sentimental. When we have picked ourselves up we begin to suppose that such a state of mind must have been caused by something of which the significance was inherent and the value absolute. "This," we say, "is absolute beauty." Perhaps it is. Only, let us hesitate to give that rather alarming style to anything that has moved us less rapturously or less spontaneously.

For ninety-nine out of a hundred of our aesthetic experiences have been carefully prepared. Art rarely catches us: we go half way to meet it, we hunt it down even with a pack of critics. In our chastest moments we enter a concert-hall or gallery with the deliberate intention of being moved; in our most abandoned we pick up Browning or Alfred de Musset and allow our egotism to bask in their oblique beauty.[1] Now when we come to art with a mood of which we expect it to make something brilliant or touching there can be no question of being possessed by absolute beauty. The emotion that we obtain is thrilling enough, and exquisite may be; but it is self-conscious and reminiscent: it is conditioned. It is conditioned by our mood: what is more—critics please take note—this precedent mood, not only colors and conditions our experience, but draws us inevitably towards those works of art in which it scents sympathy and approval. To a reflective moralist Wordsworth will always mean more than a yellow primrose meant to Peter Bell.[2] In our moments of bitter disillusionment it is such a comfort to jest with Pope and His Lordship that we lose all patience with the advanced politician who prefers Blake.[3] And, behold we are in a world of personal predilections, a thousand miles from absolute values.

Discussion of this question is complicated by the fact that a belief in the absolute nature of beauty is generally considered meritorious. It can be hitched onto, and even made to support, a disbelief in the theory that the universe is a whimsical and unpremeditated adventure which rolls merrily down the road to ruin without knowing in the least where it is going or caring to go

139

anywhere in particular. This theory is unpopular. Wherefore, absolute beauty is too often fitted into a whole system of absolutes, or rather into The Absolute; and of course it would be intolerable to suppose that we could ever fail to recognize—should I say Him? Unluckily, history and personal experience—those two black beasts of a priori idealists—here await us. If beauty be absolute, the past was sometimes insensitive, or we are: for the past failed to recognize the beauty of much that seems to us supremely beautiful, and sincerely admired much that to us seems trash. And we, ourselves, did we never despise what today we adore? Murillo and Salvator Rosa and forgers of works by both enjoyed for years the passionate admiration of the cognoscenti.[4] In Dr. Johnson's time "no composition in our language had been oftener perused than Pomfret's 'Choice'."[5] If ever there was a man who should have been incapable of going wrong about poetry that man was Thomas Gray. How shall we explain his enthusiasm for Macpherson's fraud?[6] And if there be another of whom the bowling over might be taken as conclusive evidence in the court of literary appeal that other is surely Coleridge. Hark to him: "My earliest acquaintances will not have forgotten the undisciplined eagerness and impetuous zeal, with which I labored to make proselytes, not only of my companions, but of all with whom I conversed, of whatever rank, and in whatever place. . . . And with almost equal delight did I receive the three or four following publications of the same author." That author was the Reverend Mr. Bowles.[7]

I was saying that any work of art that has given the authentic thrill to a man of real sensibility must have an absolute and inherent value. And, of course, we all are really sensitive. Only, it is sometimes difficult to be sure that our thrill was the real *coup de foudre* and not the mere gratification of a personal appetite. Let us admit so much: let us admit that we do sometimes mistake what happens to suit us for what is absolutely and universally good; which once admitted, it will be easy to concede further that no one can hope to recognize all manifestations of beauty. History is adamant against any other conclusion. No one can quite escape his age, his civilization, and his peculiar disposition; from which it seems to follow that not even the unanimous censure of generations can utterly discredit anything. The admis-

sion comes in the nick of time: history was on the point of calling
attention to the attitude of the seventeenth and eighteenth centu-
ries to Gothic, Romanesque and Byzantine art.

The fact is, most of our enthusiasms and antipathies
are the bastard offspring of a pure aesthetic sense and a perma-
nent disposition or transitory mood. The best of us start with a
temperament and a point of view, the worst with a cut-and-dried
theory of life; and for the artist who can flatter and intensify
these we have a singular kindness, while to him who appears
indifferent or hostile it is hard to be even just. What is more,
those who are most sensitive to art are apt to be most sensitive to
these wretched, irrelevant implications. They pry so deeply into
a work that they cannot help sometimes spying on the author
behind it. And remember, though rightly we set high and apart
that supreme rapture in which we are carried to a world of im-
personal and disinterested admiration, our aesthetic experience
would be small indeed were it confined to this. More often than
not, it must be of works that have moved him partly by matching
a mood that the best of critics writes. More often than not he is
disentangling and exhibiting qualities of which all he can truly
say is that they have proved comfortable or exhilirating to a
particular person at a particular moment. He is dealing with
matters of taste; and about tastes, you know, *non est disputandum.*

I shall not pretend that when I call the poetry of Mil-
ton good I suppose my judgement to have no more validity than
what may be claimed for that of the urchin who says the same of
peppermints: but I do think a critic should cultivate a sense of
humor.[8] If he be very sure that his enthusiasm is the only appro-
priate response of a perfectly disinterested sensibility to absolute
beauty let him be as dogmatic as is compatible with good breed-
ing: failing that, I counsel as great a measure of modesty as may
be compatible with the literary character. Let him remember
that, as a rule, he is not demanding homage for what he knows to
be absolutely good but pointing to what he likes and trying to
explain why he likes it. That to my mind, is the chief function of
a critic. An unerring eye for masterpieces is of more use to a
dealer than to him. Mistakes do not matter: if we are to call
mistakes what are perhaps no more than the records of a perverse
or obscure mood. Was it a mistake in 1890 to rave about Wag-

ner?[9] Is it a mistake to find him intolerable now? Frankly, I suspect the man or woman of the nineties who was unmoved by Wagner of having wanted sensibility, and him or her who today revels in that music of being aesthetically oversexed. Be that as it may, never to pretend to like what bores or dislike what pleases him, to be honest in his reactions and exact in their description is all I ask of a critic. It is asking a good deal it seems to me. To a lady who protested that she knew what she liked, Whistler is said to have replied—"So, Madame, do the beasts of the field."[10] Do they? Then all I can say is, the beasts of the field are more highly developed than most of the ladies and gentlemen who write about art in the papers.

NOTES

1. Bell's use of "oblique beauty" in connection with the poets Robert Browning (1812–89) and Alfred de Musset (1810–57) probably refers to the quality in their work which seems suddenly to give us a flash insight into the character of the poet and then just as quickly to hide it again.

2. *"Peter Bell"* is a poem by William Wordsworth (1770–1850) written in 1798. The reference to a yellow primrose occurs in the first part of the poem, in the course of illustrating what an insensitive fellow Peter was.

3. The jesting of which Bell speaks is in the correspondence between Alexander Pope (1688–1744), Lord Bolingbroke (1678–1751), and Jonathan Swift (1667–1745). In his essay "Pope" Leslie Stephen describes the correspondence as a look behind the scenes in Vanity Fair characterized by high comedy with a dash of satire and of tragedy. Bell sees the conversations of these urbane men as in sharp contrast to the earnest seriousness of a follower of the English mystic William Blake (1757–1827). Blake saw political alterations—especially revolutions—as acts of self-realization through which a body politic passes. His works *Europe, America,* and *The French Revolution* embody this theme.

4. The works of both the Spaniard Bartolome Murillo (1617–82) and the Italian Salvatore Rosa (1615–73) were popular in England in the late 18th, and throughout the 19th centuries. Murillo was a great colorist; Rosa created fantastic, romantic landscapes.

5. English poet John Pomfret (1667–1703) wrote his most popular poem, *The Choice,* in 1700. Samuel Johnson (1709–84) made the quoted comment in his life of Pomfret (*Lives of the English Poets,* vol. 1).

6. In December 1761 James Macpherson (1736–96) published *Fingal,* poems which he supposedly had collected on trips to the Highlands, then translated from Gaelic, and arranged. Many of them were attri-

buted to Ossian, a 3rd-century Highland poet. Thomas Gray (1716-71), the English poet, was convinced that the poems were truly of ancient origin, although from the first there was some doubt. After Macpherson published a second book of poems, *Temora*, in 1763, Samuel Johnson attacked him as a fraud, in *Journey to the Western Islands of Scotland* (1775). The controversy raged throughout the 1770s.

7. Samuel Taylor Coleridge (1772–1834) speaks of William Lisle Bowles's (1762–1850) influence upon himself in the first chapter of his *Biographia Literaria* (1817), which Bell quotes here. Bowles's sonnets came into Coleridge's hand when the latter was only seventeen. At that early age Coleridge felt that Bowles was one of the "first who combined natural thoughts with natural diction . . ." (London: Dent, Everyman Library, 1939, p. 7). Maturity altered this impression.

8. This judgment of the work of the poet John Milton (1608–74) has considerable critical weight behind it when one stops to consider that Milton was held second only to Shakespeare by mid-Victorian critics such as Leslie Stephen. Bell's point is also that no matter how secure an aesthetic judgment appears to be, we must stand ready to revise it.

9. Between 1885 and 1895 a wave of Wagnermania swept Paris. Without any effort actually to penetrate Wagner's music, people such as Edouard Dujardin in the *Revue Wagnérienne* developed the "philosophical significance" of Wagner. Teodor de Wyzewa and Stephane Mallarmé developed symbolist theory in Wagnerian terms, e.g., Mallarmé's essay on Wagner in *Revue Wagnérienne,* vol. 1, no. 7, August 8, 1885. Painters such as Odilon Redon produced lithographs of scenes from Wagner's works.

10. Even before the publication of *The Gentle Art of Making Enemies* (1890), James McNeill Whistler (1834–1903) had a reputation as an outspoken, even insulting character. His most famous attack was on the critic John Ruskin, at that time (1878) the leader of taste in England, when he sued for slander and libel because of Ruskin's harsh critical comments. Whistler won the case, but lost much money in pursuing it.

The Critic as Guide

Already I am in a scrape with the critics. I am in a
scrape for having said, a couple of years ago, that a critic was
nothing but a sign-post, and for having added, somewhat later,
that he was a fallible sign-post at that. So now, contributing to a
supplement which, being written by critics is sure to be read by
them, I naturally take the opportunity of explaining that what I
said, if rightly understood, was perfectly civil and obliging.

[Perhaps I shall stand a better chance of pardon when
it is perceived that I, too, am fallible, and, what is more, that I
am quite aware of the fact. The reader can see for himself that,
from first thoughts to last—in three years, that is—not only have
my opinions on the art of criticism been modified, but my critical
opinions have themselves become less confident.][1] To recall what
I did say: I said that critics exist for the public, and that it is no
part of their business to help artists with good advice. I argued
that a critic no more exists for artists than a paleontologist does
for the Dinosaurs on whose fossils he expatiates, and that, though
artists happen to create those exciting objects which are the mat-
ter of a critic's discourse, that discourse is all for the benefit of the
critic's readers. For these, I said he is to procure aesthetic pleas-
ures: and his existence is made necessary by the curious fact that,
though works of art are charged with a power of provoking ex-
traordinarily intense and desirable emotions, the most sensitive
people are often incapable of experiencing them until a jog or a
drop of stimulant even has been given to their appreciative facul-

Reprinted from the *New Republic*, New York, 26 October 1921: 259–61.

ties. A critic should be a guide and an animator. His it is, first to bring his reader into the presence of what he believes to be art, then to cajole or bully him into a receptive frame of mind. He must, therefore, besides conviction, possess a power of persuasion and stimulation: and if anyone imagines that these are common or contemptible gifts, he mistakes. It would, of course, be much nicer to think that the essential part of a critic's work was the discovery and glorification of Absolute Beauty; only, unluckily it is far from certain that absolute beauty exists, and most unlikely, if it does, that any human being can distinguish it from what is relative. The wiser course, therefore, is to ask of critics no more than sincerity, and to leave divine certitude to superior beings— magistrates, for instance, and curates, and fathers of large families, and Mr. Bernard Shaw.[2] At any rate, it is imprudent, I am sure, in us critics to maintain so stoutly as we are apt to do, that when we call a work of art "good" we do not mean simply that we like it with passion and conviction but that it is absolutely so, seeing that the most sensitive people of one age have ever extolled some things which the most sensitive people of another have cried down, and have cried down what others have extolled. And, indeed, I will bet whatever my contribution may be worth that there is not a single contributor to this supplement who would not flatly contradict a vast number of those aesthetic judgements which have been pronounced with equal confidence by the most illustrious of his predecessors. No critic can be sure that what he likes has absolute value; and it is a mark of mere silliness to suppose that what he dislikes can have no value at all. Neither is there any need of certainty. A critic must have sincerity and conviction—he must be convinced of the genuineness of his own feelings. Never may he pretend to feel more or less or something other than what he does feel; and what he feels he should be able to express and even, to some extent, account for. Finally he must have the power of infecting others with his own enthusiasm. Anyone who possesses these qualities and can do these things I call a good critic. "And what about discrimination?" says someone, "What about the very meaning of the word?" Certainly discrimination between artists, between the parts and qualities of a work of art, and between one's own reactions, are important instruments of criticism; but they are not the

146

only ones, nor I believe are they indispensable. At any rate, if the proper end of criticism be the fullest appreciation of art, if the function of a critic be the stimulation of the reader's power of comprehending and enjoying, all means to that end must be good. The rest of this essay will be devoted to a consideration of the means most commonly employed.

Discriminating critics, as opposed to those other two great classes—The Impressionistic and The Biographical—are peculiar in this amongst other things: they alone extract light from refuse and deal profitably with bad art: I am not going back on my axiom—The proper end of criticism is appreciation: but I must observe that one means of stimulating a taste for what is most excellent is an elaborate dissection of what is not. I remember walking with an eminent contributor to the *New Republic* and a lady who admired so intemperately the writings of Rupert Brooke that our companion was at last provoked into analyzing them with magisterial severity. He concluded by observing that a comparison of the more airy and fantastic productions of this gallant young author with the poems of Andrew Marvell would have the instant effect of putting the former in their place[3]. The lady took the hint; and has since confessed that never before had she so clearly seen or thoroughly enjoyed the peculiar beauties, the sweetness, the artful simplicity and sly whimsicality of the most enchanting of English poets. The discriminating critic is not afraid of classifying artists and putting them in their places. Analysis is one of his most precious instruments. He will pose the question—"Why is Milton a great poet?"—and will proceed to disengage certain definite qualities, the existence of which can be proved by demonstration and handled objectively with almost scientific precision. This sort of criticism was brought to perfection in the eighteenth century; and certainly it did sometimes lead critics quite out of sight and reach of the living spirit of poetry. It was responsible for masses of amazing obtuseness (especially in criticism of the visual arts); it was the frequent cause of downright silliness; it made it possible for Dr. Johnson, commenting on the line "Time and the hour runs through the roughest day," to "suppose every reader is disgusted at the tautology": but it performed the immense service of stimulating enthusiasm for clear thought and exact expression.[4] These discriminating

and objective critics will always be particularly useful to those whose intellects dominate their emotions, and who need some sort of intellectual jolt to set their aesthetic sensibilities going. Happily, the race shows no signs of becoming extinct, and Sir Walter Raleigh and M. Lanson are the by no means unworthy successors of Dr. Johnson and Saint-Évremond.[5]

It is inexact to say that the nineteenth century invented impressionist criticism; but it was in the later years of that century that impressionism became self-conscious and pompous enough to array itself in a theory. The method everyone knows: the critic clears his mind of general ideas, of canons of art, and, so far as possible, of all knowledge of good and evil; he gets what emotions he can from the work before him, and then confides them to the public. He does not attempt to criticize in the literal sense of the word; he merely tells us what a book, a picture or a piece of music made him feel. This method can be intensely exciting; what is more, it has made vast additions to our aesthetic experience. It is the instrument that goes deepest: sometimes it goes too deep, passes clean through the object of contemplation, and brings up from the writer's own consciousness something for which in the work itself no answerable provocation is to be found. This leads, of course, to disappointment and vexation, or else to common dishonesty, and can add nothing to the reader's appreciation. On the other hand, there are in some works of art subtleties and adumbrations hardly to be disentangled by any other means. In much of the best modern poetry— since Dante and Chaucer I mean—there are beauties which would rarely have been apprehended had not someone, throwing the whole apparatus of objective criticism aside, vividly described, not the beauties themselves, but what they made him feel. And I will go so far as to admit that, in a work of art, there may be qualities significant and precious but so recondite and elusive that we shall hardly grasp them unless some adventurer, guided by his own experience, can trace their progress and show us their roots in the mind from which they sprang.

Impressionistic criticism of literature is not much approved nowadays, though Mr. Arthur Symons[6] and one or two of his contemporaries still preserve it from the last outrages of a new and possible less subtle generation, while M. Proust, by using it

to fine effect in his extraordinary masterpiece may even bring it again into fashion.[7] But it has got a bad name by keeping low company; for it has come to be associated with those journalistic reviewers who describe, not the feelings and ideas provoked in them by reading a book, but what they thought and felt and did at or about the time they were supposed to be reading it. These are the chatterboxes who will tell you how they got up, cut themselves shaving, ate sausages, spilt the tea, and nearly missed the train in which they began to read the latest work of Benedetto Croce which, unluckily, having got into a conversation with a pretty typist or a humorous bagman, they quite forgot, left in the carriage, and so can tell you no more about. But this is not impressionism, it is mere vulgarity.[8]

If in literary criticism the impressionist method is falling into disfavor, in the criticism of music and painting it holds the field. Nor is this surprising: to write objectively about a symphony or a picture, to seize its peculiar intrinsic qualities and describe them exactly in words, is a feat beyond the power of most. Wherefore, as a rule, the unfortunate critic must either discourse on history, archaeology and psychology, or chatter about his own feelings. With the exception of Mr. Roger Fry,[9] there is not in England one critic capable of saying so much, to the purpose, about the intrinsic qualities of a work of visual art as half a dozen or more—Sir Walter Raleigh, Mr. Murry, Mr. Squire, and Mr. MacCarthy to begin with—can be trusted to say easily, and if necessary, weekly, about the intrinsic qualities of a book.[10] To be sure, Mr. Fry is a great exception: with my own ears I have heard him take two or three normally intelligent people through a gallery and by severely objective means provoke in them a perfect frenzy of enthusiasm for masterpieces of utterly different schools and ages. Doubtless that is what art-criticism should be; but perhaps it is wrong to despise utterly those who achieve something less.

Just at present it is the thing to laugh at biographical and historical critics, a class of which Sainte-Beuve is the obvious representative, and to which belong such writers as Taine and Francesco de Sanctis and all who try to explain works of art by describing their social and political circumstances.[11] "At any rate," it is said, "these are not critics." I shall not quarrel over

149

words; but I am persuaded that, when they care genuinely for books and have a gift of exposition, these perform the same function as their more aesthetically-minded brethren. I am sure that a causerie by Sainte-Beuve often sends a reader, with a zest he had never found unaided, to a book he had never opened unadvised. There are plenty of men and women, equipped to relish the finest and subtlest things in literature, who can hardly come at a book save through its author, or at an author save through the story of his life and picture of his surroundings; wherefore few things do more to promote and disseminate a taste for art and letters and, I will add, for all things of the spirit, than biographical and historical criticism and the discussion of tendencies and ideas.

And this brings me to my conclusion. Though the immediate object of criticism is to put readers in the way of appreciating fully a work or works in the merit of which the critic believes, its ultimate value lies further afield in more general effects. Good criticism not only puts people in the way of appreciating particular works; it makes them feel, it makes them remember, what intense and surprising pleasures are peculiar to the life of the spirit. For these it creates an appetite, and keeps that appetite sharp: and I would seriously advise anyone who complains that his taste for reading has deserted him to take a dip into the great critics and biographers and see whether they will not send him back to his books. For, though books, pictures and music stand charged with a mysterious power of delighting and exciting and enhancing the value of life; though they are the keys that unlock the door to the world of the spirit—the world that is best worth living in—; busy men and women soon forget. It is for critics to be ever jogging their memories. Theirs it is to point the road and hold open the unlocked doors. In that way they become officers in the kingdom of the spirit or, to use a humbler and preferable term, essential instruments of culture.

NOTES

1. The bracketed sentences were added when the essay was reprinted in *Since Cézanne.*

2. English playwright George Bernard Shaw (1856–1950) was well known for his willingness to make pronouncements upon any topic whatsoever.

3. The obvious implication is that the poems of Rupert Brooke (1887–1915) are lightweight compared to Marvell's (1621–78) meta-physical poetry. We must not overlook the fact that the woman in question may have been as much enamored of Brooke's image as a charming, sensitive, young man—and with his tragic death on Skiros— as of his poetry. Bell's point is that a discriminating critic can instruct *via* negative comments.

4. The line about time and hour is from *Macbeth*, act 1, sc. 3. For Johnson's discussion of it see "Johnson on Shakespeare," vol. 8, Yale Edition of his works.

5. Dr. Johnson, Walter Alexander Raleigh (1861–1922), and French writers Seigneur de Saint-Évremond (1610–1703) and Gustave Lanson (1857–1934) are discriminating critics. Johnson jolts our intellect into a receptiveness for art by using logic. Saint-Évremond, followed by Ra-leigh and Lanson, draws us into literature intellectually by building judgments, and perceptions, upon biographical and historical informa-tion. Impressionistic criticism does not appeal to the intellect at all, while biographical and historical critics report without drawing us into aesthetic judgment.

6. Arthur Symons's (1865–1945) study of the French poet Charles Baudelaire is an excellent example of the kind of criticism which Bell calls impressionistic. Symons is interested in the sentiment which Baudelaire's poetry conveys, and in interpreting Baudelaire's life in terms of that sentiment.

7. Bell here refers to Marcel Proust's (1871–1922) *Remembrance of Things Past*. In his book on Proust, Bell speaks of the author's ability to fuse his impressions into a form, so as to create good literature.

8. Benedetto Croce's (1866–1952) best known work, *Aesthetics as Science of Expression and General Linguistic* (1902), was first translated into English in 1909. Croce's idea that the work of art is a completed object while still in the mind of the artist is not compatible with Bell's views on creativity. If the critic in question were reading the latest Croce, it might have been either *La poesia di Dante* or *Storia della storiografia italiana nel sec XIX,* both published in 1921.

9. As Bell notes, he had ample opportunity to *hear* Roger Fry's (1866–1934) criticism. They were close friends, members of the Bloomsbury Group, and they agreed upon many issues in aesthetics. A certain strain had appeared in their relationship by 1926—see letter 585 in *The Letters of Roger Fry* by Denys Sutton (London: Chatto & Windus, 1972). We may *read* the kind of writing which the public had received from Fry in 1921 in *Vision and Design,* containing Fry's early theoretical statement, "An Essay in Aesthetics," as well as writings on such artists as Giotto and El Greco.

10. Literary critics John Middleton Murry (1889–1957), John Squire (1884–1958), and Desmond MacCarthy (1877–1952) contributed at one time or another to such magazines as *Athenaeum, New Statesman and Nation,* and *Saturday Review.* MacCarthy was a close friend of Bell, and a member of the Bloomsbury Group.

11. The three historical critics Charles Augustin Sainte-Beuve (1804–69), Hippolyte Taine (1828–93), and Francesco de Sanctis (1817–83) would agree that literature could not be understood apart from its historical context, although each of them has a different reason for saying so. De Sanctis's criticism sprang from the influence of, and his reaction against, German idealism. Taine's criticism has a naturalistic basis in his belief in determinism, and in the notion that there are fundamental principles governing both natural and moral matters. Sainte-Beuve's criticism rests upon an atomistic approach, suspicious of generalizations which put too much order in history, and demanding truth to the complexity from which literature springs. Bell employs historical criticism himself in *Landmarks in Nineteenth-Century Painting* (1927) and in *An Account of French Painting* (1931).

The "Difference" of Literature

I gather from reviews of my last book[1]—especially from American reviews which are on the whole much better than English—that it is the general opinion that I am settling down. This opinion I would encourage: and so I am a little out of humor with the Chicago *Evening Post* (July 7, 1922) for having raised a question on which I cannot be silent, and my views on which have already got me into the hottest water culture can brew.

> [Mr. Bell's theory of "significant form"] was a good theory in one way [says my critic.] It enabled him to accept cubistic and futuristic pictures. [Incidentally, Mr. Bell never did accept the Italian futurists, and always laughed at their theories, while admitting that theories don't matter a straw one way or the other.] But it was a bad theory for this reason—literature, even lyrical poetry, can never be pure form, purged from all recognition of objects.

If, then, pure form was the essential characteristic of pure art, literature was not pure. This, in the opinion of the Chicago *Evening Post*, "was rather tough on us people who get more from literature than from painting." Was it? For the life of me, I can't see why.

The *Post*, I think, must find some special virtue in the word "pure"; for my part I grow to attach less and less importance to it as I become more and more uncertain what it means. All I am sure of is that literature is an art altogether different

Reprinted from the *New Republic*, New York, 29 November 1922: 18–19.

from the arts of painting and music, and that to appreciate it a man need not possess that peculiar sense of abstract form—"pure form," if you will—without which he can get little or nothing from the other two. I am not going to argue; I am going only to record my own experience, which will be found, I fancy, to square pretty well with that of my critics, and from it draw such inferences as no one will be likely to dispute. If a really intelligent and well-educated man—a literary journalist, a don, or a civil servant—tells me of some book ancient or modern, that has impressed him, I am interested: I am sufficiently interested to get the book from the library and have a look at it. Were the same person to express enthusiasm for a show of modern pictures or an old master discovered in a country house, I should evince no more curiosity than good manners required, and perhaps not that. On the other hand, there are a few people, painters for the most part—people whose particular judgments are often utterly opposed to mine—to whose recommendation of a picture I pay the same attention that I pay to a recommendation by a highly intelligent and educated person of a book. Mark that here is no question of particular sympathy, no question of agreeing with the particular judgments of my counsellor or of his agreeing with mine; if Mr. Burton Rascoe,[2] who teases me and may be intelligent, or Mr. Wyndham Lewis who reviles and is certainly not well educated,[3] were seriously to tell me that I ought to see the work of such and such a painter, I should make a point of seeing it. Now, if people who are admittedly amongst the most intelligent and best educated in England—people, too, with whom I live on terms of the greatest friendliness—cannot give me a "tip" that would send me across the road, whereas people, less intelligent, and with whom I am apt to quarrel, can send me across half Europe, does it not seem to follow that there is a peculiar quality in pictures and a peculiar power of recognizing it, which from the vast majority of highly intelligent and generally discriminating people appears to be wholly absent? About any particular work it may well happen that these last—the literary and cultivated—agree with me, while the others—the picture-understanding few—differ; but, somehow, I feel that whereas my literary friends and I are not really agreeing about the same thing, the arguments of my opponents are concerned with the

things I know to be essential but think that they have misjudged. I am seriously interested in what they say; and I feel that they can appreciate—in a way my literary friends cannot—what precisely it is I admire or dislike.

Let us take the matter a step further. Someone will say, "Yes, I agree; the opinion of the truly intelligent and well-educated on a book of exposition or erudition, on criticism, on a novel or even on a play, carries weight: but what about poetry?" Now, I will admit that the opinion of a cultivated bourgeois—to use the offensive term with which young people who wrote poems or painted pictures used to damn those who claimed only to appreciate—that the opinion of a cultivated bourgeois in poetry is of less weight than his opinion on history, biography, novels and the rest. All the same, if the sort of man I have in mind earnestly advised me to read a particular poem, I should read it. Surely we all agree that such people do get genuine pleasure from lyrical poetry; that poetry means a great deal to them; that it profoundly affects their lives. But were such people never to see a picture again I cannot believe that it would make to them any serious difference. No one supposes that intelligent people read the best books for hours together from a sense of duty; whereas we know that they are bored to death by forty-five minutes in a picture gallery. They do get something, they get much, from literature; from the plastic arts they get next to nothing. What is the meaning of this?

Well, we all agree that there is in literature an immense amount of stuff which is not purely aesthetic, which is cognitive and suggestive, and which an intelligent bourgeois can understand as well as anyone else. In painting, on the other hand, there is no more of this cognitive stuff than can be squeezed out of the subject; and that will rarely be enough to keep an active mind busy for five minutes. It is not surprising, therefore, that a man of good understanding but no especial sensibility should make more of one than of the other. So far we all agree; but now comes a division. Those who insist on the fundamental unity of the arts, who are positive that the essential quality in all is the same, will argue that, in fact, the cultivated bourgeois no more appreciates that essential quality in literature than in painting. In either the essence escapes him. He never

155

penetrates to the heart of the matter, never comprehends that which makes a picture or a poem a work of art. It may be so; but if we are to assume that the essence of all the arts is the same, that literature beneath its intellectual and adventitious trappings is as "pure" as painting or music, and that whoever is insensitive to the essence of painting will be insensitive to the fundamental qualities of literature, we shall soon find ourselves forced to a conclusion as tough, at least, as that deplored by the Chicago Evening Post.

For, often, in the matter of painting, literary artists are to my personal knowledge no more sensitive than cultivated bourgeois. About the best poet writing in England is, to my thinking, T. S. Eliot; about the best novelist, Virginia Woolf.[4] Yet, if Mr. Eliot were to tell me that in his ancestral Boston home hangs a picture by "a painter of the Umbrian school"[5] whom he conjectures to have been Raphael, or if Mrs. Woolf told me that a young painter had taken her to see a picture which she considered as good as any Cézanne ever painted, (neither, be it understood, is, in fact, addicted to laying down the law or even expressing an opinion on such matters) I should be no more excited than if my friend Mr. Bertrand Russell[6] were to tell some similar story—no more excited, that is, than Mr. Russell would be if I, in an offhand way, were to announce that I had knocked the bottom out of the Einstein theory. This comparison I choose, not, as some will surmise, to raise a laugh, but for the sake of exactitude. Were I to comment on Einstein, whom I don't understand, I make no doubt my comments would be more entertaining and agreeable than those of the academic and disgruntled professors who feel that their noses have somehow been put out of joint by the new theory and say so professorially. But what I should say would be literary and semi-philosophic; something that no genuine mathematician could dream for a moment of taking seriously. Similarly, the three eminent writers I have named, though what they had to say about a picture would certainly be better worth hearing than anything that could be said by Dr. MacColl[7] or the president of the Royal Academy, would be most unlikely so much as to touch the heart of the matter. You see I have no doubt whatever that I am more sensitive to the essential, to what I used to call the "pure," qualities of a picture

156

than are Mr. Eliot or Mrs. Woolf: am I on that account to con-
clude that I am more sensitive than they to the essential quality
of the art in which they excel? Even to please the Chicago *Eve-
ning Post* I cannot consent to make such a fool of myself.

For the mere examination of our own experience has
brought us to this: first-rate literary artists are as much at sea as
cultivated bourgeois when they come to talk of pictures. Are we,
then, to assume that literary artists do not understand their own
business, or shall we admit that their business is something en-
tirely different from that of the painter? Between these two alter-
natives I unhesitatingly vote for the second. I grope back,
nervously, towards my original hypothesis. Literature, I cannot
help thinking, must be something very different from paint-
ing—a less pure art I should say, an art with more body in it and,
I will add, an art of far more importance to the human race. I
am persuaded that people can genuinely appreciate literature
though they lack that strange power of reacting intensely to ab-
stract form which is essential to a comprehension of the visual
arts. And this I account for by supposing that formal significance,
without which a picture is utterly worthless, is not the essential
quality, is not even the most important quality, in a book. If,
indeed, I rightly understand what formal beauty is, I believe that
you can have good literature without it and good literary criti-
cism without much appreciation of it. I can see no formal beauty
worth speaking of in Balzac or Dickens neither do I believe that
Leslie Stephen had any great sense of it.[8] Now a picture is quite
valueless without formal beauty—the beauty of a pot, a carpet,
or a building—and he who has no sense of this sort of beauty will
get nothing worth having from visual art.

The fact is, subject, and the overtones emanating from
it, wit, irony, pathos, drama, criticism, didacticism even—quali-
ties which in painting count for little or nothing—do seem to be
of the essence of literature; what is more, to appreciate literature,
a man must be thoroughly alive to them. So, when a writer tries
to confine himself to territories which he can cultivate in com-
mon with painting and music, when he reduces content and its
overtones to a minimum, when he sets himself to create form
which shall be abstractly beautiful, he invariably comes short of
greatness: what is worse, he is apt to be a bore. The painter or

musician, on the other hand, who tries to deal with a content suitable to literature, to comprehend the ideas and emotions of life and render their implications and associations, falls more often than not into vulgarity and melodrama. Of this a reasonable explanation seems to be that literature is one thing, painting and music another.

The point of literature may be blunter than that of the visual arts; but literature has an amplitude unknown to them, and its effectiveness compared with theirs is as the effectiveness of a bombshell compared with that of a rapier—or shall I say of the climate compared with the view from a window. The visual arts means a good deal to a few people, and count for something to a few more; literature plays an immense part in the lives of almost all intelligent men and women, of precisely those men and women who, in the long run, are the masters of life. Having made such handsome concessions may we not invite the writers, and amateurs of writing, to conceive it possible that even they have their limitations? Will they not admit that the power of appreciating abstract form is peculiar gift? After all, the vast majority, including the most intelligent, cannot really tell when a piano is lsightly out of tune. And it seems to me possible that the appreciation of the visual arts is something as peculiar as this. Remember, every disability is said to have its compensations. Blind men are said to hear, feel, taste and smell more exquisitely than the seeing; and literary people, I dare say, possess a surer hold on the significance of life than those who have been blest, or cursed, with a peculiar feeling for the significance of formal relations.

NOTES

1. This is a reference to *Since Cézanne* (1922).

2. Arthur Burton Rascoe (1892–1957), American editor and journalist, wrote an article entitled "Art and Clive Bell" for the *Reviewer*, 3 (June 1922): 497–95. Rascoe is sharply critical of several intemperate comments in *Art*, all of which Bell acknowledges in either his preface to the (new) 1948 edition of *Art*, or in his introductory essay to *Since Cézanne*. The teasing to which Bell refers comes in Rascoe's description of his emotional reaction to a Picasso drawing. Challenging Bell to tell him whether his emotion is genuinely aesthetic, Rascoe makes it perfectly clear, in the course of his discussion, that he is responding aesthetically (in Bell's sense), and that he knows it.

3. Bell's "Wilcoxism" appeared in the *Athenaeum*, 5 March 1920. In this article he suggested that it was ridiculous to suppose that the work of Percy Wyndham Lewis (1882–1957) could be compared to that of Matisse or Derain. Bell did credit Lewis with the "negative qualities" of "the absence of vulgarity and false sentiment, the sobriety of color, the painstaking search for design." In the *Athenaeum* of 12 March, Lewis responded, in a letter, to Bell's "parade of dishonesty and effrontery." "He regards Paris," says Lewis, "with something of the awestruck glee and relish of a provincial urchin at the sight of a Cockney guttersnipe." Bell's letter in response appeared in the *Athenaeum* of 19 March: "I should be sorry to quarrel with Mr. Wyndham Lewis about anything so insignificant as his art or my character. . . ."

 Bell's comment on Lewis must be understood against the background of this public quarrel.

4. T.S. Eliot (1888–1965) was a frequent visitor to the gatherings of the Bloomsbury Group. He is included in Bell's *Old Friends* (1956). Virginia Woolf (1882–1941) was a central member of the Bloomsbury Group as well as being Bell's sister-in-law. Bell dedicated *Civilization* to her. She also is included in *Old Friends*.

5. An allusion to Eliot's poem, "Mr. Eliot's Sunday Morning Service."

6. The philosopher Bertrand Russell (1872–1970) was a long-time friend, although he was never associated with the Bloomsbury Group.

7. Douglas Sutherland MacColl (1859–1948) was an art critic as well as a painter. His continual opposition to Cézanne led Bell to question MacColl's taste. MacColl states his case against Cézanne in *Confessions of a Keeper* (1931).

8. Bell's father-in-law, Leslie Stephen (1832–1904) was a giant in Victorian literary circles. He edited the *Dictionary of National Biography*, wrote a great deal of criticism and a work on British moral philosophy. It was Stephen's influence as an archetypical Victorian against which the Bloomsbury Group was reacting. Bell's interest in significant form is a far cry from Stephen's interest in the moral dimensions of works of art.

The Artistic Problem

We all agree now—by we I mean intelligent people under sixty—that a work of art is like a rose. A rose is not beautiful because it is like something else. Neither is a work of art. Roses and works of art are beautiful in themselves. Unluckily, the matter does not end there: a rose is the visible result of an infinitude of complicated goings on in the bosom of the earth and in the air above, and similarly a work of art is the product of strange activities in the human mind. In so far as we are mere spectators and connoisseurs we need not bother about these; all we are concerned with is the finished product, the work of art. To produce the best eggs it may be that hens should be fed on hot meal mash. That is a question for the farmer. For us what matters is the quality of the eggs, since it is them and not hot meal mash that we propose to eat for breakfast. Few, however, can take quite so lordly an attitude towards art. We contemplate the object, we experience the appropriate emotion, and then we begin asking "Why" and "How?" Personally, I am so conscious of these insistent questions that, at risk of some misunderstanding, I habitually describe works of art as "significant" rather than "beautiful" forms. For works of art, unlike roses, are the creations and expressions of conscious minds. I beg that no theological red herring may here be drawn across the scent.

A work of art is an object beautiful, or significant, in itself, nowise dependent for its value on the outside world, capa-

Reprinted from the *Athenaeum*, 20 June 1919: 496–97, by permission of the *New Statesman*, London.

ble by itself of provoking in us that emotion which we call aesthetic. Agreed. But men do not create such things unconsciously and without effort, as they breathe in their sleep. On the contrary, for their production are required special energies and a peculiar state of mind. A work of art, like a rose, is the result of a string of causes: and some of us are so vain as to take more interest in the operations of the human mind than in fertilizers and watering-pots.

In the pre-natal history of a work of art I seem to detect at any rate three factors—a state of peculiar and intense sensibility, the creative impulse, and the artistic problem. An artist, I imagine, is one who often and easily is thrown into that state of acute and sympathetic agitation which most of us, once or twice in our lives, have had the happiness of experiencing. And have you noticed that many men and most boys, when genuinely in love, find themselves, the moment the object of their emotion is withdrawn, driven by their feelings into scribbling verses? An artist, I imagine, is always falling in love with everything. Always he is being thrown into a "state of mind." The sight of a tree or an omnibus, the screaming of whistles or the whistling of birds, the smell of roast pig, a gesture, a look, any trivial event may provoke a crisis, filling him with an intolerable desire to express himself. The artist cannot embrace the object of his emotion. He does not even wish to. Once, perhaps, that was his desire; if so, like the pointer and the setter, he has converted the barbarous pouncing instinct into the civilized pleasure of tremulous contemplation. Be that as it may, the contemplative moment is short. Simultaneously almost with the emotion arises the longing to express, to create a form that shall match the feeling, that shall commemorate the moment of ecstasy.

This moment of passionate apprehension is, unless I mistake, the source of the creative impulse; indeed, the latter seems to follow so promptly on the former that one is often tempted to regard them as a single movement. The next step is longer. The creative impulse is one thing; creation another. If the artist's form is to be the equivalent of an experience, if it is to be significant in fact, every scrap of it has got to be fused and fashioned in the white heat of his emotion. And how is his emotion to be kept at white heat through the long, cold days of formal con-

struction? Emotions seem to grow cold and set like glue. The intense power and energy called forth by the first thrilling vision grow slack for want of incentive. What engine is to generate the heat and make taut the energies by which alone significant form can be created? That is where the artistic problem comes in.

The artistic problem is the problem of making a match between an emotional experience and a form that has been conceived but not created. Evidently the conception of some sort of form accompanies, or closely follows, the creative impulse. The artist says, or rather feels, to himself—I should like to express that in words or in lines and colors, or in notes. But to make anything out of his impulse he will need something more than this vague desire to express or to create. He will need a definite, fully conceived form into which his experience can be made to fit. And this fitting, this matching of his experience with his form, will be his problem. It will serve the double purpose of concentrating his energies and stimulating his intellect. It will be at once a canal and a goad. And his energy and intellect between them will have to keep warm his emotion. Shakespeare kept tense the muscle of his mind and boiling and racing his blood by struggling to confine his turbulent spirit within the trim mould of the sonnet. Pindar, the most passionate of poets, drove and pressed his feelings through the convolutions of the ode. Bach wrote fugues. The master of S. Vitale found an equivalent for his disquieting ecstasies in severely stylistic portraits wrought in an intractable medium. Giotto expressed himself through a series of pictured legends. El Greco seems to have achieved his stupendous designs by laboring to make significant the fustian of theatrical piety.[1]

There is apparently nothing that an artist cannot vivify. He can create a work of art out of some riddle in engineering or harmonics, an anecdote, or the frank representation of a natural object. Only, to be satisfactory, the problem must be for him who employs it a goad and a limitation. A goad that calls forth all his energies: a limitation that focuses them on some object far more precise and comprehensible than the expression of a vague sensibility or, to say the same thing in another way, the creation of indefinite beauty. However much an artist may have felt, he cannot just sit down and express it, he cannot create form in the

vague. He must sit down to write a play or a poem, to paint a portrait or a still life.

Almost everyone has had his moment of ecstasy, and the creative impulse is not uncommon; but those only who have a pretty strong sense of art understand the necessity for the artistic problem. What is known of it by the public is not much liked; it has a bad name and is reckoned unsympathetic. For the artistic problem, which limits the artist's freedom, fixes his attention on a point, and drives his emotion through narrow tubes, is what imports the conventional element into art. It seems to come between the spontaneous thrill of the artist and the receptive enthusiasm of his public with an air of artificiality. Thus, a generation brought up on Wordsworth could hardly believe in the genuineness of Racine. Our fathers and grandfathers felt, and felt rightly, that art was something that came from and spoke to the depths of the human soul. But how, said they, should deep call to deep in Alexandrines and a pseudoclassical convention, to say nothing of full-bottomed wigs?[2] They forgot to reckon with the artistic problem, and made the mistake that people make who fancy that nothing looking so unlike a Raphael or a Titian as a Matisse or a Picasso can be a work of art. They thought that because the stuff of art comes from the depths of human nature it can be expressed only in terms of naturalism. They did not realize that the creating of an equivalent for an aesthetic experience out of natural speech or the common forms of nature is only one amongst an infinite number of possible problems. There are still ladies who feel sure that had they been in Laura's[3] shoes Petrarch might have experienced something more vivid than what comes through his mellifluous but elaborate *rime*. To them he would have expressed himself otherwise. Possibly: but whatever he experienced could not have become art—significant form—till it had been withdrawn from the world of experience and converted into poetry by some such exacting problem.

One problem in itself is as good as another, just as one kind of nib is as good as another, since problems are valuable only as means. That problem is best for any particular artist that serves that particular artist best. The ideal problem will be the one that raises his power most while limiting his fancy least. The incessant recourse of European writers to dramatic form suggests

that here is a problem which to them is peculiarly favorable. Its conventions, I suppose, are sufficiently strict to compel the artist to exert himself to the utmost, yet not so strict as to present those appalling technical difficulties—the sort presented by a sestina or a chant royal—that make self-expression impossible to any but a consummate master. The novel, on the other hand, as we are just beginning to suspect, affords for most writers an unsatisfactory because insufficiently rigorous problem. Each age has its favorites. Indeed, the history of art is very much the history of the problem. The stuff of art is always the same, and always it must be converted into form before it can become art; it is in their choice of converting-machines that the ages differ conspicuously.

Two tasks that painters and writers sometimes set themselves are often mistaken for artistic problems, but are, in fact, nothing of the sort. One is literal representation: the other the supply of genius direct from the cask. To match a realistic form with an aesthetic experience is a problem that has served well many great artists: Chardin and Tolstoi will do as examples.[4] To make a realistic form and match it with nothing is no problem at all. Though to say just what the camera would say is beyond the skill and science of most of us, it is a task that will never raise an artist's temperature above boiling-point. A painter may go into the woods, get his thrill, go home and fetch his panel-box, and proceed to set down in cold blood what he finds before him. No good can come of it, as the gloomy walls of any official exhibition will show. Realistic novels fail for the same reason: with all their gifts, neither Zola nor Edmond de Goncourt, nor Mr. Arnold Bennett, ever produced a work of art.[5] Also, a thorough anarchist will never be an artist, though many artists have believed that they were thorough anarchists. One man cannot pour an aesthetic experience straight into another, leaving out the problem. He cannot exude form; he must set himself to create a particular form. Automatic writing will never be poetry, nor automatic scrabbling design. The artist must submit his creative impulse to the conditions of a problem. Often great artists set their own problems; always they are bound by them. That would be a shallow critic who supposed that Mallarmé wrote down what words he chose in what order he pleased, unbound by any sense of a definite form to be created

and a most definite conception to be realized.[6] Mallarmé was as severely bound by his problem as was Racine by his. It was as definite—for all that it was unformulated—as absolute and as necessary. The same may be said of Picasso in his most abstract works; but not of all his followers, nor of all Mallarmé's either.

NOTES

1. The artists to whom Bell refers selected a specific form within which to present themselves: Shakespeare the sonnet; Pindar the ode; Bach the fugue; the artists (it is not known whether there was only one master) of the mosaics in the apse of the Church of San Vitale in Ravenna chose the tiny bits of color of mosaic; Giotto selected Biblical themes; El Greco continually framed his paintings as if within a proscenium. Bell's point is that the artistic problem is the problem of melding a form and an expression.

2. William Wordsworth's (1770–1850) poetry is personal and romantic, a far cry from the drama of Jean Baptiste Racine (1639–99), in which elaborately costumed actors pose and deliver their lines.

3. The French lady who is praised in the work of the Italian poet Petrarch (1304–74), said to have been Laure de Noves (1308?–48).

4. Jean-Baptiste-Simeon Chardin (1699–1779), French master of the realistic still life; Lev Nikolaevich Tolstoi (1869–1910), Russian novelist and philosopher, whose essay *What is Art?* is of most interest to Bell.

5. Emile Zola (1840–1902), Edmond de Goncourt (1822–96)—two giant figures in French naturalistic literature—and Arnold Bennett (1867–1931), the English novelist, are treated rather cavalierly here. Can this attack on "realistic novels" be any more than an exhibition of a bias on Bell's part when he is willing to accept the mosaic as an "intractable medium"?

6. Stéphane Mallarmé (1842–98) hoped for a poetry in which the creative dimension of language would be reasserted in such a way as to reveal the essential innocence of things.

Order and Authority, I

M. André Lhote is not only a first-rate painter, he is a capable writer as well;[1] so when, some weeks ago, he began to tell us what was wrong with modern art, and how to put it right, naturally we pricked up our ears. We were not disappointed. M. Lhote had several good things to say, and he said them clearly; the thing, however, which he said most emphatically of all was that he, André Lhote, besides being a painter and a writer, is a Frenchman. He has a natural taste for order and a superstitious belief in authority. That is why he recommends to the reverent study of the young of all nations, David—David, the schoolmaster! *Merci*, we have our own Professor Tonks.[2]

Not that I would compare David, who was a first-rate practitioner and something of an artist, with the great Agrippa of the Slade. But from David even we have little or nothing to learn. For one thing, art cannot be taught; for another, if it could be, a dry doctrinaire is not the man to teach it. Very justly, M. Lhote compares the Bouchers and the Fragonards of the eighteenth century with the Impressionists: alike they were charming, a little drunk, and disorderly. But when he asserts that it was David who rescued painting from the agreeable frivolity of the former, he must be prepared for contradiction: some people will have it that it was rather his pupil, Ingres.[3] David, they will say, was little better than a politic pedagogue, who, observing that with the Revolution classical virtues and classical costumes had come into fashion, that Brutus, the tyrannicide, and Aristides,

Reprinted from the *Athenaeum*, 7 November 1919: 1157–58, by permission of the *New Statesman*, London.

called "the just" were the heroes of the hour, suited his manners to his company and gave the public an art worthy of highly self-conscious liberals. The timely discoveries made at Herculaneum and Pompeii, they will argue, stood him in good stead.[4] From these he learnt just how citizens and citizen-soldiers should be drawn; and he drew them: with the result that the next generation of Frenchmen were sighing,

Qui nous délivera des Grecs et des Romains?[5]

Whoever may have rescued European painting from the charming disorder of the age of reason, there can be no question as to who saved it from the riot of impressionism. That was the doing of the Post-Impressionists headed by Cézanne. Forms and colors must be so organized as to compose coherent and self-supporting wholes; that is the central conviction which has inspired the art of the last twenty years. Order: that has been the watchword; but order imposed from within. And order so imposed, order imposed by the artist's inmost sense of what a work of art should be, is something altogether different from the order obtained by submission to a theory of painting. One springs from a personal conviction; the other is enjoined by authority. Modern artists tend to feel strongly the necessity for the former, and, if they be Frenchmen, to believe intellectually in the propriety of the latter.

Look at a picture by Cézanne or by Picasso. What could be more orderly? Cubism is nothing but the extreme manifestation of this passion for order, for the complete organization of forms and colors. The artist has subordinated his predilections and prejudices, his peculiar way of seeing and feeling, his whims, his fancies and his eccentricities, to a dominant sense of design. Yet the picture is personal. In the first place a picture must be an organic whole, but that whole may be made up of anything that happens to possess the artist's mind. Now look at a picture by Baudry or Poynter, and you will see the last word in painting by precept.[6] The virtuous apprentice has stuck to the rules. He has done all that his teacher bade him do. And he has done nothing else. David ought to be pleased. Pray, M. Lhote, give him top marks.

Post-Impressionism, which reaffirmed the artist's la-

169

tent sense of order and reawoke a passion to create objects complete in themselves, left the painter in full possession of his individuality. Now, individualism is the breath of every artist's life, and a thing of which no Frenchman, in his heart, can quite approve. So, if an artist happens also to be a Frenchman—and the combination is admirably common—what is he to do? Why, look one way and row the other; which is what M. Lhote does. He paints delightfully personal and impenitent pictures, and preaches artistic Caesarism and David, "the saviour of society." All the week he is a French artist, traditional as all real artists must be, but never denying, when it comes to practice, that tradition is merely an indispensable means to self-expression; and on Sundays, I dare say, he goes, like Cézanne, to lean on M. le Curé, who leans on Rome, while his *concierge* receives the pure gospel of Syndicalism, which, also, is based on absolute truths, immutable, and above criticism.[7]

It is notorious that you may with impunity call a placable Frenchman "butor," scélérat," "coquin fieffé," "sale chameau," "député " even, or "sénateur "; but two things you may not do: you may not call him "espèce d'individu " and you may not say "vous n' êtes pas logique."[8] It is as unpardonable to call a Frenchman "illogique" as to shout after the Venetian who has almost capsized your gondola "mal educato." M. Lhote is "logique" all right: but "logical" in France has a peculiar meaning. It means that you accept the consequences of your generalizations without bothering about any little discrepancies that may occur between those consequences and the facts ascertained by experience; it does not mean that your high a priori generalizations are themselves to be tested by the nasty, searching instrument of reason. Thus it comes about that the second master to whom M. Lhote would put this wild and willful age of ours to school is that mysterious trinity of painters which goes by the name of "Le Nain."

I can quite understand M. Lhote's liking for the brothers Le Nain, because I share it. Their simple, honest vision and frank statement are peculiarly sympathetic to the generation that swears by Cézanne. Here are men of good faith who feel things directly, and say not a word more than they feel. With a little ingenuity and disingenuousness one might make a *douanier*[9] of

them. They are scrupulous, sincere, and born painters. But they are not orderly. They are not organizers of form and color. No: they are not. On the contrary, these good fellows had the most elementary notions of composition. They seem hardly to have guessed that what one sees is but a transitory and incoherent fragment, out of which it is the business of art to draw permanence and unity. They set down what they saw, and it is a bit of good luck if what they saw turns out to have somewhat the air of a whole. Yet M. Lhote, preaching his crusade against disorder, picks out the Le Nain and sets them up as an example. What is the meaning of this?

M. Lhote himself supplies the answer. It is not order so much as authority that he is after; and authority is good wherever found and by whomsoever exercised. "Look," says he, "at Le Nain's peasants. The painter represents them to us in the most ordinary attitude. It is the poetry of everyday duties accepted without revolt. Le Nain's personages are engaged in being independent as little as possible." No Bolshevism here: and what a lesson for us all! Let painters submit themselves lowly and reverently to David, and seventeenth-century peasants to their feudal superiors. Not that I have the least reason for supposing M. Lhote to be in politics an aristocrat: probably he is a better democrat than I am. It is the Kratos, the rule, he cares for. Do as you are told by Louis XIV or Lenin or David; only be sure that it is as you are told. M. Lhote, of course, does nothing of the sort. He respects the tradition, he takes tips from Watteau[10] or Ingres or Cézanne, but orders he takes from no man. He is an artist, you see.

In many ways this respect for authority has served French art well. It is the source of that traditionalism, that tradition of high seriousness, craftsmanship, and good taste, which, even in the darkest days of early Victorianism, saved French painting from falling into the pit of stale vulgarity out of which English has hardly yet crawled. French revolutions in painting are fruitful, English barren—let the Pre-Raphaelite movement be my witness.[11] The harvest sown by Turner and Constable was garnered abroad.[12] Revolutions depart from tradition. Yes, but they depart as a tree departs from the earth. They grow out of it; and in England there is no soil. On the other hand, it is French

171

conventionality—for that is what this taste for discipline comes to—which holds down French painting, as a whole, below Italian. There are journeys a Frenchman dare not take because, before he reached their end, he would be confronted by one of those bogeys before which the stoutest French heart quails—"C'est inadmissible," "C'est convenu," "La patrie en danger."[13] One day he may be called upon to break bounds, to renounce the national tradition, deny the pre-eminence of his country, question the sufficiency of Poussin and the perfection of Racine or conceive it possible that some person or thing should be more noble, reverend, and touching than his mother. On that day the Frenchman will turn back. "C'est inadmissible."

France, the greatest country on earth, is singularly poor in the greatest characters—great ones she has galore. Her standard of civilization, of intellectual and spiritual activity, is higher than that of any other nation; yet an absence of vast, outstanding figures is one of the most obvious facts in her history. Her literature is to English what her painting is to Italian, only more so. Her genius is enterprising without being particularly bold or original, and though it has brought so much to perfection it has discovered comparatively little. Assuredly France is the intellectual capital of the world, since, compared with hers, all other post-Renaissance civilizations have an air distinctly provincial. Yet, face to face with the rest of the world, France is provincial herself. Here is a puzzle; a solution of which, if it is to be attempted at all, must be attempted in another article.

NOTES

1. Bell is referring to an article by André Lhote (1885–1962), the French cubist painter, which appeared in the *Athenaeum* of 22 August, 1919, entitled "A First Visit to the Louvre." Lhote argues that Jacques Louis David (1748–1825), the great neo-classical French painter, and the Le Nain brothers—Antoine (1588–1648), Louis (1593–1640), and Mathieu (1607–77)—French naturalists, should be seen as the two sources for contemporary painting. According to Lhote, the Le Nain brothers, like Cézanne, analyze without amplifying the subject, without moralizing or story telling. Since David brought an affirmation of plastic values into an historical situation characterized by the charming carelessness of painters such as Francois Boucher (1703–70) and Jean Honoré Fragonard (1732–1806), Lhote sees him at the head of a path leading directly to cubism. As Bell's argument progresses we can see that at some points he and Lhote are not really in disagreement. For example, Lhote does not say that the Le Nains are particularly good at organizing form and color; it is their anaylysis he praises. Clearly, however, Bell and Lhote are opposed with respect to the value and importance of David. Lhote feels that David avoided the sentimental and the tragic while Bell feels that David was a master at both, and thus fails as a painter.

2. The English painter Henry Tonks (1862–1937) was a member of the staff of the Slade School at this time. To Bell he represented the worst of English academic painting. He is the "Agrippa of the Slade" referred to in the following paragraph.

3. Jean Auguste Dominique Ingres (1780–1867), French neo-classical painter.

4. Charles III of Naples began systematically excavating Herculaneum in 1738, discovering several important buildings between 1738 and 1768. Many artifacts, including statues and entire wall paintings, were removed to Naples. Beginning in 1763, Pompeii was systematically ex-

173

cavated. David could have taken any of these artifacts as models for his paintings.

5. "Who will deliver us from the Greeks and the Romans?"

6. Both Paul Jacques Aimé Baudry (1828–86), French sculptor, and Sir Edward John Poynter (1836–1919), English painter, were fashionable artists of their time. Baudry produced commerical statues of bronze and alabaster; Poynter, dull paintings in the classical genre.

7. Syndicalism, the political doctrine that any form of state is an instrument of oppression.

8. "You may with immunity call a placable Frenchman a blockhead, scum, cheat, dirty camel, congressman even, or senator; but two things you may not do: you may not call him a dirty individual, and you may not say, 'You are not logical.' "

9. This is a reference to the painter Henri Rousseau (1844–1910), who was called *douanier* because he was a retired customs officer. His innocent, direct feeling can be seen in *The Dream* (Museum of Modern Art, New York), reproduced in Jansen's *History of Art* (Englewood Cliffs, N.J.: Prentice-Hall, and New York: Harry N. Abrams, 1969).

10. Jean-Antoine Watteau (1684–1721) set the tone in French painting immediately before David.

11. The Pre-Raphaelite Brotherhood was founded by the English painters John Millais (1829–96), W. Holman Hunt (1827–1910), and D. G. Rossetti (1828–82). Adopting a very literal realism, they aspired to bring a moral seriousness to painting. Bell found their work sentimental and excessively moralistic.

12. Joseph Mallord Turner (1775–1851) and John Constable (1776–1837) were English contemporaries of David. While the latter's neo-classicism dominated France, Turner and Constable concerned themselves in their landscapes with light instead of details of scene. Their interest in atmosphere was harvested a generation later in France by the Impressionists.

13. The clichés are translated as: "It is inadmissable," "It is agreed," "The country in danger."

Duncan Grant

Today, when the Carfax Gallery opens its doors at No. 5 Bond Street, and invites the cultivated public to look at the paintings of Duncan Grant, that public will have a chance of discovering what has for some time been known to alert critics here and abroad—that at last we have in England a painter whom Europe may have to take seriously.[1] Nothing of the sort has happened since the time of Constable; so naturally one is excited.

If the public knows little of Duncan Grant the public is not to blame. During the fifteen years that he has been at work not once has he held "a one-man show," while his sendings to periodic exhibitions have been rare and unobtrusive. To be sure, there is a picture by him in the Tate Gallery. But who ever thought of going there to look for a work of art? Besides, during the last few years the Tate, like most other places of the sort, has been given over to civil servants. Duncan Grant is a scrupulous, slow, and not particularly methodical worker. His output is small; and no sooner is a picture finished than it is carried off by one of those watchful amateurs who seem a good deal more eager to buy than he is to sell. Apparently he cares little for fame; so the public gets few opportunities of coming acquainted with his work.

Duncan Grant is, in my opinion, the best English painter alive. And how English he is! (British, I should say, for he

Reprinted from the *Athenaeum*, 6 February 1920: 182–83, by permission of the *New Statesman*, London.

is a Highlander.) Of course he has been influenced by Cézanne and the modern Frenchmen. He is of the movement. Superficially his work may look exotic and odd. Odd it will certainly look to people unfamiliar with painting. But anyone who has studied and understood the Italians will see at a glance that Duncan Grant is thoroughly in the great tradition; while he who also knows the work of Wilson, Gainsborough, Crome, Cotman, Constable, and Turner will either deny that there is such a thing as an English tradition, or admit that Duncan Grant is in it.[2] For my part, I am inclined to believe that an English pictorial tradition exists, though assuredly it is a tiny and almost imperceptible rill, to be traced as often, perhaps, through English poetry as through English painting. At all events, there are national characteristics; and these you will find asserting themselves for good or ill in the work of our better painters.

Duncan Grant's ancestors are Piero della Francesca, Gainsborough, and the Elizabethan poets.[3] There is something Greek about him, too; not the archeological Greek of Germany, nor yet the Greco-Roman academicism of France, but rather that romantic, sensuous Hellenism of the English literary tradition. It is, perhaps, most obvious in his early work, where, indeed, all the influences I have named can easily be found. Then, at the right moment, he plunged headlong into the movement, became the student of Cézanne, Matisse, Picasso, though not, curiously enough, of Bonnard,[4] the modern artist with whose work his own has the closest affinity, and, for a year or two, suffered his personality to disappear almost beneath the heavy, fertilizing spate. He painted French exercises. He was learning. He has learnt. He can now express, not someone else's ideas, but himself, completely and with delicious ease, in the language of his age. He is a finished and highly personal modern artist.

I dare say Duncan Grant's most national characteristic is the ease with which he achieves beauty. To paint beautifully comes as naturally to him as to speak English does to me. Almost all English artists of any merit have had this gift, and most of them have turned it to sorry account. It was so pleasant to please that they tried to do nothing else, so easy to do it that they scampered and gambolled down the hill that ends in mere prettiness. From this catastrophe Duncan Grant has been saved

176

by a gift which, amongst British painters, is far from common. He is extremely intelligent. His intellect is strong enough to keep in hand that most charming and unruly of its sister gifts, sensibility. And a painter who possesses both sensibility and the intellect to direct it is in a fair way to becoming a master.

The sensibility of English artists, whether verbal or visual, is as notorious as their sense of beauty. This becomes less surprising when we reflect that the former includes the latter. The fact is, critics, with their habitual slovenliness, apply the term "sensibility" to two different things. Sometimes they are talking about the artist's imagination, and sometimes about his use of the instrument: sometimes about his reactions, and sometimes—in the case of painters—about the tips of his fingers. It is true that both qualities owe their existence to and are conditioned by one fundamental gift—a peculiar poise—a state of feeling—which may well be described as "sensibility." But, though both are consequences of this peculiar delicacy and what I should like to call "light-triggeredness" of temperament, they are by no means identical. By "sensibility" critics may mean an artist's power of responding easily and intensely to the aesthetic significance of what he sees; this power they might call, if they cared to be precise, "sensibility of inspiration." At other times they imply no more than sensibility of touch; in which case they mean that the contact between the artist's brush and his canvas has the quality of a thrilling caress, so that it seems almost as if the instrument that bridged the gulf between his fingers and the surface of his picture must have been as much alive as himself. "Sensibility of handling" or "handwriting" is the proper name for this. In a word, there is sensibility of the imagination and sensibility of the senses: one is receptive, the other executive. Now Duncan Grant's reactions before the visible universe are exquisitely vivid and personal, and the quality of his paint is often as charming as a kiss. He is an artist who possesses both kinds of sensibility. These are adorable gifts; but they are not extraordinarily rare amongst English painters of the better sort.

In my judgement Gainsborough and Duncan Grant are the English painters who have been most splendidly endowed with sensibility of both sorts, but I could name a dozen who have been handsomely supplied. In my own time there have been

177

four—Burne-Jones[5] (you should look at his early work), Conder, Steer and John, all of whom had an allowance far above the average, while in America there was Whistler. No one, I suppose, would claim for any of these, save perhaps, Whistler, a place even in the second rank of artists.[6] From which it follows clearly enough that something more than delicacy of reaction and touch is needed to make a man first-rate. What is needed is, of course, constructive power. An artist must be able to convert his inspiration into significant form; for in art it is not from a word to a blow, but from a tremulous, excited vision to an orderly mental conception, and from that conception, by means of the problem and with the help of technique, to externalization in form. That is where intelligence and creative power come in. And no British painter has, as yet, combined with sure and abundant sensibility, power and intelligence of a sort to do perfectly and without fail this desperate and exacting work. In other words, there has been no British painter of the first magnitude. But I mistake or Gainsborough, Crome, Constable and Duncan Grant were all born with the possibility of greatness in them.

Many British (or, to make myself safe, I will say English-speaking) painters have had enough sensibility of inspiration to make them distinguished and romantic figures. Who but feels that Wilson, Blake, Reynolds, Turner and Rossetti were remarkable men?[7] Others have had that facility and exquisiteness of handling which gives us the enviable and almost inexhaustible producer of charming objects—Hogarth, Cotman, Keene, Whistler, Conder, Steer, Davies.[8] Indeed, with the exceptions of Blake and Rossetti—two heavy-handed men of genius—and of Reynolds, whose reactions were something too perfunctory, I question whether there be a man in either list who wanted much for sensibility of either sort. But what English painter could conceive and effectively carry out a work of art? Crome I think has done it; Gainsborough and Constable at any rate came near; and it is because Duncan Grant may be the fourth name in our list that some of us are now looking forward with considerable excitement to his exhibition.

An Englishman who is an artist can hardly help being a poet; I neither applaud nor altogether deplore the fact, though certainly it has been the ruin of many promising painters. The

178

doom of Englishmen is not reversed for Duncan Grant: he is a poet; but he is a poet in the right way—in the right way, I mean, for a painter to be a poet. Certainly his vision is not purely pictorial; and because he feels the literary significance of what he sees his conceptions are apt to be literary. But he does not impose his conceptions on his pictures; he works his pictures out of his conceptions. Anyone who will compare them with those of Rossetti or Watts[9] will see in a moment what I mean. In Duncan Grant there is, I agree, something that reminds one unmistakably of the Elizabethan poets, something fantastic and whimsical and at the same time intensely lyrical. I should find it hard to make my meaning clearer, yet I am conscious enough that my epithets applied to painting are anything but precise. But though they may be lyrical or fantastic or witty, these pictures never tell a story or point a moral.

My notion is that Duncan Grant often starts from some mixed motif which, as he labors to reduce it to form and color, he cuts, chips and knocks about till you would suppose that he must have quite whittled the alloy away. But the fact is, the very material out of which he builds is colored in poetry. The thing he has to build is a monument of pure visual art; that is what he plans, designs, elaborates and finally executes. Only, when he has achieved it, we cannot help noticing the color of the bricks. All notice, and some enjoy, this adscititious literary overtone. Make no mistake, however, the literary element in the art of Duncan Grant is what has been left over, not what has been added. A Blake or a Watts conceives a picture and makes of it a story; a Giorgione or a Piero di Cosimo steals the germ of a poem and by curious cultivation grows out of it a picture.[10] In the former class you will find men who may be great figures, but can never be more than mediocre artists: Duncan Grant is of the latter. He is in the English tradition without being in the English rut. He has sensibility of inspiration, beauty of touch, and poetry; but, controlling these, he has intelligence and artistic integrity. He is extremely English; but he is more of an artist than an Englishman.

NOTES

1. The English painter Duncan James Corrowr Grant (1885–) was a member of the Bloomsbury Group, and a close friend of Clive and Vanessa Bell. Together with Vanessa, he decorated the interior of the Bells' home, Charleston.

2. Together with John Constable (1776–1837), Richard Wilson (1714–82), Thomas Gainsborough (1727–88)—who also excelled at portraiture—John Crome (1768–1821), John Cotman (1782–1824), and Joseph M. W. Turner (1775–1851) form the tradition in English landscape painting. A comparison of Grant's *Lemon Gatherers* with the work of this tradition will reveal the justice of Bell's comment. Earlier, I attempted to indicate how Grant may be seen as within what Bell calls the great tradition, i.e., the tradition of the mosaics at Ravenna, of Giotto, and of Cézanne. The Italian painter Piero della Francesca (1410/20–1492) is also within the great tradition.

3. With this reference to the Elizabethan poets Bell seems to have in mind the tendency of authors like Shakespeare (1564–93) and Christopher Marlowe (1564–93) to write of real persons and events rather than idealized ones. There is a sensuousness about Grant's *Bathers* which springs from their naturalness. This is true, too, of the figures in *Lemon Gatherers*.

4. Pierre Bonnard (1867–1947) was a founding member of the *Fauves*. Bold use of violent color caused this name—The Wild Beasts—to be applied to Matisse and Cézanne, among others.

5. An examination of Sir Edward Burne-Jones's (1833—98) work even as reproduced in a folio such as *Pre-Raphaelite Painters* by Ironside and Gere shows that his early paintings (1860s) are quite different from the work of the 1880s. The earlier work, e.g., *Clerk Sanders,* a watercolor of 1861, has many of the qualities of the mosaics at Ravenna. The later work, e.g., *King Cophetua and the Beggar-Maid,* an oil of 1884, is based upon a space which allows the painting to be literary and moralistic.

6. To me, Bell seems quite justified in rating James McNeill Whistler (1834–1903) above Charles Conder (1860–1961), who painted in a manner after Whistler, and Augustus John (1878–1961), who never had the patience to truly give form to anything. Philip Steer (1860–1942) is a different matter, however. I consider his landscapes and figures to be better than the work of Conder and John.

7. William Blake (1757–1827) is an extreme case of an artist whose images come from within. D. G. Rossetti (1828–82), although a founding member of the Pre-Raphaelite Brotherhood which claimed to be committed to exact realism, could not refrain from seeing nature as a morality play. Joseph Turner was a scandal in his own time for "never finishing his work," i.e., he left masses of color which could not be seen as objects. The landscapes of Richard Wilson and the portraits of Joshua Reynolds (1723–92) come closest to reproducing what appears before the artist. Yet, both of these painters have survived as important figures because they broke away from traditions of exact representation.

8. Bell has quite a mixed group of artists here. William Hogarth (1697–1794), John Cotman, and Charles Keene (1823–91) all produced work which is quite realistic. Hogarth and Keene used their careful observation for satire; Cotman for his renderings of antiquities. Whistler, Conder, and Steer were all charming in the way in which Impressionism can be charming. The American painter Arthur Davies (1862–1928) painted decorative works in a cubist style. He helped to organize the Armory Show of 1913 in New York, which introduced Post-Impressionism to America.

9. George Fredrich Watts (1817–1904) was not a Pre-Raphaelite, but he did paint a host of highly moralistic allegories.

10. Georgio del Castelfranco (1475–1510), the Venetian (known as Giorgione), and Piero de Cosimo (1462–1521?), of the Florentine School, both refuse to spiritualize their subjects, so their ideas come across as emerging from (with) the painting instead of being preexisting moral tales which must be presented.

The Two Corots

Modern psychologists, with their taste for dual personality and all that, might do worse than turn their attention to the case of Jean-Baptiste Corot.[1] How comes it that the man who produced fifty, I suppose, of the best pictures of the century, produced some hundreds of, if not the worst, at least a deplorable badness. None of the convenient explanations quite does. It is true that before 1840—he began painting seriously in '22—Corot produced, so far as I know, nothing detestable; and in his middle, sometimes called his "studio" period, little; but it is not true that in the last fifteen years of his life he produced nothing else. In the last fifteen years of his life he painted many of his finest figures, and his figures are perhaps his finest pictures. Nor is it quite true that after 1860 he painted no good landscapes. "Le Beffroi de Douai" (collection Moreau-Nelaton, Arts decoratifs) is dated 1871.[2]

"Le Beffroi de Douai" and the late figures suffice to prove that age alone will not account for the general deterioration of his output. Success, I think, accounts for much. Corot was the least avaricious of men, but he valued money for some of the things that money will buy—the bare necessities and modest comforts of one's friends for instance. Surely it was worth knocking off one of those trashy little idylls that M. Chauchard[3] could never resist when by so doing Daumier,[4] old, penniless, and blind, could be saved from eviction? Corot, when he became a

Reprinted from the *Nation and Athenaeum*, 9 October 1926: 18–20, by permission of the *New Statesman*, London.

best seller, took to boiling other people's pots. For his figures there was never a market, during his life Corot was never taken seriously as a portrait painter; wherefore to the end he painted figures, not for the MM. Chauchards of two hemispheres, but for him for whom he had painted Italian landscapes from '25 to '35, for himself, or, as I am tempted to say, for "his better self." How different was the spirit in which he painted his figures from that in which he painted his fluffy idylls may be conjectured from this recorded saying of his: *"Je peins une poitrine de femme tout comme je peindrais une boîte au lait."*[5] Forty years later when Marquet[6] said the same thing the idealists were up in arms; and the Chauchards have been idealists always.

Still the question remains: how could the Corot who was painting those amazing figures—"La dame en bleu" is dated 1874—paint those otherwise amazing nymph-ridden glades?[7] The only answer I can suggest, is that there were two Corots, Corot the great painter and Corot the brave bourgeois of the rue du Bac. Unluckily, that answer raises a further question—a question that certainly ought to be answered but will not be answered easily: Is painting a knack, or is it the expression of a mind? Is to be a great painter like being a great cricketer; or must a great painter, somehow or other, be spiritually (I use the word as opposed to mechanically) great? On the first hypothesis there is no mystery about the feeblest productions of the greatest artists: sometimes his knack fails him and Hobbs gets out for a duck.[8] On the second it seems strange that a great man should ever look quite so small as Corot looks frequently; stranger still that during a period of fifteen years or more he should sprinkle miseries with masterpieces, for all the world as though painting great pictures were for him a matter of chance.

Obviously a painter must have knack: to me it appears not less obvious that the valuable painter uses knack to externalize something in himself other than knack. When the product is great it is generally assumed that the thing externalized must have been great also; but to me that assumption seems illegitimate. Might not a great power of externalization (knack) so externalize a small thing as to give a splendid result? Here I shall not even attempt to answer that question. When Corot failed I believe he was using his knack to externalize something not small

183

but unreal: he was grinding without grist. And on such occasions, it is not surprising if knack, having nothing to work on, played truant. The stimulus being unreal the reaction was half-hearted. In youth notoriously an artist, poet or painter, finds in his own enthusiastic experience an adequate motive. That will account for Corot's first and best period. Later, maybe, an artist needs a third quality, besides enthusiasm and knack, a quality which selects and conditions motives, which distinguishes the genuine from the plausible, a quality which—to invoke a helpful colloquialism—gets the best out of a man. This third partner not only finds a problem to bring together knack and emotion, not only trims and tests experience before handing it over for realization to the craftsman, but keeps a guiding hand on the craftsman himself, so much so that, I regret to say, when no genuine emotion has been engendered, it can teach mere knack so to feign the airs of inspired knack as to deceive the very elect. This is the power in which I suspect Corot of deficiency. It is called intellect.

Corot was a rather stupid man and an instinctive painter. Few of those recorded sayings of his about values and conscience and what not are interesting, and many are quite silly. Some of his maxims go clean contrary to his practice; for he talked like poor Poll though he painted like an angel. When he was young he was adequately stimulated by what he saw, and the difficulty of rendering his passionate and personal vision evoked all his gift of expression. But as he grew older and more at ease with his proper experience, he had, or rather thought he had, to lace his genuine and genial reactions (I use the epithet in both the French and English sense) with something grander— with a dash of mythology or literature. The drug was spurious too. All this about Theocritus and Virgil is the purest bunkum. It was as much as the master could do to get through a few chapters of Balzac or pages of Hugo in a twelvemonth. Only when he painted the figure did he feel no call to vamp up a more elevated state of mind than he was capable of experiencing naturally. Only before that problem did he remain always young and candid. For human beings, he asked himself to feel only what he felt for a *boite au lait*, only what he had felt for La Trinità dei Monti or Chartres cathedral—an exquisitely pure and intense passion engendered by the eyes.[9] Manifestly M. Chauchard needed something better.

A cleverer man would never so have deceived himself. But Corot was stupid and modest and willing to believe what dealers and patrons and inferior painters told him about the importance of ideas in art and the supreme beauty of the classical dictionary. A cleverer man, being capable of self-criticism, would have understood that the dew-drenched nymphs and matutinal pixies meant no more to him than a yellow primrose did to Peter Bell.[10] A cleverer man would never have suffered himself to be imposed upon by Daubigny.[11]

Daubigny, twenty years his junior and a mediocre painter to boot, professed for Corot an honorable admiration, sought him out, and, incredible as it may appear, had on the modest and uncritical master an immense and lamentable effect. Up to the middle of his life the predominant influence on the art of Corot had been Claude.[12] Claude had imposed a severe, a compressed if not tight, style on the expansive lyricism of the Parisian romantic, which not Michallon, nor Delacroix, nor all the school of Barbizon had been able to loosen.[13] In his first Roman period for instance, always it is the contour that interests him: color he uses strictly to further his design. *"Ce que je cherche, c'est la forme, l'ensemble, la valeur des tons: la couleur, pour moi, vient après":* which being so, in 1835 that eminent critic and Egyptologist M. Lenormant naturally felt moved to complain that *"M. Corot ne parle la langue du paysage qu'en bégayant: sa touche est lourde et mate: la souplesse, l'humidité, le charme de la nature lui sont étrangers."*[14] Daubigny seems to have rubbed this criticism in. He loosened the master's style, enabling him to alternate henceforth—only in his landscapes be it understood—between fluency and fluffiness. He handed him a recipe for making pictures. Often it is said that Corot became feeble in his later years because he became poetical. In a sense he was poetical always: but if for "poetical" you read "literary," the criticism is just, so far as it goes. His landscapes became feeble because they became insincere; and they became insincere because sometimes he was trying to express sentiments not his own, at others nothing at all. He became mechanical. And it was Daubigny who taught him the trade of mass-production. Was ever such a case of *détournement d'un majeur?*[15]

It is fashionable to say that an artist ought not to be too intelligent—I dare say I have said it myself; in any case, like

other fashions it is absurd. That by pure intellect you cannot create a work of art is true enough: but as a retriever—to say nothing of horse-breaker—the intellect is invaluable. No more than anyone else can an artist be too intelligent. Had Corot had more wits about him he would early have recognized the nature of his genius and, knowing what food suited it, would have snapped his fingers at the quacks. He had miraculous vision, a superb painting gift, and limited imagination. He saw what no one else could see; and from what he saw he could extract all that he could express, which was more than almost anyone else could have expressed. The problem that suited him was the problem that kept his gift fully employed translating his vision. Now to assimilate into vision a number of facts perceived with the mind's rather than the body's eyes is not impossible; but it requires the imagination of a Giotto or a Rembrandt. This truth appears to have been known to another great painter of limited imagination, Renoir, who, when he has a mind to give us a "Judgment of Paris,"[16] takes care to pose his favorite models in the familiar landscape of Provence. But Corot, when he set himself to turn the woods of Ville d'Avray into Arcady, seems really to have supposed that the problem must be changed. I must—he seems to have said—at once paint a picture and render a peculiarly subtle, literary mood. I must be Corot and Theocritus at the same time. Giorgione might have done it.[17] But Corot, before such a problem, is no longer a painter before a *boîte au lait,* but a lower-form boy before a dictionary and a poem by Tennyson to be turned into elegiacs. Well, the boy knows how to deal with this problem: "You must have a trick," says he. Corot, alas! had one too. Trees in Arcady are more feathery than in the Isle-de-France, pools more misty and mysterious, young ladies more diaphanous and indecisive, and the whole is steeped in "the light that never was." There's a picture for you. Yes, but not an early Corot.

NOTES

1. Jean-Baptiste Camille Corot (1796–1875) is regarded as one of the greatest of French landscape painters.

2. Corot's *Le Beffroi de Douai* (1871) now hangs in the Louvre. A reproduction may be seen in *Jean-Baptiste-Camille Corot* by Madeleine Hours (New York: H. N. Abrams, 1972).

3. Jean-Baptiste-Hippolyte (Alfred) Chauchard (1821–1909) was founder and director of *les grands magasins du Louvre.* Bell claims, in a footnote, that among the fifty Corots which Chauchard gave to the Louvre there was not one first-rate picture.

4. The French painter Honoré Daumier (1810–79) is well remembered for his satirical caricatures.

5. "I paint a woman's bosom just as I would a milk can."

6. Albert Marquet (1875–1947) was a French painter of the fauvist group.

7. *La dame en bleu,* painted in 1874, is now in the Louvre. A reproduction can be seen in McGraw Hill's *Encyclopedia of World Art.*

8. J.B. Hobbs was a great cricket batsman for the Surrey team between World Wars I and II. "To get out for a duck" in cricket is to be called out without scoring.

9. Corot painted a work entitled *La Trinità dei Monti* in 1826–28 (now in the Museum d'Art et d'Histoire in Geneva). A reproduction is in *Corot* by Marc Lafargue (trans. Lindsay Wellington; London: T. Lane, 1926).

10. Bell repeats himself. See "De Gustibus," above, and appended note 2.

11. Charles François Daubigny (1817–78) was also a landscape painter.

12. Claude Gellée (1600–1682), known as Claude Lorraine, painted landscapes in a classical, poetical style. His influence on Corot is clear.

13. Achille Etna Michallon (1796–1822), and the Barbizon painters—a group who settled near Barbizon in the 1840s including Theodore Rousseau and Daubigny—attempted to escape the conventions of French classical landscape. Eugene Delacroix (1798–1863) revolted against the neo-classicism of David in his romantic work. Both of these important efforts swirled around Corot without seeming to touch him.

14. I have been unable to pinpoint the quotations from Corot and from Charles Lenormant (1802–59), because I have not been able to examine a copy of Lenormant's *Les Artistes Contemporains*. This book, published in Paris by A. Mesnier, is of two volumes, the first on the Salon of 1831, the second on the Salon on 1833. Since Corot won a second medal in the Salon of 1833, it seems natural that Lenormant would have written about him in his second volume. Corot's comment can be translated: "What I am looking for is the shape, the wholeness, the value of the tones: the color, for me, is secondary." Lenormant comments: "Mr. Corot cannot but stutter when speaking the language of the landscape: his hand is heavy and dull: the vibrant, glistening charm of nature is foreign to him."

15. "Corrupting the morals of an adult."

16. Pierre Auguste Renoir (1841–1919) painted the *Judgment of Paris* in 1908 (now in the Halvorsen Collection, Oslo). A reproduction can be seen in *The Art of Renoir* by Albert C. Barnes and Violette DeMazia.

17. Giorgione was a revolutionary figure in Renaissance art, insisting that painters work directly with color instead of beginning with a drawing. Cf. "Duncan Grant," above, and appended note 2.

Black and White

The exhibition at the Leicester Galleries[1] of a series of drawings by Matisse, dated 1935, is an event. That they are exquisite goes without saying. I am convinced that they are more; but that they raise a question I admit.

It was my first impression that this series of nudes was a series of enchanting arabesques. The handwriting was as seductive and quick as one expects the handwriting of Matisse to be; the disposition of blacks and whites was magically right; and from the complex of enticing lines emanated that troubling sense of life which emanates from even the most superficial of Matisse's creations. But were these appetizing things more than decorative? Were they expressive? Was the drawing more than calligraphic? Was is plastic? Had the artist his eye on the object or only on the tip of his pen?

Manifestly the artist claims to have worked with his eye on the object. Mainfestly, I say, because he has portrayed his own hand on the drawing-board, with the model and the mirror before him.[2] Is the claim made good? I have no doubt now that it is. These beautifully decorative pieces are expressive; these exquisitely sensitive and rapid lines contain volume; these abstractions are fraught with a sense of living mass, weight and stress. Matisse has both seen and felt what he has rendered. Consider Nos. 77, 74, and 69. These languid, though live, forms, for all their air of flowers dangling from broken stems, reveal themselves

Reprinted from the *New Statesman and Nation*, 15 February 1936: 226–27, by permission of the *New Statesman*, London.

gradually as deeply significant. That doubled-up and elongated petal expresses perfectly the essence of a crumpled arm, the taut muscles of which bear the weight of a body; while that other arm, though it hangs like the cracked tendril of a vine, implies in two lines all the substance of a human limb. Observe how in No. 69 the ripples on the smooth surface of a sheet of paper render the subtle modeling and firm contours of solid flesh. How superficial now appears the notion that these combinations of lines and spaces were to be classed with Oriental patterns. They come nearer to the drawings of Botticelli, or of Ingres for that matter.

Besides this series of 1935 drawings, there are a certain number of earlier works, drawings and lithographs, most of which will be familiar to amateurs of contemporary art. Also there are half a dozen illustrations for Joyce's *Ulysses*.[3] These are particularly interesting because here we can watch the artist at work, elaborating and emending his idea, through three or four consecutive stages. Baudelaire, though he knew precious little English, translated Poe, with the result that the French still believe that Poe was a poet.[4] It is to be expected that for many years to come they will take Joyce for a genius.

By rendering concrete values in form that is almost abstract Matisse shows himself, for all the apparent flatness of his design, a plastic artist. Augustus John, by whom a collection of etchings is showing at the Adams Gallery (2 Pall Mall Place), is essentially descriptive.[5] His work tends ever towards illustration. Describing, describing brilliantly, is his affair. These etchings— all, I think, of his best period, from about 1906 to 1910, and profoundly influenced by Rembrandt—are less purely descriptive than his later pictures because he digs deeper into what he sees. In *The Caravan* for instance, he has extracted from a vision the elements of a composition, instead of just recording the facts with a magnificent sweep of the arm. I am no judge of the technique of etching but I feel pretty sure that, as etchings, these are admirable. They are more. Well etched etchings we know all too well; we find them hanging in the waiting-rooms of cultivated surgeons and dentists. These, at least, are well etched etchings by somebody. They are personal, and the person behind them is Augustus John.

The Dobsons at the Storran Gallery (106 Brompton

Road) are, I think, all working drawings. They are of two kinds, projects for compositions and studies of single figures. Some of the former—2 and 4, for instance—may possibly remind you of Braque.[6] The resemblance, if it exists, is probably fortuitous; and anyhow one convention is as useful as another to a sculptor who is simply noting an idea for composition. It is in the studies for figures (e.g. 3,6,11) that the artist is seen at his best. This is the kind of sculptor's drawing which, by reason of its preoccupation with volume and absence of niggle, will always delight people who feel deeply the significance of form. The other day I heard Dobson described by a well-known royal academician as "academic." I take no exception to the epithet provided it be rightly understood. He is not royal academic of course; there is nothing commercial about his art. Neither is it academic in that honorable but boring way in which the drawings of Neville Lewis, also to be seen at the Storran Gallery, incline to be.[7] Lewis has done better than this and will do better again no doubt. He seems to have discovered a formula, based on the best conventions, which he applies, not without thought to be sure, but without much feeling. The consequence is that when you have looked at a couple of his drawings you know as much about his art as when you have looked at them all.

If you care to contrast a drawing or, better, a piece of sculpture by Dobson with a piece by Epstein—there is nothing by Epstein here—you will understand in a moment the sense in which Dobson is academic.[8] He can say all he has to say within the limits of the classical tradition. All his songs are written for a normal compass, he need not stretch his voice. It is by subtle relations and gradations, by a consistent rightness and tautness, and not by sweeping gestures and surprising effects, that he makes his points. He works inwards, perfecting harmonies and balancing masses to a scruple. The difference between Dobson and Epstein is, in kind, the difference between Houdon and Bernini, between Racine and Victor Hugo, between seeing the world in a grain of sand and finding the planet too small for one's passion.[9] I see no reason for setting one method against the other; in fact I consider the attempt to do so extremely silly. Only, it so happens that the two best sculptors alive, Maillol and Dobson (who is in some sort Maillol's pupil) are both academic by tem-

perament.[10] And here you can see a dozen fine drawings by the younger; and, what is more you can buy one of them for a dozen guineas.

NOTES

1. The Leicester Galleries are located in Cork Street, London.

2. Judging from this description, the drawing to which Bell refers is *Reclining Nude in Studio,* which is reproduced in *Matisse as a Draughtsman* by Victor Carlson (Greenwich, Conn.: New York Graphic Society, 1971). I have not been able to discover the names of the drawings to which Bell refers by catalog numbers, but the kind of work which he describes from 1935 may be seen reproduced in *Cahiers d'Art,* 20, nos. 3–5 (1936):69–148. Included on these pages are 8 full nudes from 1935 (as well as some heads) in many of which either the model or the artist is reflected in a mirror, an article by Christian Zervos discussing Matisse's creative process in terms quite compatible with Bell's ideas in "The Artistic Problem," and a poem by Tristan Tzara.

3. The edition of Joyce's *Ulysses* illustrated by Matisse was published in 1935 by the Limited Editions Club, New York. There are six illustrations—*Calypso, Eole, Polyphème, Nausicaä, Circe,* and *Ithagua.*

4. The French poet Pierre Charles Baudelaire (1821–67) introduced Edgar Allan Poe (1809–49) to Europe. Baudelaire first translated Poe in 1848, wrote a long essay on him for *Revue de Paris* in 1852, and issued a collection of Poe translations in 1856. All his life Baudelaire continued to translate Poe, making him well-known throughout Europe. French poets of the stature of Mallarmé, Rimbaud, and Valéry were admirers of Poe, whose reputation among Europeans far exceeded that in England and America. T. S. Eliot attributed Poe's status in Europe to misunderstandings of English on the part of Baudelaire, Mallarmé, and Valéry—see "From Poe to Valéry" in his *To Criticize The Critic* (New York: Farrar, Straus & Giroux, 1965). Bell's point is that the Matisse drawings will make look *Ulysses* better than it really is.

5. Augustus John (1878–1961), best known as a painter, did many works between 1905 and 1912 using gypsy caravans as subject. The

etching to which Bell refers is *Caravan with Horse,* which was exhibited throughout February 1936. A reproduction may be seen in *A Catalogue of Etchings by Augustus John, 1901–1914* by Campbell Dodgson (London: Charles Chenil & Co., 1920), on page 144. The Adams Gallery is now located at 24 Davies Street, Berkeley Square, London.

6. Frank Dobson (1889–1963) created considerable interest from 1920 on when his work—clearly influenced by cubism—began to appear. Bell is quite justified in suggesting a likeness with Georges Braque (1882–1963), French cubist painter. I have not been able to discover the names of the subjects of the drawings to which Bell refers by catalog number.

7. Neville Lewis's (1895–) drawings were regularly reproduced in *Studio* until 1948.

8. Jacob Epstein's (1880–1959) work clearly reflects his interest in the sculpture of Egypt, Africa, and Polynesia. Although influenced by cubism, Dobson's work is Western.

9. Bell contrasts the delicate portrait sculptures of Antoine Houdon (1741–1828) with the huge, baroque sculptures of Gian Lorenzo Bernini (1598–1680), and the careful dramatic poems of Jean Racine (1639–85) with the expansive romantic writing of Victor Hugo (1802–85).

10. The parallel which Bell establishes between Dobson and Aristide Maillol (1861–1944) seems quite just in light of the influence of Cézanne on Maillol. The latter worked with nature as composed of a few solids which, simplified, were to be arranged in space.

The Bran-pie and Eclecticism

It is a constant source of satisfaction to the Philistines that fashions in taste—taste in art I mean—appear to change as capriciously as fashions in frocks. Of course they do not; or rather—since I am far from sure that the changes of dressmakers' fashions are as aimless as the gentlemen who pay the bills suppose—of course, the changes in artistic taste are not capricious at all, but are determined rationally by the needs of artists and the spirit of the age. Equally false is the popular fancy that "anything may come into fashion one of these days." *Anything* may not: the choice of works that admit of resuscitation is strictly limited. Those only are eligible which have received a particular consecration: they must have been admitted to the bran-pie.

In this pie are the names only of those whom, vaguely enough, we call classics; they may be major classics or minor or minimus, but classics they all must be. All, that is to say, must be of those who have had a peculiar artistic experience and have created a form in which to express it. Unlike the popular favorites, these do not merely supply a want, but have qualities of their own: qualities which appeal not merely to an ephemeral but wide-spread mood of sentiment or curiosity, but to something rare and permanent. They appeal, in some way or other, to aesthetic sensibility; and to this they will appeal again. The age which produced and formed them vanished; but sooner or later they will be recognized by another which has need of their particular contribution, of their peculiar point of view. Sooner or

Reprinted from the *New Republic*, New York, 4 June 1924: 43–45.

later justice, as the biographers say, will be done; their works will be deliberately fished out of the pie (for the pie is not a lucky-bag from which one draws at haphazard) and sooner or later they will be brought into fashion.

The popular writers, or painters, or composers, the vast majority, who supply quite legitimately, and often ably and agreeably, a popular want, but lack those qualities which appeal to the essential and unchanging part of aesthetic sensibility, are out of it. No matter how great its contemporary vogue, their work, as art, dies with the society for which it was produced. Indeed it is not art, properly speaking—if it were it would live. At best it is artistic: but I say it dies "as art," because as archeological data some of it will survive in the erudition of scholars and *Kunstforschers.*[1] Before generalizing about the state of mind of the mid-seventeenth century, Professor Lanson or Professor Saintsbury[2] will think it right to dip into the two most popular authors of that age—Mlle. Scudéry and Le Calprenède; nevertheless their writings, as literature, are as dead as those of Eugène Sue or Silas K. Hocking.[3] They are dead; whereas *La Princess de Clèves,* though it has been out of fashion and will be so again, is immortal.[4] *La Princesse* is in the pie; sometimes she will lie hid, or half hidden, in the bran; but it will be open to any age with a taste for finesse in writing and sentiment, to pick her out and hold her up for admiration—indeed for adoration. *Le Grand Cyrus*[5] is not so preserved; nor are the poems of Martin Tupper and Macpherson, and Mason and the Rev. William Bowles:[6] they are not at the bottom of the pie, where lie at present, I understand, the novels of George Eliot and the poems of Alfred de Musset,[7] but at the bottom of the sea. Rather they are sinking ever through a bottomless ocean of oblivion, on which swims bravely the pie-dish: *fluctuat nec mergitur.*[8]

Who makes the pie? A few thousand people in each generation—the artists, the aesthetes, the high-brows, the intellectuals—call them by what bad name you will, I shall call them "the cultured." You will not suspect me of suggesting that culture makes no mistakes: of the handful of classics chosen by each generation one or two will be expelled ultimately, while a name or two may be added by succeeding generations. But note that the whole business is done by a few specially gifted and trained

men and women. The public has no finger in this pie. The public is out of it because the public can no more judge of art than of the higher mathematics. If the great public—of which, when it comes to making a mathematical pie, I am one—believes that Newton and Einstein are amongst the masters of thought, that is not because the great public is in a position to test the validity of their conclusions, or even to follow the arguments by which they reach them. And the public believes Giotto to have been a great painter for precisely the same reason that it believes Newton to have been an eminent astronomer. It takes it from its betters.

Were that rare breed of sensitive and discriminating people which emerges from each generation to become extinct, there would be no one in the world to know that Giotto's frescoes at Padua were better than *The Roll Call.*[9] Manifestly the public likes *The Roll Call* better than anything Giotto has to offer. Wherefore, did it rest with the public, Giotto would soon be as completely forgotten as Lady Butler will be. Culture both makes and maintains the pie. For though culture cannot make the public like, it can make the public respect. The man-in-the-street admires, not only the plays of Shakespeare, but the plays of Dryden which he never reads and never dreams of reading. He would be the first to assert—were he told of it—that *All for Love* must be greater than *Charley's Aunt,*[10] or that a picture by Raphael was better than a picture by the Hon. John Collier.[11] And, though, it may happen, and sometimes does, that the cultivated elite and the general public agree in liking genuinely—and therefore for different reasons—a contemporary, though a popular favorite (Dickens is an obvious example) may get into the pie—it is never the public that puts him there.

Now the odd thing, at first sight, is that of the names which are in the pie, only those of a few giants are uninterruptedly kept on the top. The rest must be content to go in and out of fashion. Thus, in the eighteenth century, the names of many of the greatest fifteenth century painters were almost unknown; and the exquisite poetry of the Middle Ages was neglected till the beginning of the romantic revival, when it was the turn, for a while, of Pope and Dryden to be despised. The explanation is supposed to be that human beings have but two hands with which to dip; that human sensibility can react intensely and

sincerely only to a certain quantity of art, and only to such as for one reason or another is congenial to it; that the attempt to enjoy everything ends in enjoying nothing; and that that way professorships of art and literature lie.

It is certain that most people do tend to appreciate, if not one kind of art only, at any rate only cognate manifestations. Voltaire, who could enjoy Racine and Virgil, got a nightmare from supping with Shakespeare, and romantic revellers in Shakespeare who adored Hugo maintained that they found no meat in Racine. Both were right, then? Certainly the case against eclecticism is plausible. To hold right opinions in art is useless: if you cannot react to a work you had better leave it alone. Here is God's plenty. What need has he who can appreciate Gothic architecture, Elizabethan poetry, and the romantic music of the nineteenth century to bother about the Augustans? Per contra, what need has anyone, blest with that sensibility which finds ecstasy in perfection—one therefore who can get to the heart of the Attic drama and the art of the grand siècle—what need has he of the romantics? The more genuinely one enjoys the delicacy of Jane Austen, the more genuinely will one detest the extravagance of Dostoievsky.[12] The whole of art is too vast for any one mind to comprehend, and what cannot be comprehended had best be ignored. It is not ignored, however: your delight in what Shakespeare has, makes you intensely conscious of what Racine has not; and will make you furious with anyone who admires him for his economy. True enough; for if artistic achievement is so vast that no one sensibility can taste it all, the possibilities of art are too numerous for even the greatest native genius to exploit them all. No form, no class of forms, can comprehend the whole of aesthetic experience. Inevitably Shakespeare has his defects, and so has Racine; and the more passionately we love the qualities of one the more strongly we shall feel a want of them in the other.

The artists begin it; they set the fashion, drawing the names they want from the pie. Their choice is always intelligible. They want what will both nourish and defend them—masters whose achievement seems to justify their attempts. These they study and extol; but those others, the ones who attacked the problem from the other end, and seem therefore to have had, not

a different, but a contradictory conception of art—they are the enemy, or rather the enemy's bludgeon. To be for them is to be against us. Is it wonderful, then, that Wordsworth, who knew so well what he was doing and believed in it so intensely, should have been so fiercely aware of the defects, and so blind to the merits, of Pope who was so manifestly doing something else?

Yet there is something to be said for eclecticism too. For, though no one can enjoy passionately all art, some can appreciate more than one kind; and it seems sensible to go on widening one's appreciation until unmistakably one is reducing its depth. Enough is as good as a feast; but it is a poor thing to starve on principle. It would be silly to deprive oneself of aesthetic pleasures out of deference to a theory; and that is, in fact, what most do who scrupulously follow the fashion. For artists in the throes of creation a certain narrowness of appreciation may be necessary. Creation is an act of faith; and perhaps they cannot risk weakening their convictions. But that is no reason why we, amateurs, should suffer the artists to cap us with their blinkers— the prejudices imposed by our own temperaments are obstructive enough. Also, it becomes us, I think, to remember that no one whose name is in the pie can be without merit, and that without attempting to force one's reactions it is possible to keep a civil tongue in one's head.

This is a palinode. Twenty years ago painters, followed by critics and amateurs—*quorum pars minima fui*[13]—set up a cry for directness, design and significance. They dipped into the pie and brought up the Byzantine and Romanesque artists; they added the niggers.[14] So far so good; a great deal of unjustly neglected art was brought into fashion and appreciated. But then, because we appreciated, as the last generation has not, austerity and abstract design, we would hear no good word for anything charming, untidy or humane. Down with the Greeks! Down with the Impressionists! Down with the Eighteenth Century! We could not admire Dante—not the interesting, anecdotic, raconteur of the Inferno but the abstract architect of the Paradiso— without decrying Milton—who was deemed "poetical."[15] We could not give Defoe his due without dismissing Flaubert as "literary."[16] Was it really necessary? Could we not have loved Cézanne so well if we had tried to understand Watteau more?[17]

199

The question is of some immediate interest, because, if we were right then, we are wrong now. Eclecticism is coming into fashion—let no fanatic be unduly cast down, it will go out again. Cultivated taste is all for getting as big handfuls as it can, and for digging them from every corner of the dish. We are for a mixed diet; some go so far as to admit that what is their poison may be another's meat. A reason for this is, I suspect, that cultivated opinion is not much inclined to be intimidated by contemporary artists. We follow Stravinsky through his surprising evolutions and admire; but Stravinsky can no longer persuade us to despise Beethoven.[18] We shall go on admiring Milton whether Mr. T. S. Eliot likes him or not; nor will the young poets' war on wit put us out of humor with M. Anatole France.[19] Whether we lose something in intensity to compensate this gain in width I hardly know; what is more, I doubt whether we care. We mean to enjoy ourselves. Life is become too unsure for us to sacrifice any certain pleasure to potential good. We have sniffed winter in the air, and we mean to gather our roses. And, then, we have another motive to eclecticism: scepticism. Is it, after all, so very important to preserve a clean palate? Must we deny ourselves the delights of memoir-reading for fear of blunting our appetite for lyrics? Are there not other values in life? And is not fanaticism extremely ridiculous?

NOTES

1. Art historians.

2. Gustave Lanson (see also above, "The Critic as Guide," note 5) (1857–1934) remains to this day one of the greatest of historical critics. His *History of French Literature* is a landmark. George Edward Batman Saintsbury (1845–1933) was known during his own time as the greatest systematic expositor of French literature to the English. His *Short History of French Literature* (1882) stands as the center of his effort.

3. Magdaleine de Scudéry (1607–1701), and Gautier de Costes de La Calprenède (1614–63) were popular French writers in the 17th century; Silas Kitto Hocking (1850–1933) and Marie Joseph Sue (1804–57) were popular writers of the 19th century. Hocking ground out 33 novels. Sue is remembered for *The Wandering Jew* and *The Mysteries of Paris.*

4. *La Princesse de Clèves,* written by Marie Madeleine LaFayette (1634–93) between 1672–78, is regarded as the prototype for French classical literature.

5. *Artamène, ou le grand Cyrus* was written by Madaleine de Scudéry in 1650.

6. Martin Farquhar Tupper (1810–89), *Proverbial Philosophy* in blank verse. For James Macpherson see above, "De Gustibus," note 6. William Mason (1724–97) wrote *The English Garden* in blank verse. For Bowles, see "De Gustibus," above, note 7. All referred to were popular in their own time but were "not art, properly speaking," in Bell's terms.

7. George Eliot (1819–80) author of *Silas Marner* and *Middlemarch,* and French poet Alfred de Musset (1810–57) who wrote *Poésies divers-*

es and *Le Spectacle dans un fauteuil,* illustrate writers of permanent artistic value whose popularity is temporarily in abeyance.

8. "It floats (along) without being submerged." (This is the motto for the city of Paris.)

9. *The Roll Call,* a painting by Elizabeth Southerdan Thompson Butler (1844–1933), was first exhibited at the Academy in London in 1874. Overnight it gained popularity without precedent in English art history. Purchased by Queen Victoria, it hangs at Windsor Castle.

10. John Dryden's (1631–1700) *All For Love* (1678), is a dramatic version, in blank verse, of the story of Anthony and Cleopatra. *Charley's Aunt,* a farce written by English actor Brandon Thomas (1856–1914), opened in 1892, and ran 1,466 performances. It was revived virtually every year from 1901–38, playing all around the world, and was converted into a musical and a film.

11. Raffaello Sanzio (1483–1520) continues to be considered one of the greatest painters of the Italian Renaissance. John Collier (1850–1934) was known for his portraits, which, in the academic manner, faithfully reproduced everything which appeared before the artist's eye.

12. In this comparison of Jane Austen (1775–1817) and Fedor Dostoevski (1821–81) I do not believe that Bell means to suggest that Austen's work has less content than Dostoevski's; rather she is more subtle.

13. "Of whom I was the least significant one."

14. "They" in this sentence refers to the Post-Impressionists, and those who supported them, including, of course, Bell himself. Paul Gauguin (1848–1903) was the first of the Post-Impressionists to notice the aesthetic appeal of African and Oceanic sculpture. Later, Pablo Picasso (1881–1973) and others used this art as a weapon against older conceptions of beauty in both sculpture and painting. Roger Fry has an essay "Negro Sculpture" in *Vision and Design.* Bell's article "Negro Sculpture" can be found in *Since Cézanne.*

15. T. S. Eliot's (1888–1965) antipathy for John Milton is clear in Eliot's essays "The Metaphysical Poets" and "Andrew Marvell" (1921); his appreciation of Dante equally clear in 1920 with the publication of *The Sacred Wood.* Since Eliot frequently visited in Bloomsbury during this time, it is most likely that Bell's comments here are based upon conversations with him.

16. The contrast between Daniel Defoe's (1659–1731) *Robinson Crusoe* and Gustave Flaubert's (1821–80) *Madame Bovary* is probably the kind of difference Bell has in mind.

17. In contrast with the highly formal quality of Cézanne's work, Jean-Antoine Watteau's (1684–1721) work would be literary and formless. It was against the background of Watteau's influence that David introduced neo-classicism in France.

18. Igor Fedorovich Stravinsky (1882–1971) caused a revolution in music at the beginning of this century with *Fireworks, The Fire Bird,* and *The Rite of Spring.*

19. Until his death in 1924 Anatole France was one of the most widely known of French writers. His wit lay in his ability to be gently satirical of himself and the world around him. Paul Valéry, the great French poet, was elected to France's chair at the Academy, and in his reception address suggested that France's writing did not compare favorably with more complex and explosive literary styles then being developed.

Art Teaching

It was Miss Richardson who brought children's painting into fashion. I know what Ruskin said; also I know that what he said on this subject had little effect on his contemporaries. It was only when Miss Richardson, helped by Roger Fry, persuaded my generation to look at pictures by children of between five and twelve that the more sensitive were bowled over by the prettiness of what they were shown.[1] They were charming, these artifacts, and so absurdly did some of us exaggerate their significance that optimists assumed, naturally enough, that these small creatures had only to continue as they had begun, encouraged of course by sympathetic teachers, to become in due time Matisses, or Dufys at the very least.[2] In this, however, optimists mistook. One must suppose the human child born with taste and a turn for decoration, both of which, somewhere between ten and fifteen, the adolescent loses. Of this strange fact in natural history no biologist has so far offered a satisfactory explanation; but certain it seems that not one adult in ten thousand can appreciate what he or she, as a baby, could create.

This melancholy discovery was not allowed to damp the ardor, still less to diminish the numbers, of those who, self-consecrated to the task of firing the imagination and washing the faces of potential masters, had gone into the teaching business. Only they shifted their ground, and so doing improved their position. If we cannot teach children to become artists, they argued,

Reprinted from the *New Statesman and Nation,* 26 August 1950: 225–26, by permission of the *New Statesman,* London.

we can teach them, through the practice of drawing and painting of course, to appreciate art, through the appreciation of art they will come to understand life, through an understanding of life they will become good citizens. The sorites was inconclusive, but the move was profitable. Politicians who care not a rap for art are bound to pretend at any rate that they care passionately for the production of good citizens. The moment art-teaching became a branch of welfare-work it became possible to extract a penny or even a twopenny rate for the maintenance of art-classes and their teachers.

It may be true that training children to paint and draw a little is one way of stimulating appreciation. I doubt whether it is the best. What I am sure of is that by making drawing and painting-lessons part of the curriculum you will do nothing for creative art—except in so far as you are giving artists a chance of eking out a living by teaching. That, however, is not to dismay the people who are taking care of the future. Their cry is—"All for the milk-bar and never mind the cow." And perhaps they are right. For, in the coming of age, a capacity for appreciation may stand a man in better stead than a gift of creation. The outlook for the creative artist is bleak.

It is bleak because a young, unorthodox, creative artist—so long as he remains unorthodox—is a beggar living on alms. "Doxies" vary like fashions. (At this present writing, a more or less abstract style is the thing and representation is not.) A fresh, creative artist is apt to reject current dogmas and to be regarded with disfavor, if regarded at all, by official taste. The young heretic is rarely popular: so he becomes a parasite on those few sensitive, unofficial but well-to-do people who are capable of appreciating his generally unacceptable productions. He must sponge on the fortunate and perceptive. Now the charity of one or two aesthetes will not keep a beggar when prices are high; what made the climate of nineteenth-century France peculiarly favorable to undisciped genius was that wages and prices were so low that a young Impressionist with a patron might hope to live as handsomely as a cab-driver. When you remember that present tendencies are not only to raise "the standard of living"—to increase material satisfactions, that means, in return for what the community deems useful work—but also to eliminate the one

205

class disposed to give unpopular artists any wages at all, you will probably agree that the outlook for young heretics is what I said it was.

Certainly the politicians who willingly subsidize the teachers cannot be expected to favor that intractable individualist, the independent artist. To them, to their constituents at all events, his activities, from which no demonstrable welfare accrues, will appear useless if not anti-social. What philanthropic politicians want to do is to educate the multitude so that many instead of few may have access to the intense and enduring pleasures art is said to offer. They wish "the common man," as apparently he likes to be called, to enjoy pictures; and this wish is not only praiseworthy but perhaps attainable. Some, no doubt, would be glad also to promote the creation of art; but to do that it would be necessary, amongst other things, to change the way of the world, which presumably they would not do even if they could. Luckily their main purpose may be achieved, though the second remain a pious hope. Education might provide the common man with limited power of appreciation, enough perhaps to enjoy intermittently works of art that have been discovered by uncommon men and in due course recognized by officials. There is the art of the past: so, should creation cease entirely, which seems likely enough, there will yet be plenty in the museums and galleries for the common may to enjoy. Only, it is well to ask oneself whether in a barren society human beings will retain the power of enjoyment.

Should the creation of art, of great art at all events, cease for a while, we must hope that men and women will appreciate what they have. We must hope they will be able to find in works ready to hand a means to happiness. The palace of pleasures exists, well stocked; a free treat awaits inside. But the door is locked. Insensibility and ignorance bar the way. How are common men and women to be supplied with a key? That, I take it, is the problem with which philanthropic politicians are willing to grapple.

By teaching children to paint and draw, say the art-masters. They may be right. Nevertheless, there is another way, which to me seems promising but to which, so far as I know, little thought has yet been given in this country. It may be that the

easiest way of persuading people to look at pictures, sculpture, buildings and works of art generally is to teach them, not drawing and painting, but Art-History. It may be the Art-Historian is a better educator than the Color-Master. At least I have observed—and I believe the experience of those best qualified to speak on the subject confirms my observation—that once people know a little art-history their interest in works of art grows surprisingly. They look at them for silly reasons; but they look. And, should they chance to be blest with a modicum of sensibility, looking for evidence they may stumble on art. No one who has enjoyed my advantages is likely to be unaware of the fact that a man may, and sometimes does, become an eminent *Kunstforscher* without once in his life experiencing an aesthetic emotion. All the same, of those who, for one reason or another, make a habit of looking at works of art, a certain number, one must suppose, will eventually derive some pleasure from art's essential significance. These, philanthropic ladies and gentlemen, will be your successes—these students who through Art-History come at art. But observe that your failures, those who cannot go beyond considering the work as a document, and using it as such, will not have wasted their time. They will have had the benefit of a liberal education. The study of Art-History is nothing less. Those who have not learnt to enjoy Beauty will at least have acquired Culture.

For consider: the student will have been forced to read some history and to look at the map, perhaps to read a little psychology as well; his researches may lead him to dabble in literature; pushing his studies in the hope of a scholarship he may even be tempted to acquire the rudiments of a foreign language. At worst a course of Art-History gives a tincture of civility; at best it may engender a love of art. But let no one imagine it will provoke creation.

There is a simple way of promoting these studies. As soon as Oxford and Cambridge have founded schools of Art-History, as soon as it is possible to take degrees in this subject at the great universities, the subject will become popular in the secondary schools As soon as parents realize that, helped by bounties and prizes provided by the tax-payer, boys and girls can make of Art-History a ladder that leads to that coveted insur-

ance-ticket "B.A. Oxon. or Cantab.," all over the country you will see boys and girls looking at works of art and taking a fairly intelligent interest in them. That, I suppose, is what philanthropic politicians desire.

NOTES

1. While the English art critic John Ruskin (1819–1900) advocated teaching children precise rendering of things such as flowers and small animals, art educator Marion Richardson (1892–1946) and critic Roger Fry (1866–1934) were interested in children's spontaneous expression of their grasp of form. Ruskin's position is developed in "Education in Art," *Works*, vol. 10 (New York: Thomas Crowell & Co, n.d.). The efforts of Richardson and Fry are recorded in letters 394, 399, and 447 of Denys Sutton's *Letters of Roger Fry* (London: Chatto & Windus, 1972).

2. Raoul Dufy (1877–1953), French textile designer and painter.

PART III
A Checklist of the Published
Writings of Clive Bell
by Donald A. Laing

Introduction

The following pages list the first English and first American appearances of Clive Bell's published writings. While I have made every effort to make this list as complete as I can at the present time, the likelihood of omissions remains large, particularly in the areas of newspaper correspondence and exhibition catalogs. Clive Bell was never slow with his pen, and it seems probable that many letters still lie buried in the columns of newspapers. At the moment I know of only three prefaces to exhibition catalogs by Bell: his comments on "The English Group" in the catalog to the Second Post-Impressionist Exhibition; "Marchand," the preface to the Marchand Exhibition at the Carfax Galleries in 1915, which has been reprinted in *Pot-Boilers;* and the introduction to the Sickert Exhibition at the Eldar Galleries in 1919, which Alan Bowness mentions in his Arts Council pamphlet, *Decade 1910–20.* It seems to me most unlikely that these are the only three such prefaces written by Bell in a career of more than forty years.

Most of the work on this checklist was done while I was in England on a Canada Council Doctoral Fellowship and I should like at this point to thank the Council. I must acknowledge the New Statesman and Nation Publishing Company for their kindness in permitting me to consult their files and to publish my findings. I am grateful to the patient and helpful staffs at several libraries, especially those at the British Museum Library of Newspapers and Periodicals at Colindale, at the Victoria and Albert Museum, at the University of Toronto, and at the Toronto Public Library. I am grateful, too, for the assistance given me

213

by Miss Mary Anne Stevens, Mr. Alan Bowness, and Mr. William G. Bywater, Jr. Above all I must thank Professor S.P. Rosenbaum of the University of Toronto for the constant support of his knowledge and kindness.

BOOKS AND PAMPHLETS

Art. London: Chatto and Windus, 1914. New York: F.A. Stokes, 1914.

Peace at Once. Manchester and London: National Labour Press, 1915.

Ad Familiares. London: Pelican Press, 1917. The following poems appear
in this collection: "The Card House," "Letter to a Lady: A Gli
Alberetti, Venice," "To V.S. with a Book," "Myself to Myself,"
"Spring," "Reply to Mrs. Jowitt," "To Gerald Shove," "March,"
"April," "June," "October," "December," and "Letter to a Lady."

Pot-Boilers. London: Chatto and Windus, 1918.

Poems. Richmond: Printed and published by Leonard and Virginia
Woolf at the Hogarth Press, 1921. This collection includes all the
poems published in *Ad Familiares* and adds the following: "To Lo-
pokova Dancing," "After Asclepiades," "The Last Infirmity," and
"ΠΑΝΤΩΝ ΓΛΥΚΥΤΑΤΟΝ ΜΕΤΑΒΟΛΗ." In *Poems* the title of
"To V.S. with a Book" is changed to "To A.V.S. with a Book."

Since Cézanne. London: Chatto and Windus, 1922. New York: Harcourt,
Brace, 1922.

The Legend of Monte della Sibilla; or, le Paradis de la reine Sibille. Richmond:
Printed and published by Leonard and Virginia Woolf at the Ho-
garth Press, 1923.

On British Freedom. London: Chatto and Windus, 1923. New York:
Harcourt, Brace, 1923.

Landmarks in Nineteenth-Century Painting. London: Chatto and Windus,
1927. New York: Harcourt, Brace, 1927.

Civilization: An Essay. London: Chatto and Windus, 1928. New York:
Harcourt, Brace, 1928.

Proust. London: Leonard and Virginia Woolf at the Hogarth Press, 1928. New York: Harcourt, Brace, 1928.

An Account of French Painting. London: Chatto and Windus, 1931. New York: Harcourt, Brace, 1932.

Enjoying Pictures: Meditations in the National Gallery and Elsewhere. London: Chatto and Windus, 1934. New York: Harcourt, Brace, 1934.

Warmongers. London: Peace Pledge Union, [1938].

Victor Pasmore. Harmondsworth: Penguin, 1945.

Modern French Painting: The Cone Collection. Baltimore: Johns Hopkins, 1951.

The French Impressionists: With Fifty Plates in Full Colour. London: Phaidon, [1952]. Greenwich, Conn.: Phaidon distributed by New York Graphic Society, 1952. Although the first edition of this book indicates that it was published in 1951, it was not actually published until 1952. According to the records of Phaidon Press, the book was prepared for publication in 1951, but, owing to printing and binding delays, it did not arrive in time to be published that autumn and so was delayed until the spring of 1952. I am grateful to Mr. Arthur Morris of the Phaidon Press for this information.

Old Friends: Personal Recollections. London: Chatto and Windus, 1956. New York: Harcourt, Brace, 1957.

CONTRIBUTIONS TO BOOKS AND PAMPHLETS

Euphrosyne: A Collection of Verse. Cambridge: Elijah Johnson, 1905. This anonymous collection contains poems written by Lytton Strachey, Leonard Woolf, and several other friends of Bell while he was at Cambridge. The following poems appear to be by Clive Bell: "Lines Written at Dusk in the Great Court," "'Tis many a day since last I saw you, dear," "Pereunt et Imputantur," "Casanova," "In the Days of Utter Night," "At Dawn," "Rain at Night after a Day of Heat," "The Trinity Ball," "A Lady Smoking a Cigarette," "L'Andalouse (from the French of Alfred de Musset)," "Curtailed Sonnet: George Meredith," "Assonance," "Roundel," and "After a Dance (à Madame de Montmartre)."

Renoir, P.A. *Les Parapluies.* Introduction by Clive Bell. London: Percy Lund Humphries, 1945.

Stamper, Frances Byng, and Caroline Lucas, eds. *Twelfth Century Paintings at Hardham and Clayton.* Introduction by Clive Bell. Lewes: Miller's Press, 1947.

Gernsheim, Helmut. *Julia Margaret Cameron: Her Life and Photographic Work.* Introduction by Clive Bell. London: Fountain Press, 1948.

March, Richard, and Tambimuttu, eds. *T.S.Eliot: A Symposium from Conrad Aiken et al.* London: Editions Poetry, 1948. This collection contains "How Pleasant to know Mr. Eliot" by Clive Bell on pages 15–19. This essay is reprinted as "Encounters with T.S.Eliot" in *Old Friends.*

EXHIBITION CATALOGS

"The English Group." *Second Post-Impressionist Exhibition: Catalogue with Thirty-nine Half-tone Reproductions and Frontispiece in Four Colours,* London: Ballantyne and Co., 1912, 9–12. This exhibition was held at the Grafton Galleries from 5 October until 31 December, 1912.

Preface to the Marchand Exhibition, Carfax Galleries, June 1915. Reprinted as "Marchand" in *Pot-Boilers.* I have not been able to locate a copy of the original catalog, and have thus seen the essay only in its reprinted version.

"Sickert." Preface to *Walter Sickert—A Catalogue of Paintings and Drawings,* London: Eldar Gallery, Jan.-Feb. 1919, 3–8. This catalog announces that "the Eldar Gallery are issuing a large, illustrated work on Sickert," strictly limited to 100 copies, with a preface by Clive Bell. I have been unable to locate a copy of this book.

CONTRIBUTIONS TO PERIODICALS AND NEWSPAPERS

1909

Review of *John Keats: A Literary Biography,* By A.E. Hancock. *Athenaeum,* 2 January 1909: 8–9. Unsigned.

Review of *The Letters of James Boswell to the Rev. W.J. Temple. Athenaeum,* 13 February 1909: 191–92. Unsigned. Reprinted as "Boswell's Letters" in *Pot-Boilers.*

Review of *The Great English Letter-Writers,* by W.J. and C.W. Dawson. *Athenaeum,* 6 March 1909: 288. Unsigned.

Review of *Shelley,* by Francis Thompson. *Athenaeum,* 24 April 1909: 490 –91. Unsigned.

Review of *The Love Letters of Thomas Carlyle and Jane Welsh,* ed. A. Carlyle. *Athenaeum,* 8 May 1909: 553. Unsigned. Reprinted as the second part of "Carlyle's Loves and Love Letters" in *Pot-Boilers.*

Review of *Nineteenth Century Teachers,* by J. Wedgwood. *Athenaeum,* 19 June 1909: 723–24. Unsigned.

Review of *The Orphan, and Venice Preserved,* by Thomas Otway, ed. C.F. McClumpha; and *The Spanish Gipsie, and All's Lost by Lust,* by Thomas Middleton and William Rowley, ed. E.C. Morris. *Athenaeum,* 31 July 1909: 136. Unsigned.

Review of *Fasciculus Joanni Willis Clark dicatus. Athenaeum,* 7 August 1909: 153. Unsigned.

Review of *George Bernard Shaw,* by G.K. Chesterton. *Athenaeum,* 11 September 1909: 291–92. Unsigned.

Review of *Carlyle's First Love, Margaret Gordon, Lady Bannerman,* by Raymond Clare. *Athenaeum,* 30 October 1909: 524–25. Unsigned. Reprinted as the first part of "Carlyle's Loves and Love-Letters" in *Pot-Boilers.*

Review of *Letters from George Eliot to Elma Stuart, 1872–1880,* ed. Roland Stuart. *Athenaeum,* 27 November 1909: 657. Unsigned.

"Dobson Recital at Bechstein Hall." *Athenaeum,* 4 December 1909: 707–8. Signed C.B.

Review of *Shelley, the Man and the Poet,* by A. Clutton-Brock. *Athenaeum,* 18 December 1909: 753–54. Unsigned.

Review of *Yet Again,* by Max Beerbohm. *Athenaeum,* 18 December 1909: 759–60. Unsigned.

1910

Review of *The Autobiography,* by Anna Robeson Burr. *Athenaeum,* 12 February 1910: 180–81. Unsigned.

Review of *Keats: Poems Published in 1820,* ed. M. Robertson. *Athenaeum,* 19 February 1910: 215–16. Unsigned.

Review of *John Keats: Sa vie et son oeuvre,* and *An Essay on Keats's Treatment of the Heroic Rhythm and Blank Verse,* by Lucien Wolff. *Athenaeum,* 19 March 1910: 336–37. Unsigned.

Review of *Things Worth Thinking About,* by T.G. Tucker. *Athenaeum,* 16 April 1910: 458. Unsigned.

Review of *Mad Shepherds, and Other Human Studies,* by L.P. Jacks. *Athenaeum,* 18 June 1910: 729. Unsigned.

Review of *Threnodies, Sketches, and Other Poems,* by the Author of "Thysia." *Athenaeum,* 25 June 1910: 755. Unsigned.

Review of *Les Maîtres Sonneurs,* by George Sand, ed. Stéphanie Barlet. *Athenaeum,* 2 July 1910: 10. Unsigned.

Review of *Gathered Leaves from the Prose of Mary E. Coleridge,* with a Memoir by Edith Sichel. *Athenaeum,* 9 July 1910: 33–34. Unsigned. Reprinted as "Miss Coleridge" in *Pot-Boilers.*

Review of *Love and Honour, and The Siege of Rhodes,* by Sir William D'Avenant, ed. James W. Turner. *Athenaeum,* 16 July 1910: 79–80. Unsigned.

Review of *Dead Language and Dead Languages, with Special Reference to Latin,* by J.P. Postgate. *Athenaeum,* 6 August 1910: 152–53. Unsigned.

"Prof. Kynaston." *Athenaeum,* 6 August 1910: 153. Unsigned.

"Linley Sambourne." *Athenaeum,* 6 August 1910: 162. Unsigned.

Review of *Celt and Saxon,* by George Meredith. *Athenaeum,* 13 August 1910: 176. Unsigned.

Review of *The Merry Wives of Windsor,* by William Shakespeare, illustrated by Hugh Thomson. *Athenaeum,* 22 October 1910: 496. Unsigned.

Review of *Howards End,* by E.M. Forster. *Athenaeum,* 3 December 1910: 696. Unsigned.

Review of *People and Questions,* by G.S. Street. *Athenaeum,* 17 December 1910: 763. Unsigned.

" 'Rosamond' at the little Theatre." *Athenaeum,* 17 December 1910: 776. Signed C.

1911

Review of *The Letters of Edward John Trelawny,* ed. H. Buxton Forman. *Athenaeum,* 7 January 1911: 7–8 Unsigned. Reprinted as "Trelawny's Letters" in *Pot-Boilers.*

Review of *Notes on the Post-Impressionist Painters, Grafton Galleries, 1910–11,* by C.J. Holmes. *Athenaeum,* 7 January 1911: 19–20. Unsigned.

Review of *The First Temptation of Saint Anthony,* by Gustave Flaubert, trans. René Francis, ed. Louis Bertrand. *Athenaeum,* 14 January 1911: 38. Unsigned.

Review of *Revolution in Art,* by Frank Rutter. *Athenaeum,* 4 February 1911: 135. Unsigned.

Review of *The Plays of Thomas Love Peacock,* ed. A.B. Young. *Athenaeum,* 4 February 1911: 139–40. Unsigned. Reprinted as the first part of "Peacock" in *Pot-Boilers.*

Review of *The Works of John M. Synge. Athenaeum,* 18 February 1911: 182–83. Unsigned.

Review of *Notes on Wiltshire Names, Volume I, Place-Names,* by John C. Longstaff. *Athenaeum,* 29 April 1911: 474. Unsigned.

Review of *The Post-Impressionists,* by C. Lewis Hind. *Athenaeum,* 8 July 1911: 51. Unsigned.

"The 'Trachiniae' at the Court Theatre." *Athenaeum,* 15 July 1911: 84. Signed C.B. Reprinted as the second part of "Sophocles in London" in *Pot-Boilers.*

"Garden City Folk Plays." *Athenaeum,* 2 September 1911: 279–80 Unsigned.

"The Decorations at the Borough Polytechnic." *Athenaeum,* 23 September 1911: 366. Unsigned.

Review of *The Flight of the Dragon: An Essay on the Theory and Practice of Art in China,* by Laurence Binyon. *Athenaeum,* 7 October 1911: 428–29. Unsigned. Reprinted as "The Flight of the Dragon" in *Pot-Boilers.*

"Old Masters at the Grafton Galleries." *Nation*, 7 October 1911: 13–14. Signed C.B.

Review of *The Life of Thomas Love Peacock*, by Carl Van Doren, and *Thomas Love Peacock*, by A. Martin Freeman. *Athenaeum*, 14 October 1911: 450–52. Unsigned. Reprinted as the second part of "Peacock" in *Pot-Boilers*.

1912

Review of *The Lysistrata of Aristophanes, acted at Athens in the Year B.C. 411*, trans. Benjamin Bickley Rogers. *Athenaeum*, 13 January 1912: 33–34. Unsigned. Reprinted as "The Lysistrata" in *Pot-Boilers*.

" 'Oedipus Rex' at Covent Garden." *Athenaeum*, 20 January 1912: 75–76. Signed C.B. Reprinted as the first part of "Sophocles in London" in *Pot-Boilers*.

Paragraph beginning "The decorations at the Borough Polytechnic . . ." *Athenaeum*, 27 April 1912: 478. Unsigned.

"Ibsen." *Athenaeum*, 22 June 1912: 697–98. Unsigned. Reprinted in *Pot-Boilers*.

"The London Salon at the Albert Hall." *Athenaeum*, 27 July 1912: 98–99. Signed C.B. Reprinted as "The London Salon" in *Pot-Boilers*.

1913

"Post-Impressionism and Aesthetics." *Burlington Magazine*, 22 (Jan. 1913): 226–30.

"Montaigne in Facsimile." *Athenaeum*, 4 January 1913: 7–8. Unsigned. Reprinted in *Pot-Boilers*.

"Mr. Roger Fry's Criticism." *Nation*, 22 February 1913: 853–54. Letter.

"Mr. Shaw and Mr. Fry." *Nation*, 8 March 1913: 928. Letter.

"Post-Impressionism Again." *Nation*, 29 March 1913: 1060–61. Signed C.

"The New Post-Impressionist Show." *Nation*, 25 October 1913: 172–73. Reprinted as "English Post-Impressionists" in *Pot-Boilers*.

1914

"Aesthetics: A Reply." *New Statesman,* 21 March 1914: 756–57. Reprinted as "Countercheck Quarrelsome" in *Pot-Boilers.*

"The Place for Persian Carpets." *New Statesman,* 4 April 1914: 816–17. Letter.

"Persian Miniatures." *Burlington Magazine,* 25 (May 1914): 111–17. Reprinted in *Pot-Boilers.*

"The Government and National Art." *Nation,* 9 May 1914: 229. Letter.

"An Expensive 'Masterpiece.' " *New Statesman,* 11 July 1914: 435. Reprinted in *Pot-Boilers.*

"William Morris." *New Statesman,* 3 October 1914: 757–58. Reprinted in *Pot-Boilers.*

1915

"Conscription." *Nation,* 16 January 1915: 500–501. Letter.

"Conscription." *Nation,* 26 June 1915: 419. Letter.

"Mr. Clive Bell's Pamphlet." *Nation,* 4 September 1915: 737–38. Letter.

"The Suppression of a Pamphlet." *New Statesman,* 4 September 1915: 515–16. Letter.

"Art and War." *International Journal of Ethics,* 26 (Oct. 1915): 1–10. Reprinted in *Pot-Boilers.*

1916

"Sport and War." *New Statesman,* 5 February 1916: 420. Letter.

"The Months: March, April, June, October, December." *Nation,* 18 November 1916: 261. Poems. "March" reprinted in *Living Age,* 17 March 1917: 642. "April" reprinted in *Living Age,* 14 April 1917, 66. Reprinted in *Ad Familiares* and *Poems.*

1917

"Before the War." *Cambridge Magazine,* 12 May 1917: 581–82. Reprinted in *Pot-Boilers.*

"Contemporary Art in England." *Burlington Magazine,* 31 (July 1917): 30–37. Reprinted in *Pot-Boilers.*

1918

"The Coming General Election." *Nation*, 10 August 1918: 497. Letter.

1919

"Tradition and Movements." *Athenaeum*, 4 April 1919: 142–44. Reprinted in *Arts and Decoration*, 11 (June 1919): 86–87. Reprinted in *Since Cézanne*.

"The Douanier Rousseau." *New Republic*, 12 April 1919: 335–36. Reprinted in *Since Cézanne*.

"The London Group." *Athenaeum*, 25 April 1919: 241–42.

"Cézanne." *Athenaeum*, 16 May 1919: 339–40. Reprinted in *Since Cézanne*.

"Cézanne." *Athenaeum*, 30 May 1919: 408; 13 June 1919: 472; and 25 July 1919: 663. Letters.

" 'Significant Form.' " *Burlington Magazine*, 34 (June 1919): 257. Letter.

"Standards." *New Republic*, 14 June 1919: 207–9 Reprinted in *Since Cézanne*.

"The Artistic Problem." *Athenaeum*, 20 June 1919: 496–97. Reprinted in *Since Cézanne*.

"Renoir." *Athenaeum*, 25 July 1919: 659–60. Reprinted in *New Republic*, 10 September 1919: 173–75. Reprinted in *Since Cézanne*.

"New Ballet." *New Republic*, 30 July 1919: 414–16.

"The French Pictures at Heal's." *Nation*, 16 August 1919: 586–88.

"London Posters." *Athenaeum*, 5 September 1919: 854. Letter.

"The French Pictures." *Nation*, 6 September 1919: 672. Letter. Signed "The Author."

"Criticism." *Athenaeum*, 26 September 1919: 953–54. Reprinted in *New Republic*, 8 October 1919: 287–90. Reprinted in *Since Cézanne*.

"The French Pictures." *Nation*, 27 September 1919: 766. Letter.

"Order and Authority." *Athenaeum,* 7 November 1919: 1157–58; and 14 November 1919; 1191–93. Reprinted in *New Republic,* 3 December 1919: 17–19; and 10 December 1919: 48–50. Reprinted in *Since Cézanne.*

1920

"L'Atelier de Courbet." *Burlington Magazine,* 36 (Jan. 1920): 3.

"The Tyranny of Names and Dates." *Arts and Decoration,* 12 (Feb. 1920): 234–35.

"Duncan Grant." *Athenaeum,* 6 February 1920: 182–83. Reprinted as "Duncan Grant: A Great Modern English Painter" in *Arts and Decoration,* 13 (Sept. 1920): 246. Reprinted in *Since Cézanne.*

"The New Art Salon." *Athenaeum,* 27 February 1920: 280–81. Signed C.B.

"Wilcoxism." *New Republic,* 3 March 1920: 21–23. Reprinted in *Athenaeum,* 5 March 1920: 311–12. Reprinted in *Since Cézanne.*

"Bonnard." *Athenaeum,* 19 March 1920: 374–75. Reprinted in *Since Cézanne.*

"Wilcoxism." *Athenaeum,* 19 March 1920: 379. Letter.

"The Independent Gallery." *Athenaeum,* 7 May 1920: 612. Signed C.B.

"Mrs. Wilcox Once More." *New Republic,* 12 May 1920: 351. Letter.

"Matisse and Picasso." *Athenaeum,* 14 May 1920: 643–44. Reprinted in *New Republic,* 19 May 1920: 379–80. Reprinted in *Arts and Decoration,* 14 (Nov. 1920): 42–44. Reprinted in *Since Cézanne.*

"Mr. Fry's Pictures." *New Statesman,* 19 June 1920: 307–8.

"A Plea for an Open Mind." *Arts and Decoration,* 13 (June 1920): 87.

"Marquet." *Athenaeum,* 2 July 1920: 21. Reprinted in *Since Cézanne.*

"Negro Sculpture." *Athenaeum,* 20 August 1920: 247–48. Reprinted in *Living Age,* 25 September 1920: 786–89. Reprinted in *Since Cézanne.*

"The Place of Art in Art Criticism." *Athenaeum,* 3 September 1920:

311–12. Reprinted in *New Republic,* 15 September 1920: 73–74. Reprinted in *Since Cézanne.*

"Esotericism and 'Art.' " *Athenaeum,* 17 September 1920: 387. Letter.

"Tchehov and Ibsen." *Athenaeum,* 1 October 1920: 450.

"Art and Politics." *Athenaeum,* 5 November 1920: 623; and 12 November 1920: 660–62. Reprinted in *New Republic,* 10 November 1920: 261–63. Reprinted in *Since Cézanne.*

1921

"Mr. Fry's Criticism." *New Statesman,* 8 January 1921: 422–23.

"The Independent Gallery." *Burlington Magazine,* 38 (March 1921): 146–49.

"The Last Infirmity." *Nation and Athenaeum,* 5 March 1921: 778. Poem. Reprinted in *Poems.*

"The Authority of M. Derain." *New Statesman,* 5 March 1921: 643–44. Reprinted in *New Republic,* 16 March 1921: 65–66. Reprinted in *Since Cézanne.*

"De Gustibus." *New Republic,* 18 May 1921: 343–44. Reprinted as "Second Thoughts" in *Since Cézanne.*

"Othon Friesz." *Burlington Magazine,* 38 (June 1921): 278–82. Reprinted in *Since Cézanne.*

"παντων γλυκυτατον μεταβολη." *New Statesman,* 11 June 1921: 274. Poem. Reprinted in *Poems.*

" 'Plus de Jazz.' " *New Republic,* 21 September 1921: 92–96. Reprinted in *Since Cézanne.*

"A Committee of Taste." *Burlington Magazine,* 39 (Oct. 1921): 196–98.

"The Critic as Guide." *New Republic,* 26 October 1921: 259–61. Reprinted as "Last Thoughts" in *Since Cézanne.*

1922

"The Creed of an Aesthete." *New Republic,* 25 January 1922: 241–42.

"The Cleaning of Pictures." *Burlington Magazine,* 40 (March 1922): 127
–28.

"Good Words." *New Statesman,* 1 April 1922: 729. Letter.

"Incognita." *New Statesman,* 29 July 1922: 469.

"Congreve and Molière." *New Statesman,* 12 August 1922: 512. Letter.

"Hard Times and Standards." *New Republic,* 25 October 1922: 217–19.

"The 'Difference' of Literature." *New Republic,* 29 November 1922:
18–19.

"Art Labels and Art Merit." *Arts and Decoration,* 18 (Dec. 1922): 60.

1923

"Elegance Down the Ages." *Nation and Athenaeum,* 19 May 1923: 228.
Reprinted in *New Republic,* 13 June 1923: 76–77.

"The Sculptor's Problem." *Nation and Athenaeum,* 28 July 1923: 543–45.

"Lytton Strachey." *New Statesman,* 4 August 1923: 496–97.

"Mr. Bell on Art." *Nation and Athenaeum,* 18 August 1923: 637. Letter.

"A New Critic." *New Statesman,* 25 August 1923: 572–73.

"T.S. Eliot." *Nation and Athenaeum,* 22 September 1923: 772–73.

"The Rediscovery of Paganism." *Nation and Athenaeum,* 20 October 1923:
116–17. Reprinted in *New Republic,* 14 November 1923: 305–7. Re-
printed in *Landmarks in Ninteenth-Century Painting.*

"The Italian Schools in Trafalgar Square." *Nation and Athenaeum,* 29
December 1923: 492. Signed C.B.

1924

"An Old Picture Collection." *Nation and Athenaeum,* 5 January 1924:
519. Signed C.B.

"The Mystery of Manet." *New Republic,* 16 January 1924: 196–98. Re-
printed in *Nation and Athenaeum,* 19 January 1924: 570–71. Reprint-
ed in *Landmarks in Nineteenth-Century Painting.*

"The Art of Old Peru." *Nation and Athenaeum*, 23 February 1924: 736.

"Byron's Last Year." *Nation and Athenaeum*, 15 March 1924: 836–38. Reprinted as "Byron's Last Journey," *New Republic*, 28 May 1924: 25.

"Jean Cocteau." *Nation and Athenaeum*, 5 April 1924: 13–14.

"The Seven Lively Arts."*New Republic*, 30 April 1924: 263–64.

"Aesthetic Truth and Futurist Nonsense." *Outlook*, 7 May 1924: 20–23.

"Arts and Art." *Nation and Athenaeum*, 10 May 1924: 179–80.

"What's On in Paris." *Vogue*, 63 (Early June 1924): 46.

"Bran-pie and Eclecticism." *New Republic*, 4 June 1924: 43–45. Reprinted in *Nation and Athenaeum*, 21 June 1924: 376–78.

"What's On in Paris." *Vogue*, 63 (Early July 1924): 51.

"Gauguin." *Nation and Athenaeum*, 12 July 1924: 475–76.

"A Mosaic Ikon of the Blessed Oliver Plunkett." *Nation and Athenaeum*, 2 August 1924: 565.

"Dr. Freud on Art." *Nation and Athenaeum*, 6 September 1924: 690–91. Reprinted in *Dial*, 78 (April 1925): 280–84.

"Dr. Freud on Art." *Nation and Athenaeum*, 27 September 1924: 773. Letter.

"Anatole France: A Recollection." *Nation and Athenaeum*, 18 October 1924: 109–10.

"The Greeks and Romans." *Nation and Athenaeum*, 1 November 1924: 182–83. Reprinted as "David's Contribution to Modern Art," *New Republic*, 26 November 1924: 16–18. Reprinted in *Landmarks in Nineteenth-Century Painting*.

"Virginia Woolf." *Dial*, 77 (Dec. 1924): 451–65.

"Géricault." *New Republic*, 17 December 1924: 92–93. Reprinted in *Nation and Athenaeum*, 21 February 1925: 713–14. Reprinted in *Landmarks*.

"Autumn Shows in Paris." *Vogue,* 64 (Late December 1924): 44–45.

192̣5

"Prolegomena to a Study of Nineteenth-Century Painting." *Criterion,* 3 (Jan. 1925): 231–44. Reprinted in *Landmarks.*

"The English." *Nation and Athenaeum,* 3 January 1925: 493–94. Reprinted in *New Republic,* 25 February 1925: 15–17. Reprinted in *Landmarks.*

"Delacroix." *New Republic,* 14 January 1925: 195–96. Reprinted in *Nation and Athenaeum,* 28 March 1925: 885–86. Reprinted in *Landmarks.*

"Jean Cocteau's Drawings." *Nation and Athenaeum,* 17 January 1925: 555–56.

"The Colonel's Theory." *Nation and Athenaeum,* 7 March 1925: 779.

"Spring Shows in and off Bond Street." *Vogue,* 65 (Late April 1925): 66–67.

"Romanticism in 1830." *New Republic,* 29 April 1925: 260–62. Reprinted in *Nation and Athenaeum,* 30 May 1925: 266–67. Reprinted in *Landmarks.*

"Vinegar and Oil." *Nation and Athenaeum,* 2 May 1925: 138.

"Sargent." *New Republic,* 20 May 1925: 340.

"Paris Again. What Next?" *Vogue,* 66 (Early July 1925): 54–55.

"Syncretism." *Nation and Athenaeum,* 1 August 1925: 541–43. Reprinted in *Landmarks.*

"A Tour of the Summer Shows." *Vogue,* 66 (Late August 1925): 42.

"See Your Own Country First." *Vogue,* 66 (Early September 1925): 50–51.

"The Anonymous Master." *Nation and Athenaeum,* 17 October 1925: 114 –15. Reprinted in *Landmarks.*

"The Pre-Raphaelites." *New Republic,* 28 October 1925: 251–53. Re-

printed in *Nation and Athenaeum,* 19 December 1925: 433–35. Reprinted in *Landmarks.*

"October Shows in London." *Vogue,* 66 (Early November 1925): 70–71.

"Barbizon." *Burlington Magazine,* 47 (Nov. 1925): 255–56. Reprinted in *Landmarks.*

"Autumn Shows in Paris." *Vogue,* 66 (Early December 1925): 96–97.

"The Art of Brancusi." *Vogue,* 66 (Late December 1925): 43–45.

1926

"The Dutch School." *Nation and Athenaeum,* 2 January 1926: 498. Reprinted in *New Republic,* 19 May 1926: 413.

"Mid-Winter Shows in London." *Vogue,* 67 (Late January 1926): 54–55.

"Frank Dobson." *Architectural Review,* 59 (February 1926): 41–45.

"The London Group and Sargent." *Vogue,* 67 (Late February 1926): 54–55.

"Notes on the Courtauld Pictures." *Vogue,* 67 (Late March 1926): 64–65.

"The Realist." *Nation and Athenaeum,* 20 March 1926: 857–59. Reprinted in *Landmarks.*

"A Great Exhibition." *Vogue,* 67 (Early April 1926): 64–65.

"The Work of Daumier." *Vogue,* 67 (Early May 1926): 70–71.

"Cocteau Collected." *Nation and Athenaeum,* 1 May 1926: 133.

"The Allied Artists at the Leicester Galleries." *Vogue,* 67 (Late May 1926): 64–65.

"Round About Surréalisme." *Vogue,* 68 (Early July 1926): 54–55.

"A New Critic on Proust." *Nation and Athenaeum,* 10 July 1926: 422.

"To Finish the Season in Paris." *Vogue,* 68 (Late July 1926): 48–49.

"Turner." *Nation and Athenaeum,* 31 July 1926: 498–500. Reprinted in *Landmarks.*

"Ingres." *Burlington Magazine,* 49 (Sept. 1926): 124–35. Reprinted in *Landmarks.*

"The Work of Maillol." *Vogue,* 68 (Early September 1926): 52–53.

"London Statues." *Nation and Athenaeum,* 2 October 1926: 767–68.

"The Two Corots." *Nation and Athenaeum,* 9 October 1926: 18–20. Reprinted in *Landmarks.*

"Autumn Shows in Paris." *Vogue,* 68 (Late November 1926): 64–65.

"Autumn Shows in London: A Retrospect." *Vogue,* 68 (Early December 1926): 78–79.

1927

"A Tour of Mid-Winter Exhibitions." *Vogue,* 69 (Early January 1927): 40–41.

"Two Impressionisms." *Nation and Athenaeum,* 8 January 1927: 505–7. Reprinted in *Landmarks.*

"The Private Collection of Mr. and Mrs. Courtauld." *Vogue,* 69 (Early February 1927): 30–31.

"Art: Notes on Some Recent and Current Exhibitions." *Vogue,* 69 (Early March 1927): 64–65.

"Are Books Too Dear?" *Nation and Athenaeum,* 16 April 1927: 46–47; and 7 May 1927: 146. Letters.

"Flowers and a Moral." *Nation and Athenaeum,* 4 June 1927: 303–4.

"We Are Amused." *Nation and Athenaeum,* 16 July 1927: 519.

"Cézanne between the Critics." *Nation and Athenaeum,* 10 December 1927: 398.

1928

"What Civilization is Not." *Life and Letters,* 1 (June 1928): 40–46. Reprinted as part of the chapter with the same title in *Civilization.*

"Mr. Anrep's Mosaics in the National Gallery." *Nation and Athenaeum,* 2 June 1928: 296.

"Our Stone Population." *Nation and Athenaeum,* 8 December 1928: 360.

1929

"Proust Studies." *Times Literary Supplement,* 28 February 1929: 163. Letter.

"Was Talleyrand Delacroix's Father?" *New Statesman,* 17 August 1929: 576–77.

"Limitation All Round." *Nation and Athenaeum,* 24 August 1929: 676. Letter.

1930

"Derain." *Formes.* No. 2 (Feb. 1930): 5–6 (English edition).

" 'Living Dangerously': A Conversation between Rebecca West, Clive Bell and Commander Locker-Lampson." *Listener,* 16 April 1930: 677–78.

"D.H. Lawrence." *Nation and Athenaeum,* 19 April 1930: 76–77. Letter.

"Why do they go to the Pictures?" *Art News,* 31 May 1930: 14.

1931

"Italianate." *Life and Letters,* 7 (Aug. 1931): 88–95. Reprinted in *An Account of French Painting.*

1933

"Matisse and Picasso." *New Statesman and Nation,* 1 July 1933: 12–13. Reprinted in V.S. Pritchett ed., *Turnstile One* (London: Turnstile Press, 1948).

"The Pacifists' Dilemma." *New Statesman and Nation,* 18 November 1933: 630. Letter.

1934

"Painters as Buyers." *New Statesman and Nation,* 27 January 1934: 116 –17.

"London Shows." *New Statesman and Nation,* 17 February 1934: 225.

"Paris Shows." *New Statesman and Nation,* 24 March 1934: 448–49.

"Dublin versus the Tate." *New Statesman and Nation,* 21 April 1934: 614.

"Duncan Grant." *New Statesman and Nation,* 19 May 1934: 763–64.

"What I Like in Art—Cosimo Tura's Madonna Enthroned." *Listener,* 13 June 1934: 990–92.

"Vuillard." *New Statesman and Nation,* 16 June 1934: 912–13.

"Shell-Mex and the Painters." *New Statesman and Nation,* 23 June 1934: 946.

"Braque." *New Statesman and Nation,* 14 July 1934: 44–45.

"Agnew's Winter Show." *New Statesman and Nation,* 24 November 1934: 753–54.

"The Zwemmer Gallery." *New Statesman and Nation,* 22 December 1934: 938–39.

1935

"Francis Birrell." *New Statesman and Nation,* 12 January 1935: 38. Letter.

"A Triumph of Ugliness." *New Statesman and Nation,* 26 January 1935: 110.

"Current Picture Shows." *New Statesman and Nation,* 23 February 1935: 246.

"A Positive Pleasure." *New Statesman and Nation,* 2 March 1935: 280–81.

"What Next in Art?" *Studio,* 109 (April 1935): 176–85.

"Art in 1910." *New Statesman and Nation,* 4 May 1935: 632–35.

"The Franco-Italian Exhibition." *New Statesman and Nation,* 6 July 1935: 14–15.

"Contemporary Art at the Tate." *New Statesman and Nation,* 20 July 1935: 93–94.

"Old Wine in New Bottles?" *Listener,* 7 August 1935: 220–21.

"Sanctions." *New Statesman and Nation,* 28 September 1935: 405. Letter.

"Cézanne." *New Statesman and Nation,* 12 October 1935: 493–94.

"Two Exhibitions." *New Statesman and Nation,* 19 October 1935: 558.

"Byron 1811–1816." *New Statesman and Nation,* 26 October 1935: 606–9.

"Byron." *New Statesman and Nation,* 9 November 1935: 672. Letter.

"Cocteau's Drawings." *New Statesman and Nation,* 14 December 1935: 935–36.

"Sanctions and War." *New Statesman and Nation,* 28 December 1935: 1011. Letter.

1936

"Notes on the Chinese Exhibition." *New Statesman and Nation,* 11 January 1936: 47–49.

"The Feminine Touch." *New Statesman and Nation,* 18 January 1936: 82–83.

"Black and White." *New Statesman and Nation,* 15 February 1936: 226–27.

"The Tragedy of Gainsborough." *Listener,* 26 February 1936: 375–78.

"Inside the 'Queen Mary': A Business Man's Dream." *Listener,* 8 April 1936, 658–60. Reprinted as "Inside the Queen Mary," *Living Age,* 350 (June 1936): 329–32.

"Four Shows." *New Statesman and Nation,* 9 May 1936: 703–4.

"French Painter and Chinese Philosopher." *New Statesman and Nation,* 23 May 1936: 806–7.

"Picasso." *New Statesman and Nation,* 30 May 1936: 857–58. Reprinted as "Picasso's Mind," *Living Age,* 350 (Aug. 1936): 532–34.

"Art and Patronage." *Listener,* 10 June 1936: 1128.

"English Hotels." *New Statesman and Nation,* 29 August 1936: 287. Letter.

"French Modern Masters in London." *Art News,* 17 October 1936: 17–18.

"The Failure of State Art." *Listener,* 21 October 1936: 745–47.

"Four Good Shows." *New Statesman and Nation,* 14 November 1936: 771–72.

"The Kiln." *New Statesman and Nation,* 5 December 1936: 891–92.

"December Shows." *New Statesman and Nation,* 12 December 1936: 979–80.

"Gauguin." *New Statesman and Nation,* 26 December 1936: 1070.

1937

"English and French." *New Statesman and Nation,* 30 January 1937: 158–59.

"The Duke." *New Statesman and Nation,* 10 April 1937: 600–601.

"Art in the Planned State." *Forum,* 97 (May 1937): 306–9.

"Victorian Taste." *Listener,* 23 June 1937: 1235–37.

"Paris." *New Statesman and Nation,* 26 June 1937: 1046–48.

"Sickert." *New Statesman and Nation,* 18 December 1937: 1062–63. A condensed version was reprinted as "England's Old Master," *Living Age,* 353 (Feb. 1938): 542.

1938

"Since Cézanne: Epilogue." *New Statesman and Nation,* 1 January 1938: 14–15; and 8 January 1938: 47–49.

"A Confusion of Names." *Times,* 14 January 1938: 10. Letter.

"Children's Paintings." *New Statesman and Nation*, 15 January 1938: 83.

"The School of 1938." *New Statesman and Nation*, 26 March 1938: 524 –26.

"The Unacademic Academy." *New Statesman and Nation*, 21 May 1938: 870–72.

"Seriousness." *New Statesman and Nation*, 4 June 1938: 952–53.

"Posters." *New Statesman and Nation*, 9 July 1938: 75–76.

"Lithographs in Colour." *New Statesman and Nation*, 24 September 1938: 456.

"Present and Future." *New Statesman and Nation*, 5 November 1938: 721 –23.

"Cubism and Functionalism." *New Statesman and Nation*, 12 November 1938: 767–68. Excerpts reprinted in *Architectural Forum*, 71 (Sept. 1939): 195–96.

"A Painter of the Nineties." *New Statesman and Nation*, 26 November 1938: 880.

"Conscription." *New Statesman and Nation*, 17 December 1938: 1048. Letter.

1939

"Scottish Art." *New Statesman and Nation*, 21 January 1939: 83–84.

"Paraphrases." *New Statesman and Nation*, 25 February 1939: 279–80.

"Picasso." *New Statesman and Nation*, 11 March 1939: 356–57.

"The Camden Town Group." *New Statesman and Nation*, 1 April 1939: 493–94.

"British Art in New York." *Times*, 21 April 1939: 12. Letter.

"A Real Academic Artist." *New Statesman and Nation*, 3 June 1939: 870.

"Wall Painting." *New Statesman and Nation*, 10 June 1939: 892.

Checklist

"To Byron." *New Statesman and Nation,* 17 June 1939: 944.

"Cézanne." *New Statesman and Nation,* 8 July 1939: 50.

"French and English." *New Statesman and Nation,* 22 July 1939: 141.

"The Welfare of Humanity." *Times,* 1 September 1939: 6. A letter signed by Clive Bell and several others.

"An Excess of Zeal." *Times,* 16 September 1939: 6. Letter.

"Stalinism." *New Statesman and Nation,* 7 October 1939: 487. Letter.

"A Ministry of Arts." *New Statesman and Nation,* 14 October 1939: 518 –19.

"Roger Fry's Last Lectures." *New Statesman and Nation,* 21 October 1939: 564.

"The Artist and His Public." *New Statesman and Nation,* 18 November 1939: 708–9.

"The Artist and the Public." *New Statesman and Nation,* 9 December 1939: 826. Letter.

"Blest Pair." *New Statesman and Nation,* 30 December 1939: 964.

1940

"Mr. Munnings and Ultra-Modern Art." *New Statesman and Nation,* 6 January 1940: 10–11.

"Ricketts and Cézanne." *New Statesman and Nation,* 6 January 1940: 14. Letter.

"Modern French Painters." *New Statesman and Nation,* 17 February 1940: 214.

"British Painting at the National Gallery." *New Statesman and Nation,* 13 April 1940: 491–92.

"Are We at War: Horse-Racing and Other Diversions." *Times,* 27 May 1940: 9. Letter.

"Victor Pasmore." *New Statesman and Nation,* 15 June 1940: 746.

"Fifth Columnists." *New Statesman and Nation*, 27 July 1940: 89. Letter.

"Two Shows." *New Statesman and Nation*, 3 August 1940: 110.

"Art for the People." *New Statesman and Nation*, 21 September 1940: 282.

"Adolescent Art." *New Statesman and Nation*, 5 October 1940: 330.

"Roman Portraits." *New Statesman and Nation*, 26 October 1940: 420.

"Rumours." *New Statesman and Nation*, 16 November 1940: 492. Letter.

"A Whitehall Ceiling." *Times*, 30 November 1940: 5. Letter.

1941

"The Leicester Galleries." *New Statesman and Nation*, 1 February 1941: 108.

"Details." *New Statesman and Nation*, 8 February 1941: 142.

"King Penguins." *New Statesman and Nation*, 22 February 1941: 196.

"Water-Colours Ancient and Modern." *New Statesman and Nation*, 15 March 1941: 271.

"Durham Company." *New Statesman and Nation*, 5 April 1941: 370–71.

"The National Gallery." *New Statesman and Nation*, 19 April 1941: 410.

"Vermeer." *New Statesman and Nation*, 10 May 1941: 448.

"Gertler." *New Statesman and Nation*, 24 May 1941: 528–29.

"The Euston Road Group in Oxford." *New Statesman and Nation*, 31 May 1941: 554.

"European Painting and Sculpture." *New Statesman and Nation*, 14 June 1941: 610.

"Miller's—The Arts in Sussex." *New Statesman and Nation*, 19 July 1941: 58.

" 'Artists of Fame and Promise.' " *New Statesman and Nation*, 26 July 1941: 82.

"A Well-deserving Enterprise." *New Statesman and Nation,* 16 August 1941: 162.

"Sickert at the National Gallery." *New Statesman and Nation,* 6 September 1941: 229–30.

"A Strange Adventure." *New Statesman and Nation,* 13 September 1941: 262.

"What to Look For in a Picture. Part of a discussion by Clive Bell, Herbert Read, and V.S. Pritchett." *Listener,* 16 October 1941: 529 –30.

"Drawings by Augustus John, R.A." *New Statesman and Nation,* 1 November 1941: 397.

"Pictures for America." *New Statesman and Nation,* 15 November 1941: 424.

1942

"Cézanne's Letters." *New Statesman and Nation,* 17 January 1942: 44.

"Painters Always Write Well." *New Statesman and Nation,* 24 January 1942: 55–56.

"Stalin's Policy." *New Statesman and Nation,* 7 March 1942: 161. Letter.

"Three Shows." *New Statesman and Nation,* 4 April 1942: 225.

"Contemporary Art." *New Statesman and Nation,* 11 April 1942: 240.

"Sickert's Last Pictures." *New Statesman and Nation,* 13 June 1942: 386.

"At Hertford House." *New Statesman and Nation,* 11 July 1942: 23.

"Two Galleries." *New Statesman and Nation,* 18 July 1942: 41.

"Fame and Promise." *New Statesman and Nation,* 25 July 1942: 60.

"Four Shows." *New Statesman and Nation,* 22 August 1942: 123.

"Autumn Shows." *New Statesman and Nation,* 19 September 1942: 187.

"Painting and Illustration." *New Statesman and Nation,* 10 October 1942: 237–38.

"Miller's." *New Statesman and Nation,* 17 October 1942: 255–56.

"A Positive Pleasure." *New Statesman and Nation,* 12 December 1942: 388–89.

"Shooting." *New Statesman and Nation,* 12 December 1942: 397.

"Current Exhibitions." *New Statesman and Nation,* 19 December 1942: 408.

"At the National Gallery." *New Statesman and Nation,* 26 December 1942: 423.

1943

"The Painters of Poland." *New Statesman and Nation,* 16 January 1943: 45–46.

"The Redfern Gallery." *New Statesman and Nation,* 20 February 1943: 124.

"Drawings and Drawings." *New Statesman and Nation,* 6 March 1943: 155.

"French Pictures in London." *New Statesman and Nation,* 15 May 1943: 320.

"Paintings in Berwick Church, Sussex." *Country Life,* 93 (4 June 1943): 1016–17.

"Steer Mystery." *New Statesman and Nation,* 26 June 1943: 415–16.

"Fame and Promise." *New Statesman and Nation,* 17 July 1943: 40.

"Rembrandt." *New Statesman and Nation,* 21 August 1943: 125–26.

"Posters." *New Statesman and Nation,* 9 October 1943: 231.

"Ballet Design." *New Statesman and Nation,* 30 October 1943: 284.

"Portraits." *New Statesman and Nation,* 13 November 1943: 315–16.

1944

"Sickert." *New Statesman and Nation,* 26 February 1944: 145.

"Gallery Books." *New Statesman and Nation,* 8 April 1944: 245.

"Leonardo." *New Statesman and Nation,* 22 April 1944: 276–77.

"Sickert." *Cornhill,* 161 (May 1944), 22–28. Reprinted as "Walter Sickert" in *Old Friends.*

"Penguin Modern Painters." *New Statesman and Nation,* 20 May 1944: 340–41.

"Portal Houses." *Times,* 1 September 1944: 5. A letter signed by Clive Bell and several others.

1945

"Art and Expertise." *Cornhill,* 161 (April 1945): 296–300.

1946

"Mr. Bodkin and Mr. Fry." *New Statesman and Nation,* 23 February 1946: 139. Letter.

"The National Gallery." *Times,* 21 November 1946: 5. A letter signed by Clive Bell and several others.

"Plein-airisme." *Listener,* 26 December 1946: 935–36.

1947

"The Art of Pierre Bonnard." *Listener,* 13 March 1947: 379–80.

1948

"A Liberal's Point of View." *Spectator,* 22 October 1948: 527–28; and *Spectator,* 5 November 1948: 592–93. Letters.

"The Critic's Role." *Nation* (New York), 20 November 1948: 578–80.

1949

"The Shadow of the Master." *New Statesman and Nation*, 23 April 1949: 402–3.

"Blood Sports." *New Statesman and Nation*, 23 July 1949: 92–93.

"Books in General." *New Statesman and Nation*, 26 November 1949: 616.

1950

"Personal Choice." *New Statesman and Nation*, 22 July 1950: 102.

"Art Teaching." *New Statesman and Nation*, 26 August 1950: 225–26.

"Copies That May Be Masterpieces." *Times*, 2 September 1950: 7. Letter.

"How England Met Modern Art." *Art News*, 49 (Oct. 1950): 24–27.

"Recollections of Lytton Strachey." *Cornhill*, 165 (Winter 1950): 11–21. Reprinted as "Lytton Strachey" in *Old Friends*.

1951

"Contemporary Art-Criticism in England." *Magazine of Art*, 44 (May 1951): 179–83.

"Students and the National Gallery." *Times*, 8 September 1951: 7. Letter.

1952

"National Collection of Photography: Fostering Appreciation and Study." *Times*, 3 March 1952: 3. A letter signed by Clive Bell and several others.

"In Place of Fear." *New Statesman and Nation*, 19 April 1952: 464. Letter.

"National Collection of Photography." *Times*, 31 May 1952: 7. A letter signed by Clive Bell and several others.

"Roger Fry (1866–1934)." *Cornhill*, 166 (Autumn 1952): 180–97. Reprinted as "Roger Fry" in *Old Friends*.

1953

"Elizabethan Portraits." *Times*, 31 August 1953: 7. Letter.

"Georges Rouault." *Apollo,* 58 (October 1953): 104–6.

1954

"What was Bloomsbury?" *Twentieth Century,* 155 (Feb. 1954): 153–60. Reprinted as "Bloomsbury" in *Old Friends.*

"The Courtauld Collection." *Times Literary Supplement,* 26 March 1954: 200. Unsigned. Two paragraphs are reprinted with some modification in "Roger Fry" in *Old Friends,* 81–83.

"Maurice Utrillo." *Apollo,* 59 (June 1954): 157–61.

" 'The Bloomsbury Group.' " *Times Literary Supplement,* 27 August 1954: 543. Letter.

"Henri Matisse." *Times,* 20 November 1954: 7. Letter.

"Henri Matisse." *Apollo,* 60 (Dec. 1954): 151–56.

INDEX

William G. Bywater, Jr., is associate professor of philosophy at Allegheny College. He received his B.A. degree (1962) from Lehigh University, his M.A. (1966) and Ph.D. (1969) degrees from the University of Michigan.

The book was designed by Don Ross. The typeface for the text is Baskerville, designed by John Baskerville in the eighteenth century; and the display face is Bauer Bodoni.

The text is printed on P & S offset text paper. The book is bound in Columbia Mills' Fictonette over binders' boards. Manufactured in the United States of America.